PUBLIC ART COLLECTIONS IN NORTH-WEST ENGLAND

A History and Guide

EDWARD MORRIS

LIVERPOOL UNIVERSITY PRESS

First published 2001 by
Liverpool University Press
4 Cambridge Street
Liverpool L69 7ZU

Copyright © 2001 Edward Morris

*British Library Cataloguing-in-
Publication Data*
A British Library CIP record is
available

ISBN 0 85323 527 9

Design and typesetting:
www.axisgraphicdesign.co.uk

Scanning: Leeds Photo Litho, Leeds

Printing and binding:
Craft Print International Ltd, Singapore

Contents

Contents continued

Preface

The last fifty years have been the age of the large museum. High levels of security and conservation for works of art, and of education and curatorial expertise for students and visitors, not to mention shops and cafés, are easier to provide in a large art gallery than in a small one. Great metropolitan museums attracting millions of tourists have prospered. Small museums in industrial areas generally unattractive to tourists have suffered. But the appreciation of art should not be primarily a matter of tourism or leisure. Rather, it should be a question of a few hours or more often minutes of emotional and spiritual relief from the pressures of office, shop, factory – or even home – amidst well-loved paintings, few of them masterpieces, in a local art gallery. This is the best available substitute for the paintings on sitting-room walls which few can afford. Huge art galleries can be daunting and intimidating even for the most resolute enthusiast. For this reason this guide devotes more space to the smaller galleries than the importance of their collections would otherwise demand. The larger galleries are well known and excellent guides are easily available. Few people know that one of the greatest paintings of the late nineteenth century, and certainly the most important painting of the Aesthetic Movement, is in Blackburn, or that, more generally, for British art of the second half of the nineteenth century, whether Pre-Raphaelite, Aesthetic, Classical or Impressionist, north-west England has, cumulatively, collections superior to those in London and the south east and far ahead of those in the West Midlands or Yorkshire.

Collections principally containing local portraits and views will not be found here. Works of art in cathedrals, churches and chapels, which are generally discussed in the Buildings of England series by Nikolaus Pevsner and others, are omitted except where the building has effectively been converted into a museum. Libraries, even those with important collections of illuminated manuscripts, are generally excluded as this book is principally concerned with paintings and sculpture rather than with drawings and watercolours which can only rarely be displayed. Indeed, very few art galleries can at any one time display all or even most of their collections of oil paintings and sculpture. Temporary loan exhibitions may displace parts of the permanent collection, although fortunately the removal to store of most or all of permanent collections in favour of exhibitions of the local photographic society or art group is now rare. The sharp reduction in the number of travelling exhibitions from London has stimulated provincial curators to conserve and display their own paintings. Public collections only accessible to visitors by prior appointment are generally omitted. Visitors may, however, find that not all the works of art described in this guide are on display. If this is the case, they should come again later – and again, and again.

Acknowledgments

Many curators have given me help and information. I am particularly grateful to Steve Blackbourn, Eddie Bowes, Richard Burns, Judith Clarke, Louanne Collins, Ann Compton, Sandra Cruise, Sarah Evans, Rebecca Finnerty, Andy Firth, Paul Flintoff, Melanie Gardner, Cherry Gray, Nick Harling, Penny Haworth, Adrian Jenkins, Joanna Jones, Louise Karlsen, Maggie McKean, Francis Marshall, Sandra Martin, Jennifer Rennie, Judy Sandling, Vicky Slowe, Alistair Smith, Emma Smith, Claire Stewart, Penny Thompson, Yvonne Webb, Lucy Whetstone, Andrew White, Stephen Whittle and Robert Woof. Dr Catherine Gordon at the Witt Library in the Courtauld Institute of Art kindly showed me many lists of paintings and collection catalogues. Mike Leber much improved my section on L.S. Lowry at Salford. Gillian Ingram provided valuable material on the development of art galleries in Birkenhead. Lynda Rea has been typing catalogues, articles, letters, labels and documents for me for over seventeen years. She typed this book and my debt to her is enormous.

Introduction

The official opening of the 1896 Spring Exhibition at the Oldham Art Gallery was described in the *Oldham Standard*. The Mayor was of course invited to speak 'and he did it willingly although he was unable to give them any ideas about art. There was a time, he dared say, many years ago, when he thought he knew something, but he now knew he never had. There was no doubt however that art, particularly engravings and pictures, had a very refining influence on the mind...' Between about 1850 and 1930 some 24 public art galleries were opened in north-west England, particularly in the industrial region of north Cheshire and of south and central Lancashire. There were generous benefactors and well-informed enthusiasts in every town or city, but even among those who, like the Mayor of Oldham, knew nothing about art and had never known anything about art there was a general conviction that art would refine and educate their people.

There were, however, formidable obstacles to the art gallery building movement. The first was the attitude of central government in London. In France, for example, as J. Comyns Carr reported in his *Art in Provincial France* of 1887, the state actually set up some of the larger provincial art galleries and supported most of them by conditional gifts of works of art. In Britain a series of Acts of Parliament from the Museums Act of 1845 to the Public Libraries Act of 1919 permitted local authorities to establish museums and art galleries. Joseph Brotherton, the Radical Member of Parliament for Salford, was one of the principal promoters of the 1845 Statute and, thanks to his local influence, Salford opened in 1850 one of the first local authority museums in England. However, none of these Acts offered any financial support or the permanent allocation of any works of art for these new museums and galleries. Henry Cole, the formidable director of the Victoria and Albert Museum, pleaded in vain for assistance from national taxation; all that could be done was the temporary loan of paintings and sculptures from the national collections in London. Worse still, these statutes imposed severe, but diminishing, restrictions on the amount that each local authority could spend on its museums and art galleries and on the extent to which works of art could be

bought from local taxation. Some enterprising town councils evaded these restrictions through local Improvement Acts; for example, Rochdale tacked on to a Bill to enable it to acquire its local trams clauses permitting it to spend much more than the prescribed amount in order to enlarge its library and set up a new art gallery and museum. Of course, approval for capital expenditure involving borrowing by councils or the purchase of land, even within the limits imposed, had to be obtained from the Local Government Board in London.

The second problem was the fragmentation of local authorities into very small units. Even Manchester did not include Salford, and Liverpool did not include Bootle. Oldham did not then include Crompton, Royton, Chadderton, Failsworth, Lees or Saddleworth. Town and city council boundaries were being constantly expanded in the later nineteenth and twentieth centuries but it is still true that the burden of establishing and maintaining urban art galleries fell largely on inner areas, not on the suburbs where the richest citizens were building grand new homes. These wealthy and influential men, often collectors themselves, were much less willing to sit on town or city councils which no longer represented the area where they lived, and thus their support for city- or town-centre art galleries was lost. County councils were only authorised to provide art galleries in 1919 and even then could not do so in areas where a public art gallery or museum already existed.

The third difficulty was the absence of any foundation on which the new art galleries could build. On the continent the secularisation of religious orders and of church property generally, together with the confiscation of aristocratic art collections, gave new art galleries there both fine buildings for conversion into museums and superb works of art to display in them. Some semi-public collections were available in the largest cities of north-west England, most notably those formed by the Royal Institutions of Manchester and Liverpool; the Royal Manchester Institution did provide a very inadequate art gallery for Manchester but the Liverpool Town Council failed in its attempt to take over the Liverpool Royal Institution collection in 1850–51 and only finally succeeded in 1948. Generally buildings for art galleries were only easily available in the area north of Preston where industrial development was slow.

The force which overcame these obstacles to the creation of art galleries in north-west England between 1850 and 1930 was above all the wealth of the

 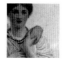 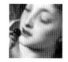 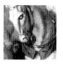

southern part of this area. The prodigious economic expansion of Lancashire between 1750 and 1850 scarcely needs demonstration, but it is also true that this growth continued at a slower pace until the First World War and absolute decline only became apparent in the early 1920s. Thus the period of the most rapid expansion of art galleries around 1880–1920 coincided with the peak of Lancashire's prosperity. Statistics of relative wealth are dangerous and it does seem that the very richest individuals preferred to live in London, but the most authoritative recent account of Lancashire's economy between 1850 and 1914 concludes that 'the wealth of the Lancashire middle classes had no parallel in England outside the metropolis'. Even in 1930, of the 35 English cities with a population of over 100,000 outside the London area eleven were in Lancashire or north Cheshire.

As for the town or city councils responsible for the new art galleries, they may have been relatively small in their boundaries, but within them they were at the peak of their power and influence during the crucial period around 1900 for the growth of art galleries. The Lancashire councils had obtained control of gas and water supplies long before Birmingham's more famous municipalisation campaign of the 1870s. Under the influence of Joseph Chamberlain's reforms in Birmingham, electricity, trams, municipal housing, and above all education (in 1902) followed on after parks, libraries, street maintenance, drains, sewers, building regulations and many aspects of public health. The scale and grandeur of the town halls of north-west England built in the late nineteenth century are evidence of the power of their municipal authorities. Even if the richest and most influential merchants and manufacturers were no longer willing to serve as councillors or aldermen after about 1880, there was by then much greater ideological consensus and social cohesion among the Lancashire urban ruling classes. The old sharp divisions between Tory and Liberal and between Anglican and Nonconformist had largely broken down, and if the pioneers of art galleries were usually Liberal and Nonconformist their political and religious opponents did not denounce art galleries simply as a matter of party allegiance.

Even where a town council was determined a build a new art gallery or museum, finance was always difficult and benefactors often played an important part. E.R. Harris in Preston, A.B. Walker in Liverpool, William

Atkinson in Southport, Joseph Whitworth in Manchester and E.R. Longworthy in Salford gave or bequeathed large amounts to museums and galleries in their areas out of general philanthropy rather than any personal interest in art or art galleries; dedicated collectors and enthusiasts such as W.H. Lever in Port Sunlight or the Grundy brothers in Blackpool were much rarer. Architectural or sculptural extravagance was still generally unaffordable and very few architects of national importance were involved in the building programme. Either a local man known to the council as efficient and experienced was selected or there was a competition, which itself deterred the most celebrated names. As for sculptors, G.W. Seale did the reliefs on Southport and Blackburn Art Galleries while J.J. Millson was responsible for the reliefs at Bury. These men were artisans rather than artists. Liverpool was better served by John Warrington Wood and Rochdale by C.J. Allen, but both sculptors had a local rather than a national reputation. Sadly neither G.F. Watts nor Puvis de Chavannes actually decorated the walls of the Harris Library, Museum and Art Gallery at Preston although they were asked to work there. The architectural style selected was generally then described as 'free Renaissance', that is, classical elements combined in a rather arts-and-crafts manner. But there were exceptions, above all at Preston where an austere and rigorous Greek neoclassicism prevailed.

Despite all these reservations, the new art galleries at Preston, Bury and Port Sunlight in particular are undoubtedly among the finest buildings of their period in north-west England. As for the internal arrangement, the art gallery rooms were usually located over the library or museum accommodation in all except the largest towns or cities. The Harris Library, Museum and Art Gallery at Preston had three stories, the art gallery on top, the museum in the middle and the library on the ground floor. Sometimes the library or museum would be eventually relocated to other premises, giving the art gallery more space. In any event museums seem to have lost their appeal after about 1890. Once towns found the means to set up art galleries, museums as a cheaper but less glamorous alternative received less attention. Town-centre sites were preferred to park sites. The art galleries at Bolton and Stockport made little progress in their remote locations, and the Whitworth Art Gallery in Manchester was in constant financial trouble until it was taken over by Manchester University.

On the other hand town-centre sites could be expensive. Although the Harris bequest paid the building costs of the Harris Library, Museum and Art Gallery, Preston Town Council still had to find £30,000 for the site. Prestige had to be paid for. The Williamson Art Gallery and Museum of 1928 was built neither in the Birkenhead town centre nor in a park but in an affluent suburb. As a result attendance figures were low.

Even if the founders of the art galleries of north-west England were rarely collectors the galleries needed works of art once they were open. An ambitious loan exhibition, relying largely on local collectors as lenders, was generally the first step to fill the empty and newly completed gallery. No doubt it was hoped that some loans would remain as gifts. This certainly happened at Southport with Miss Ball's collection; other and more notable gifts including those of Charles Lees at Oldham and Richard Newsham at Preston were probably anticipated long before the formal opening of the art galleries there. After the inaugural loan exhibition some of the larger galleries carried on with annual exhibitions of paintings for sale in the manner of the Royal Academy in London and enhanced their permanent collections from acquisitions out of these exhibitions. This was true above all in Liverpool where the 'inaugural' loan exhibition from local collections did not in fact take place until 1886, when the Walker Art Gallery had already been open for nearly ten years. Liverpool, indeed, had to rely largely on the profits from the annual exhibitions for its purchase funds. Oldham and Southport also held important annual exhibitions, attracting artists from London and other provincial centres. Manchester City Art Gallery carried on with the annual exhibitions begun by the Royal Manchester Institution in the building which it inherited from the Institution. Birkenhead tried annual exhibitions, mainly from local artists, but abandoned them after the first two. Burnley had the Edward Stocks Massey bequest and Rochdale had the James Ogden bequest to supplement their own purchase funds – or more exactly to replace them. Manchester City Council was committed to spending £2,000 each year on works of art for the Manchester City Art Gallery as part of its agreement to take over the Royal Manchester Institution. Nearly all the new art galleries had some funds for purchasing paintings. Contemporary British art was favoured, or occasionally works of the previous fifty or sixty years. Gifts followed the same pattern.

Old Masters were rarely given. J.F. Cheetham at Stalybridge and Thomas Kay at Rochdale were exceptions, but even their collections were more notable for very early 'primitive' Italian and Netherlandish art than for conventional Old Master painting. The effect of this new institutional patronage on late Victorian and Edwardian art is difficult to analyse. Frederic Leighton, who seems to have cultivated his contacts with provincial art galleries, was perhaps encouraged to devote more of his time to major history paintings such as his *Captive Andromache* which was purchased from him by the Manchester City Art Gallery. Probably the annual exhibitions of works of art for sale at Liverpool, Manchester, Oldham, Southport and elsewhere were more important to artists – as a means by which they could sell their paintings to individuals – than were the permanent collections which only ever made occasional purchases from artists. Purchasing policy was cautious and conservative, depending greatly on the standards set at the Royal Academy Summer Exhibitions. P.H. Rathbone at Liverpool at the end of the nineteenth century was more enterprising, as was Lawrence Haward between 1914 and 1945 at Manchester, but by then the larger art galleries in the area were primarily collecting historic rather than contemporary art, making generalisations difficult. Municipal art galleries were, however, the principal source of institutional patronage for late Victorian and Edwardian artists. The Tate Gallery was not founded until 1897 and its purchase funds remained small for many years. The Trustees of the Chantrey bequest (from 1876) and a few colonial galleries were more significant, but neither had the impact of the Lancashire art galleries, which concentrated on contemporary art to a greater extent than did Birmingham or Glasgow.

The new museums and art galleries were spread fairly evenly over the existing population, but there are certain trends in levels of art appreciation. Overseas trade, banking, insurance and shipping at Liverpool favoured art, as did cotton and engineering throughout east and central Lancashire. Brewers seeking respectability in a period dominated by the Temperance Movement – particularly in Liberal circles – were generous benefactors in Liverpool and Burnley. Shipbuilding at Birkenhead and soap at Port Sunlight also encouraged public art galleries. Seaside and dormitory towns such as Southport and Blackpool had notable galleries. But substantial art collections were not to be

found at St Helens with its glass, at Wigan with its coal, at Fleetwood with its fish or at Runcorn, Widnes and Northwich with their chemicals. Wigan's collection is now on display in its former Public Library designed by Alfred Waterhouse and opened in 1878, but this splendid building was provided by Thomas Taylor, a Wigan cotton-spinner rather than a coal-owner.

Very few new art galleries were established after the Second World War. No doubt this largely reflected the industrial and commercial decline of the area, although the modernist art criticism of Roger Fry and his followers had also undermined confidence not only in the conventional Victorian and Edwardian art which dominated the new art galleries but also in any absolute and objective standards in art. Modernism did supply new criteria but the manufacturers and merchants of north-west England did not generally feel themselves capable of applying them or even understanding them. Frank Hindley Smith, a Bolton mill-owner, was an exception. He declared as early as 1924 that, apart from a few independent artists like Wilson Steer and W.R. Sickert, the only other painters in England 'of any value or promise' were those inspired by Paul Cézanne. Fortunately his tastes were wider than this remarkable statement indicated and his gifts and bequests to the Bolton and Southport Art Galleries contained paintings of great variety and distinction. Generally, however, there were few generous donors or benefactors and very little public money for new art galleries or for the smaller existing galleries after 1945. Permanent collections were frequently put into storage and modern acquisitions depended heavily on the Contemporary Art Society, which took decision-making away from local curators or committees.

New museums and galleries established after 1945 are mainly to be found in tourist areas around the Lake District, Kendal, Grasmere, Coniston and Lancaster. Art was now a matter of leisure rather than of education, and private rather than public money became the dominant element. On the other hand, further south, the Whitworth Art Gallery and the Lady Lever Art Gallery, having exhausted their original endowments, fell under public control. Heavy taxation and the absence of heirs accelerated the dispersal of suburban and country-house art collections after the Second World War. The works of art at Sudley, Tatton Park, Dunham Massey and Tabley Hall remained intact in public ownership thanks to their former owners and to Liverpool City Council,

Cheshire County Council, the National Trust and Manchester University. The best paintings from Croxteth Hall went to the Walker Art Gallery in Liverpool. The collections at Eaton Hall and at Knowsley remained in private ownership. The ancient marbles at Ince Blundell went to the Liverpool Museum but the very important post-classical collections there went to the south. The Walker Art Gallery in particular acquired major works of art from some of these collections for public display in Liverpool. At Brantwood near Coniston the collection was dispersed but has now been partly reassembled.

Assistance from central government arrived at last with grants towards the purchase of works of art through the Victoria and Albert Museum and with help in conservation and design work through the North West Museums Service. In 1986 the state took over responsibility for the museums and galleries in Liverpool and Port Sunlight and gave some special assistance to the Whitworth Art Gallery. Manchester City Art Gallery obtained a large grant from the Heritage Lottery Fund for a major extension to be opened in 2001. Generally, however, the national situation was echoed in the north west. The large institutions prospered while the smaller galleries were less fortunate. The designation of a few major provincial collections as eligible for some general funding from central government will open the gap yet wider.

Public Art Collections in North-West England

Haworth Art Gallery

The Art Gallery is near the top of one of the hills overlooking the town, which is built, like most of the south Lancashire cotton towns, in a narrow valley between the bleak moors. From the Gallery and its garden there is a magnificent view over the moors towards Hameldon Hill. William Haworth and his father, Thomas, had lived in a large end terrace house in Accrington. In 1910, nineteen years after his father's death, William Haworth moved into Hollins Hill, designed for him in a simplified Jacobean style by W.H. Brierley of York. He was only to live there for three years and on the death of his sister, Anne, in 1920, she left the house to Accrington as an art gallery in fulfilment of his plans. The Haworths were successful cotton manufacturers in Accrington. Thomas, the founder of the family firm, was active in the local Baptist Church and a town councillor. William was a staunch Liberal and a county councillor. They were philanthropists and during the 1878 cotton strike, when the windows of the Accrington factory owners were broken by the strikers, their house remained undamaged. Both men were magistrates and both served as President of the Accrington Mechanics' Institute, which played a large part in the creation of a new library for Accrington in 1908. Paintings could be displayed in the Library's lecture room and by 1921 a permanent collection of some 69 pictures had been acquired mainly by gift; they were transferred to the new Haworth Art Gallery in that year. By far the most important of these was C.J. Vernet's *Storm off the French Coast* (FIGURE 1) presented by T.E. Higham, Mayor of Accrington, in 1908; he was clearly an enthusiast, since in the same year he organised an exhibition of paintings from private collections in the Library to celebrate its opening. Vernet, while still following many of the conventions of the seventeenth-century ideal landscape, particularly in composition, moved decisively towards naturalism, and even towards Romanticism with this violent storm, turbulent sea and threatening sky. He often painted directly from nature and it was said that he would go out to sea in a small open boat during storms to study 'the effects produced by the raging of the elements in all their sublimity and grandeur'.

The Haworth bequest of 1920 included not only Hollins Hill and its garden but also an art collection notable for some twenty paintings and thirty watercolours, together with £28,000 for future maintenance. The paintings

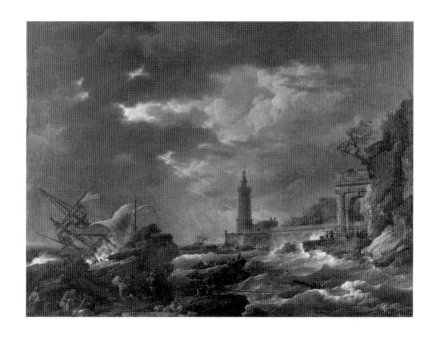

were not of exceptional quality, although J.F. Herring's *My Ladye's Palfrey* of 1849 is one of the most charming Victorian evocations of seventeenth-century aristocratic domestic leisure, exactly matching the Jacobean style of Hollins Hill. The watercolours included the usual range of landscape, architecture and still life by Copley Fielding, David Cox, Samuel Prout, W.H. Hunt and others, but Birket Foster's *The Old Chair Mender and Pedlar* is one of his most ambitious and elaborate compositions, portraying an idyllic English village life.

The Art Gallery soon attracted further gifts. In 1925 Alice Ann Nuttall bequeathed her collection. She was the widow of George Nuttall, formerly managing director of the local calico printing factory, and their collection included watercolours similar to those in the Haworth Bequest, together with two animal paintings by T.S. Cooper and Edouard Frère's *The Laundress*. Thanks to Ruskin's praise Frère's work was very widely collected in England, although much of it is coarse and uneven in quality. *The Laundress*, however, with its delicate technique and touching fall of light around the figure, has an intimate charm and dispassionate observation worthy of Chardin.

As well as cotton spinning and calico printing, textile machinery manufacture in Accrington is also represented at Haworth Art Gallery. Edwin Hitchon was engineering manager at Howard and Bullough, one of the most important firms in that field in Lancashire, before retiring to the Lake District to collect early twentieth-century topographical paintings and scenes from everyday life, mostly in watercolour. His father had given over £50,000 to Accrington Victoria Hospital and his gift of pictures reached the Haworth Art Gallery in 1946. There were other notable bequests. W.M. Barnes left Frederic Leighton's *Faith*. Based on Dorothy Dene, his favourite model, it is a study of expression and mood and of a yearning after higher things, which indeed is the real purpose of any art gallery and most particularly one developed from an environment often seen as harsh and materialist and yet directly reflecting the civic pride and cultural aspirations of its leading citizens.

Dunham Massey

Although both the fifth and sixth Earls of Stamford travelled to Italy as young men in the later eighteenth century, the collection of paintings at Dunham Massey is more notable for early views of the house than for subject pictures. However, Guercino's early *Allegory with Venus, Mars, Cupid and Time* (FIGURE 2) of about 1625, which may have been acquired by the fourth or the fifth Earl, was a remarkable purchase. No other artist seems to have painted this subject, nor was it derived from any literary source. The theme appears to relate to the dangers of love. Cupid is held captive by Venus in a net similar to the one in which she and Mars were entrapped by her husband Vulcan, who was jealous of her love for Mars. Mars is in the background of this painting to reinforce the reference, and Time seems to be pointing out the moral of the encounter with a disapproving finger. The strong contrasts of light and shade, characteristic of the artist's early work, give the painting a sense of drama, increased by the position of all the figures close to each other right in the foreground of the picture space. The fall of light onto the figures of Venus and Cupid is also of great beauty and tenderness.

Of the views of Dunham Massey the most unforgettable is dominated in the foreground by a sensitive and touching portrait of a Dutch mastiff (FIGURE 3). With his rather squat and ungainly body he occupies the position which in an eighteenth-century portrait would be the prerogative of the owner of the house. Dogs of this type seem to have been bred specially at Dunham Massey in the seventeenth and eighteenth centuries as pets, and the care and sympathy with which the artist has painted the dog's rather worried expression, as well as his coat and body, suggests that Pugg or 'Old Vertue' was particularly dear to his owners – despite the fact that in the background he seems to be chasing sheep. The artist was probably Jan Wyck, who was born in Haarlem but spent much of his life in England. The fifth Earl of Stamford brought back with him from the Grand Tour in Italy two caricatures by Thomas Patch. *A Punch Party* shows a distinguished section of Anglo-Florentine society at Charles Hadfield's Inn near Santo Spirito in Florence, while *Antiquaries at Pola* represents a group of English connoisseurs amidst the ancient buildings of Pola on the coast of Yugoslavia. A more formal portrait of the fifth Earl was painted by A.R. Mengs in Naples in 1760, and,

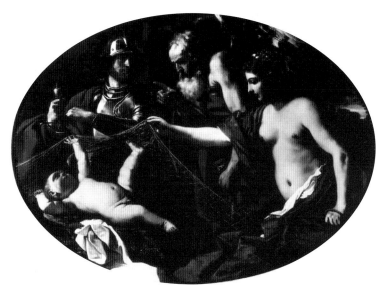

FIGURE 2

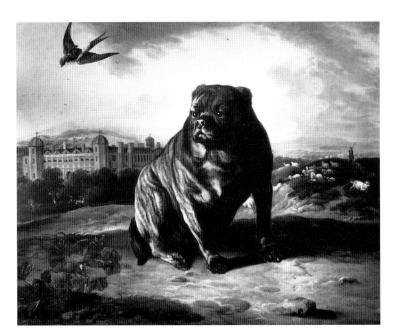

FIGURE 3

among other family portraits, there are a considerable number of works by George Romney.

The house itself was radically altered early in the twentieth century after years of neglect and no architect of national significance has ever worked on it. The Great Hall is, however, still fine despite substantial Edwardian alterations, while the Chapel, built under Cromwell in 1655, has a Puritan austerity appropriate to the religious convictions of the Booth family who then owned Dunham Massey. The house and collections passed to the National Trust as a gift in 1976, following the death of the tenth and last Earl of Stamford.

FIGURE 2

Allegory with Venus, Mars, Cupid and Time
by Guercino
(Dunham Massey, Altrincham,
National Trust Photographic Library/John Hammond)

FIGURE 3

A Dutch Mastiff with Dunham Massey in the Background
by Jan Wyck
(Dunham Massey, Altrincham,
National Trust Photographic Library/John Hammond)

Williamson Art Gallery and Museum

In 1908 the Birkenhead Art Club, which had been founded in 1903 to promote lectures, exhibitions and social facilities for its members, added a new objective to its Mission Statement: 'to exert some influence in matters of Municipal Aesthetics and to initiate the foundation of a local Art Gallery'. Some seven of its members sat on the Town Council, including five on the crucial Libraries Committee, and others belonged to wealthy and influential local families, the Lairds, the Gray-Hills, the Willmers and the Kings. Further pressure for an art gallery in Birkenhead came from John Williamson, who derived his considerable wealth from shipping, insurance and trade with South America. He was for many years Chairman of the Birkenhead School of Science and Art. In 1897 he presented to the Birkenhead Town Hall T.S. Cooper's enormous *Defeat of Kellerman's Cuirassiers and Carabineers by Somerset's Cavalry Brigade at the Battle of Waterloo*, which was painted for the 1847 Exhibition in Westminster Hall intended for the selection of paintings for the new Palace of Westminster. This dashing and vigorous, if rather disorganised, painting places Cooper in the Romantic tradition of Théodore Géricault and Eugène Delacroix, far from the placid and domestic grazing cow and sheep paintings, derived from seventeenth-century Dutch art, for which he is best known. In 1902 Williamson gave *Brutus Exhorting the Romans to Revenge the Death of Lucretia*. This was C.L. Eastlake's first major neoclassical work, painted in 1813 when the artist was only twenty, but establishing him as a highly trained and severely academic painter capable of reaching the summit of his profession – as indeed he did some 37 years later with his election as President of the Royal Academy.

In 1892 Charles Willmer had organised in the Town Hall the 'First Birkenhead Exhibition of Pictures in oil and water-colours by local Artists', and in 1910–11 his son, A.W. Willmer, devoted his salary as Mayor of Birkenhead, some £500, towards the purchase of paintings for a new art gallery for Birkenhead. The Willmers owned the *Birkenhead News*, a Liberal newspaper which consistently supported the establishment of the new gallery. Lastly Dr S.H. Nazeby Harrington joined the Birkenhead Town Council in 1892 and he was Deputy Chairman of the Libraries Committee (re-named the Libraries, Museum and Arts Committee in 1911) from 1908–34. He was Chairman of the

Merseyside Art Circle which, from a small gallery in central Liverpool, fostered interest in local art and artists. He owned a superb collection of the etchings of Francis Seymour Haden, many of which he presented to Birkenhead, and he wrote extensively on that artist. He was undoubtedly the principal force behind the creation of the Birkenhead Art Gallery. He provided the expertise. The others contributed their wealth and influence.

In 1909 a new central library and two branch libraries were opened in Birkenhead, thanks to Carnegie money, leaving the old library in Hamilton Street vacant. The Art Club petitioned the Mayor in 1908, requesting that the former library should become the new art gallery, and the Secretary of the Art Club wrote on 18 March 1908 to the Deputy Chairman of the Libraries Committee, who was also President of the Art Club, saying that he had spoken to Alderman E.G. Mason, a member of the Council Finance Committee as well as a member of the Art Club, in support of the Art Club's petition. The Secretary of the Art Club added that the Deputy Chairman of the Libraries Committee should also seek the support of the Chairman of the Finance Committee. Mason was a strong advocate of the art gallery scheme and he later became Chairman of the Libraries, Museum and Arts Committee from 1926 onwards. The support of the Chairman of the Finance Committee was also essential as he was on the Education Committee, which also wanted the old library as its offices. The pressure thus exerted by the Art Club council members on the Finance and Education Committees resulted in 1910 in a decision by the Finance Committee, ratified by the full council, to convert the old library into a museum and art gallery at a cost of about £530 and to devote the revenue from a rate of a half penny in the pound to its maintenance and improvement. Although technically a museum and art gallery, art was the dominant feature of the new institution which was often described simply as the Birkenhead Art Gallery. It opened to the public in 1912 with the usual loan exhibition of paintings and sculpture from local collections. Merseyside art was the principal feature of the exhibition, and, both here and in future acquisitions, Birkenhead tended to leave national and international art to the Walker Art Gallery on the other side of the Mersey and instead to concentrate on local art. Over the next forty years many works by the generation of Merseyside artists influenced to varying extents by Pre-Raphaelitism were bought for very small sums, often from the families of their original patrons, the Beausires, the Raes, the Millers, James Smith and others. There were also gifts and bequests, most notably in 1917 from John Elliot, who also left many Liverpool School paintings to the Walker Art Gallery in Liverpool. Consequently Birkenhead's collection of works by W.J.J.C. Bond, William

Davis, William Huggins, Robert Tonge, D.A. Williamson and W.L. Windus is not far behind the Walker Art Gallery's holdings in importance.

Birkenhead's most celebrated artist was P.W. Steer, even if he and his family left the area when he was only four, and one of the first gifts to the Birkenhead Art Gallery was Steer's *The Grove, Bridgnorth*, which A.W. Willmer presented in 1912, the year after it was painted. By 1911 Steer's landscapes were firmly in the classic English tradition, and the influence of early Gainsborough and of Constable is evident here despite Steer's looser brushstrokes. Similarly *The Muslin Dress* (FIGURE 4) of 1910 is clearly indebted to Albert Moore in its emphasis on flat pattern and in its simple arrangement parallel to the picture plane. By contrast *A Girl at her Toilet* of about 1892 is in the Realist tradition of Sickert and Degas, and the *Nude Seated on a Sofa* is another direct and immediate study from life, even if it was eventually used in Steer's *The Toilet of Venus* (Tate Gallery), one of his most obvious imitations of French late-eighteenth-century erotic art. Birkenhead's Steer collection does not include any of his innovative paintings of the 1880s directly influenced by French Impressionism, but outside that short period it is remarkably comprehensive.

The paintings by Steer were mainly assembled in the second half of the twentieth century. Earlier in the century acquisition policy had concentrated on contemporary paintings by conservative artists closely associated with the Royal Academy, notably David Murray, Adrian Stokes, Campbell Taylor, Lamorna Birch and D.Y. Cameron, together with the work of a few Scottish artists including E.A. Hornel, James Paterson and E.A. Walton. In 1913 the Birkenhead Art Gallery began a series of Spring Exhibitions of contemporary local paintings and watercolours, following the example of Oldham and of Southport, but generally without their London artists. Few paintings were sold except to the Art Gallery itself. Attendances were poor and the 1914 Exhibition was the last. Clearly the participation of the major London artists was essential if local exhibitions were to succeed, and Birkenhead had to buy its contemporary art during the 1920s and 1930s from exhibitions at Liverpool and elsewhere.

At the same time a representative collection of classic British watercolours was being purchased with notable works by J.M.W. Turner, Thomas Girtin, Peter De Wint, J.S. Cotman, W.H. Hunt and David Cox who was particularly well represented. The twentieth-century drawings and watercolours include an introspective and moving *Self Portrait* by Stanley Spencer and a dramatic *Grief* by William Orpen. Nazeby Harrington was himself a collector of British watercolours, some of which he bequeathed to Birkenhead. A few historic British oil paintings were also being purchased during the 1920s and 1930s;

FIGURE 4

The Muslin Dress
by P.W. Steer
(Williamson Art Gallery, Birkenhead)

FIGURE 5

Sea Gulls
by Albert Moore
(Williamson Art Gallery, Birkenhead)

they were principally Victorian and thus highly unfashionable at that time. The best was Albert Moore's *Sea Gulls* (FIGURE 5), bought in 1925 for £152. This painting, together with *Sea Shells,* now at the Walker Art Gallery, had been commissioned around 1870 by Frederick Leyland, the Liverpool ship-owner and perhaps the most important single patron of mid-Victorian Aesthetic and Pre-Raphaelite art. The subtle grey tonality of *Sea Gulls* and the variations in paint texture over the canvas demonstrate the artist's technical mastery. The dynamic wind-blown draperies, at once exposing and concealing the girl's body, also have an abstract beauty of their own in their rippling lines and folds and in the pattern created by the girl's restraining arms. The sense of movement and dynamism is unusual in Moore's generally more contemplative, even lethargic, work. Other Victorian paintings bought around this time included a fine *Seascape* by Henry Moore, J.W. North's *Early Spring* and Frederick Sandys's sinister *Valkyrie,* complete with the ominous raven of Odin.

This ambitious and well-informed purchasing policy must have been stimulated by the building of a new art gallery to replace the converted library in Hamilton Street. This was the Williamson Art Gallery and Museum, opened in 1928 and funded by John Williamson and by his son, Patrick. Although completed eleven years earlier than Bolton Museum and Art Gallery, the Williamson Art Gallery and Museum has moved much further away from Classicism, with a largely brick exterior, unobtrusive Corinthian columns and pilasters and generally a careful, well-detailed Neo-Georgian style. The building has only one storey: high art has come down to earth. The art gallery was built neither in the town centre nor in a park, but in the middle-class residential suburb of Oxton, and entering it for the local inhabitants must have seemed like a visit to a neighbour or to the post office. The mystique, and perhaps the prestige, of art and of the art gallery were replaced by new technology. Light levels were controlled by adjustable blinds, and a complete humidification system protected works of art from the effects of central heating. Comfortable and reassuring it may have been, but popular it was not. Annual attendance figures in the early years for one of the largest art galleries in north-west England (with fifteen galleries, including museum space) varied between only about 20,000 and 30,000. Blackburn's town-centre Museum and Art Gallery, although much smaller in area and in collections, was generally receiving around 40,000 visitors annually during the late 1930s. More recently the popularity of the Williamson Gallery has revived, with a new stress on its role as an arts centre for the Wirral.

Blackburn Museum and Art Gallery

Although Blackburn accepted the idea of a free public library and museum in principle as early as 1853, a library was only established in 1860 in a wing of the old Town Hall and it was not until 1870 that the Council decided to erect a new purpose-built library and museum. The architects were Woodzell and Collcutt of London, the style was Gothic in its Decorated phase, the cost was £8,424 and the sculptural panels on the two main façades were by G.W. Seale of Cold Harbour Lane, London. It is surprising that the Council should have gone as far as London for architects and a sculptor of such obscurity. The cause probably lay in the decision to hold a competition in which the Council were assisted 'by an eminent architect'. The sculptural panels represent *Literature, Science, Agriculture, Iron Manufactures, Cotton Manufactures* and *Commerce. Cotton Manufactures* was paid for by John Fish, whose cotton-spinning mills were at Livesey just outside Blackburn, and *Commerce* was a gift from John, Edward and Joseph Dugdale, machinists and cotton-spinners of Blackburn. Only *Literature* was specified as part of the original building contract. All the other panels were dependent on sponsorship. The museum and art gallery were accommodated in 'three spacious rooms' on the upper floor with the library beneath. The new building was formally opened to the public in 1874 with an inaugural loan exhibition of Works of Art and Industry. There was a charge for admission to the exhibition, raising £1,066 for future acquisitions, and some lenders were no doubt expected to leave their loans at the Museum and Art Gallery as gifts. In practice, however, few paintings or sculptures were acquired, and between 1892 and 1894 the building was considerably altered and extended to make on its upper floor the 'New Art Gallery', for which another inaugural loan exhibition was held, this time entirely composed of important contemporary paintings by artists including Frederic Leighton, J.E. Millais, Hubert Herkomer and Frank Dicksee. Of the 315 works of art exhibited only 54 were owned by Blackburn and most of these were watercolours, indicating that the permanent collection was still very modest in scale. An admission charge of sixpence was imposed for the exhibition which, thanks to the installation of electric lights, remained open until 10.00 pm every evening. Yet another loan exhibition on similar lines was held in 1907.

In spite of all these efforts, however, few major bequests and gifts came to Blackburn Art Gallery. Perhaps the most interesting is John Collier's *Hetty Sorrel*. She is the beautiful but weak and vain heroine of George Eliot's sternly moral novel *Adam Bede*, a very modern 'femme fatale'. In the painting she has just abandoned her illegitimate child to die in the wood, for which she will be condemned to death although ultimately reprieved. Disreputable figures like Hetty from contemporary Victorian novels were rarely painted on so large a scale and with such a powerful expression of guilt and remorse. Perhaps the intention of artist and donor was to discourage female promiscuity, then regarded as a major problem in Victorian cities. Another gift was Richard Ansdell's *The Highland Bothy* of 1847. The painting describes the primitive but highly picturesque, romantic and abundant life of the Highlander in the manner of Edwin Landseer, with the rich descriptive paint and textures of Ansdell's best work, done in Liverpool before his departure to London in 1848. Edwin Long's *Diana or Christ* of 1881 is one of the sensational scenes of the early Christian Church under the Roman Empire which were so attractive to the late Victorian public. The rich young Christian woman must offer a sacrifice to the image of Diana in third-century Ephesus. Behind her are the Roman soldiers ready with retribution when she refuses – as of course we know she will. Other gifts to Blackburn included the nineteenth-century British watercolours presented by Mrs R.B. Dodgson as early as 1884 and the similar but finer watercolours given by E.L. Hartley in 1954, notable above all for five works by J.M.W. Turner as well as watercolours by Thomas Girtin, David Cox, Samuel Prout and others.

By far the most important benefactor of Blackburn Museum and Art Gallery was Edward Hart, and his gift was of a type rare among the smaller Lancashire public collections. He bequeathed to Blackburn in 1946 about 6,000 rare coins, many from ancient Rome and Greece, together with about 500 exceptionally fine printed books and manuscripts. The illuminated manuscripts date from the mid-thirteenth century to the early sixteenth century, with most of the collection belonging to the later years of that period. There are, however, two very fine mid-thirteenth-century Psalters, the Peckover Psalter, produced in France around 1220–40, and the Blackburn Psalter, written in England about 1250–60. Hart spent a quiet and modest bachelor life in Blackburn living with his mother and sister in West Park Road. His wealth came from a long-established local family rope-making company. He was educated at Rugby and Cambridge where he studied classics. As well as his gifts to Blackburn Museum and Art Gallery he gave £30,000 towards the purchase of Witton Country Park, just on the edge of Blackburn, for its people.

The wealthy scholarly collector concentrating on his own specialist field was common enough in early twentieth-century London but rare in the smaller towns of industrial Lancashire.

Among the paintings purchased by Blackburn was one of the greatest works of art of the late nineteenth century. By 1890 Albert Moore had established a reputation for painting splendid statuesque classical figures in carefully devised settings, devoid of narrative interest or of emotional effect, but instead relying on subtle colour harmonies, immaculate composition and superbly arranged poses. Towards the end of his life, probably under the stress of his final illness, he achieved a synthesis of this almost abstract style with a new concern for expression, feeling and emotion. *The Loves of the Winds and the Seasons* (FIGURE 6), begun in 1890 and completed as he was dying in 1893, represents the courtship of the four male winds with the four female seasons. The love of Zephyr, the West Wind, for Flora, often symbolising Spring, was a traditional subject for artists, and in Moore's painting the nearly nude Zephyr is indeed chasing Spring in the left background, but elsewhere Moore's allegory is his own invention, which he explained with an enigmatic poem:

> Lo! fickle Zephyr chaseth wayward Spring,
> It is a merry race;
> Flowers laugh to birds that sing,
> Yet frequent tears shall cloud her comely face.
> The South Wind shall with blushing Autumn mate,
> Contented with her lot;
> Summer sigheth – such her fate
> She and her burning kisses are forgot.
> Two lovers rough for shudd'ring Winter strive,
> Beneath a shroud of snow;
> Heaven haply shall contrive
> Their violence she may not further know.

It is not clear why Summer, the female figure on the left watching the courtship of the South Wind and Autumn, should have been abandoned, nor why the (presumably) much less enticing Winter should have the North and East Winds quarrelling over her in a patch of snow under dark clouds in the right background. Perhaps there is an element of pessimism, reflecting the artist's approaching death. A.L. Baldry, Moore's pupil and biographer, described the painting as 'a great allegory of human passion, a piece of symbolism in which dramatic feeling was predominant and in which almost every strong natural impulse was revealed'. From the loves of the winds and

FIGURE 6

The Loves of the Winds and the Seasons
by Albert Moore
(Blackburn Museum and Art Gallery)

FIGURE 7

Mother and Child (Cherries)
by Frederic Leighton
(Blackburn Museum and Art Gallery).

the seasons will be born all the splendours – and the deformities – of the natural and human world. Moore's painting is concerned with the deepest truths of our existence and his treatment of them is both idyllic, in the superb classical figures and colour harmonies, and disturbing, in the sharp disproportion of scale between background and foreground figures and in the arbitrary concealment of the former behind the latter. There are few paintings more important than this one in the development of Symbolism in late-nineteenth-century Europe. *The Loves of the Winds and the Seasons* was bought by Blackburn from the sale of the McCulloch Collection at Christie's in 1913 for £456; this was the source for many of W.H. Lever's greatest paintings now at Port Sunlight (see p. 137); according to a contemporary press report Manchester City Art Gallery had been prepared to pay more than twice that sum for the painting, but due to confusion and misunderstanding their bid was never made at the auction, thus allowing Blackburn to buy it.

Two years earlier in 1911 Blackburn paid even more (£500) for Frederic Leighton's *Mother and Child (Cherries)* (FIGURE 7). The Japanese screen behind the mother's head immediately associates the painting with the Aesthetic Movement of the late nineteenth century; the richness of the entire compressed surface of the painting, the flowers, the carpet, the furniture, all have a decorative quality, an emphasis on pattern and on conscious arrangement characteristic of Aestheticism. At the same time the innocent domestic intimacy between mother and daughter, while possessing the relaxed languor of the Aesthetic Movement, also enjoys the muted sensuality of cherries against female lips. There were other remarkable purchases. Edward Stott's *The Watering Place, Evening* has the soft poetic glow of the artist's idyllic scenes of everyday country life. The simple pattern of lines forming the composition and the strange unreal colours convey a sense of mystical union between the young girl, the cows and the landscape. Henry Moore's *Rough Weather in the Mediterranean* is one of his best close-up studies of a small patch of rough sea dwarfing the small ship on the horizon. On a more popular level Marcus Stone offers one of his usual smooth period costume pieces with *Two's Company; Three's None* of 1892, illustrating frustrated love in a romantic garden setting, and Blackburn has a considerable group of other late-Victorian or early-twentieth-century paintings of some interest. More remarkable perhaps is Alfred Drury's marble *Age of Innocence* of 1901; it is a fine example of the interest shown by the so-called New Sculpture of that period for wistful child portraits, to which fancy dress lends an element of fantasy and poetry.

Grundy Art Gallery

The Grundy Art Gallery was founded not by a wealthy businessman but by two artists. Cuthbert C. and John R.G. Grundy were the sons of Thomas Grundy, a successful Unitarian Bury solicitor. Cuthbert was born in 1846 and was intended to follow a legal career like his father, but his university career was interrupted by illness. He then took up painting and chemistry; he began exhibiting his landscapes in 1879 and moved to Blackpool in 1888. He lived in an eight-bedroomed house in Lytham Road for the next 58 years until his death at the age of 99 in 1946. He also spent considerable periods of his life in the Lake District and in North Wales. He was President of the Royal Cambrian Academy, based in Conway, from 1913 to 1934. He never married and was a generous donor to children's charities in Bury, Manchester and Blackpool. He became a magistrate in 1919 and was the first Blackpool man to be knighted. Much less is known about John Grundy. He began exhibiting landscapes in 1880 and seems to have moved from Bury to Blackpool with his brother some years later. Both brothers were in Ambleside around 1904–1905. John died in 1915 and was apparently exclusively a landscape painter, whereas Cuthbert also painted figures. Neither brother seems to have received any extended formal art training and neither appears to have regarded himself as a professional artist selling his paintings to make a living. They had apparently inherited enough money from their father to remain amateur artists and to build an art gallery for Blackpool.

There had been a modest municipal art gallery in Blackpool since 1902 at the Revoe Branch Library. In 1903 the Grundy brothers gave their collection of 33 paintings to the Town Council to 'encourage art work and to promote the establishment of a municipal art gallery in Blackpool'. Their collection was temporarily displayed in the Revoe Library, while consideration was given to the erection of an art gallery. In 1908 a site in Queen Street was selected for a new central library and art gallery. The Grundy brothers gave £2,000 towards the building costs and a competition was held to choose an architect. It was won by Alexander Cullen, Lochhead and Brown of Hamilton, Motherwell and Glasgow and the new building was completed in 1911. The art gallery occupies the right wing and has an imposing Ionic portico to signify its function. An extension was built in 1938 consisting of two further galleries in addition to the sculpture hall and four galleries in the original building. The Grundy brothers had been

FIGURE 8

Don Juan in Hell
by Charles Ricketts
(Grundy Art Gallery, Blackpool)

enthusiastic members of the Blackpool and Fylde Sketching Club and one of their motives in giving money for the erection of a new art gallery seems to have been the provision of a good location for the Club's exhibitions.

The paintings presented by Cuthbert Grundy to the new art gallery included *Harvest, North Wales* by Henry Clarence Whaite. Whaite had been, like Grundy, a President of the Royal Cambrian Academy and it is reasonable to suppose that the two men were friends. In Whaite's painting there is his very frequent abrupt contrast between towering mountains covered in mist and cloud and small, very ordinary foreground figures, all intended to convey the immensity of nature. Lamorna Birch's *Lonely Pool*, also presented by Cuthbert Grundy, shows the artist's love of subtle light effects on water; Birch had spent his early years in Lancaster, and Grundy may have met him there. There are only six works by the two Grundy brothers at the Grundy Art Gallery and it is difficult to generalise about their style except to note that they seem to have been eclectic, as amateurs often are.

Once established the Gallery immediately set up a purchase fund and began to buy fairly undemanding paintings. From about 1927 onwards it followed the usual Lancashire pattern in acquiring rather conventional paintings each year until about 1950, generally from the Royal Academy. For example, Harold Knight's *Girl Writing* of 1930 is one of his quiet middle-class interiors with women writing, sewing or reading, observed dispassionately and unseen with an objectivity and a sensitive command of light reminiscent of Vermeer. There are also the inevitable and highly competent landscapes by Tom Mostyn and David Murray.

Some of the gifts are more interesting. Among them is a thoughtful *Portrait of T.E. Lawrence as Aircraftsman Shaw*, painted in 1935, the year of Lawrence's death, by Augustus John and presented to Blackpool by H.T. De Vere Clifton, a local landowner. John and Lawrence were friends and this simple unpretentious painting is both more convincing and more moving than John's more characteristically extrovert fancy dress portraits of Lawrence in Arab costume.

Hubert Herkomer's *Haymaking and Lovemaking* is one of his rural idylls in the tradition of Frederick Walker. It was one of a large number of paintings presented by members of the Blackpool Town Council, who evidently felt a special obligation to assist their own art gallery. Far more unconventional is Charles Ricketts's *Don Juan in Hell* (FIGURE 8). Ricketts frequently painted Don Juan, whom he saw as a Romantic hero free from all conventional restraint and willing to defy fate without fear; indeed he regarded Don Juan as a saint. In this painting the Don dominates the scene with his usual expression of arrogant superiority. Moral improvement is not the intention of the painting but Blackpool Town Council could perhaps be more indulgent towards art for art's sake than the rest of Lancashire.

Bolton Museum, Art Gallery and Aquarium

Bolton's first public museum was built between 1879 and 1882 thanks to a bequest of £5,000 from Dr Samuel Chadwick, but there were very few paintings or sculptures there. In 1890 the Mere Hall Art Gallery and Library was opened to the public. The building and the land around it, lying about a mile north of the town centre, had been presented to Bolton Council by J.P. Thomasson, a cotton manufacturer and Radical pro-Boer Liberal who also gave to Bolton one of its first Board Schools. Thomasson also gave £5,000 towards the cost of converting Mere Hall, a neoclassical house, into an art gallery. The very few paintings and sculpture in Chadwick's museum were transferred to Mere Hall. In the early years of the new art gallery, very few works of art of any importance were bought for or presented to it. Probably, as a converted country house away from the town centre, it lacked status and publicity. In 1899 W.H. Lever, who had been born in Bolton and later founded the Lady Lever Art Gallery in Port Sunlight (see p. 137), bought Hall-i'-th'-Wood, a sixteenth-century house near Bolton in which Samuel Crompton invented his spinning-mule around 1779. He restored it and gave it to Bolton Council. It was opened in 1902 as a museum of technology but at Lever's instigation it rapidly developed into a folk museum illustrating life in England in the seventeenth century. For this purpose Lever presented to the Museum furniture and paintings, principally portraits, of that period. None of them is of great importance, but this was one of the first and most influential folk museums in England, using paintings not as fine art but as objects describing the everyday life of a specific historical period.

The Mere Hall Art Gallery was replaced in 1939 by the opening of a new Museum and Art Gallery for Bolton in the Municipal Buildings erected behind the Town Hall in the imaginative form of a grand classical quadrant. This was the last of the great Lancashire public art galleries and certainly one of the finest. The new Municipal Buildings had been conceived as early as 1925 but construction was delayed, and work only began in 1932. It is surprising to find such fine and accurate classical detail as late as this. The architects were Bradshaw, Gass and Hope, a firm dating back to 1880, who were responsible for many Lancashire public buildings and cotton mills.

Meanwhile the art collections were developing slowly. There was no purchase grant from the Council until the end of the Second World War, and there were few gifts before the opening of the new art gallery in 1939. However, in 1911 W.H. Lever (see p. 137) had given *Sunset, Pueblo del Walpe, Arizona* of 1880 by Thomas Moran to Bolton and in 1936 J. Lever Tillotson, Lever's nephew and close colleague on the board of Lever Brothers, gave Moran's *The Coast of Florida* of 1882. More recently, in 1998, Bolton purchased Moran's larger and more important *Nearing Camp, Evening on the Upper Colorado River* (FIGURE 9) for £1,343,000 with the help of a large National Lottery Grant. Moran was born in Bolton in 1837 and, although he emigrated to the United States in 1844, he retained his links with England, and more particularly Bolton, throughout his life. Tillotson's father, a Bolton newspaper proprietor and an intimate friend of Lever, knew Moran well, bought his paintings and invited him to the Tillotson family home in Bolton when he was in England. He was influenced by the work of J.M.W. Turner and brought an exhibition of his paintings including *Nearing Camp, Evening on the Upper Colorado River* to London and Bolton in 1882. Moran was the leading painter of the American West, presenting a very romantic vision of a spectacular empty landscape occupied only by Indians and seen through dramatic light effects. Cotton and emigration created close links between Lancashire and the United States in the nineteenth century and Bolton's notable Moran collection both commemorates this bond and explains the appeal of the American West far beyond the United States.

In 1940 Bolton's collections were transformed by the forty paintings, drawings and sculptures bequeathed by Frank Hindley Smith, a Bolton cotton manufacturer, whose mills were at Lever Bridge on the edge of Bolton. He was born in 1863 and spent much of his later life at Southport and at Seaford in Sussex. He collected widely, but concentrated to a considerable extent on French and British nineteenth- and early-twentieth-century art. He met Roger Fry around 1921. Fry painted his portrait (now lost), and, perhaps under Fry's influence, he bought works by Jean Marchand, Othon Friesz and Dunoyer de Segonzac. In 1922 he offered Fry's *The Church of Ramatuelle* to the Manchester City Art Gallery which rejected it. With Samuel Courtauld, John Maynard Keynes and L.H. Myers, he gave financial support to a small group of young modernist artists largely selected by Fry through the London Artists' Association in the late 1920s. He read the works of Marcel Proust. On his death there were substantial bequests to the Ashmolean Museum in Oxford, the Fitzwilliam Museum in Cambridge, the Tate Gallery and the British Museum, as well as to Bolton. During his lifetime he had given many

Nearing Camp, Evening on the Upper Colorado River
by Thomas Moran
(Bolton Museum and Art Gallery, acquired with the assistance
of the National Art Collections Fund)

paintings to the Atkinson Art Gallery in Southport and Symbolist works by William Stott to Oldham Art Gallery, together with an important painting by Louis Le Nain to the National Gallery. The works left to Bolton had a regional bias, with six paintings and drawings by Edward Stott of Rochdale and by F.W. Jackson. The three landscapes by J.W. Buxton Knight reflected Hindley Smith's admiration for the Barbizon artists by whom Knight was influenced. There were, however, paintings by friends of Roger Fry, notably Duncan Grant and Vanessa Bell, as well as two works by Fry himself.

After the Second World War Bolton began to build up a notable collection of contemporary art, concentrating, particularly in the early years, on Jacob Epstein. There are a number of his rather flamboyant busts, vigorously modelled in the manner of Rodin, but more interesting is the *Study for the Slave Hold* of 1941 showing slavery breaking its chains. This was one of Epstein's didactic sculptures in which the sculptor identified himself with the misery of humanity and denounced cruelty and brutality in all its forms, employing a powerful Expressionist style remote from the Cubist and Primitivist tendencies of his early work. On being told that the *Study for the Slave Hold* was going to Bolton the sculptor commented: 'There is nowhere I would rather think of it going than to Bolton... I think the people of Bolton behaved admirably during the difficult years of the cotton famine and the fight against slavery.' Another link with Bolton is provided by Charles Holden, the architect and Epstein's first and most important patron; he was born and educated in Bolton.

Bolton also has a significant collection of British watercolours largely assembled by Harry Lucas. Lucas spent his entire working life at the Horwich Railway Locomotive Works just outside Bolton, where he was a strong Trades Unionist. He was also for many years leader of the controlling Labour councillors on the Bolton Council, and he used his considerable influence there to ensure that the Council gave generous support to the arts in all their forms in Bolton and throughout Lancashire. He had an expert knowledge of music, while in the visual arts watercolours particularly attracted him. He built up his own collection which he presented to Bolton Museum and Art Gallery and assisted the curators in buying watercolours for Bolton. His own collection was especially rich in works by Albert Goodwin, the most talented follower of Turner and remarkable for an elaborate technique capable of rendering extraordinary lighting and colour effects. There are also many Lake District and other mountain scenes reflecting Lucas's passion for mountaineering. Lucas represented the old Labour paternalist tradition in local government from which the arts in the industrial north-west of England gained so much.

Towneley Hall Art Gallery and Museums

The siting of municipal museums and art galleries in suburban parks and gardens rather than in city centres was pioneered in Salford in 1850–51 (see p. 160) – and carried much further in Sheffield where the Mappin Art Gallery in Weston Park was opened in 1887. Visitors could receive physical and cultural refreshment and nourishment (particularly at sites with a café) simultaneously, and works of art did not suffer from the smoke and pollution of the city centre. Cheap and rapid public transport out to suburban parks was available with the electric tram from the 1890s. Burnley was fortunate in having Towneley Hall with its park only about two miles from the city centre. In 1878 John Towneley, its owner, died without male heirs and the vast Towneley estates were divided among his six daughters and nieces. Alice Mary received the Hall and park as part of her share, but after her husband's death she found the large house hard to maintain on a small fraction of the income available to her ancestors and she was pleased to be able to sell it and the park to Burnley Council for much less than its real value, in order to benefit the town and its people. She, like her father and uncle before her, had a distinguished record of public service towards Burnley. The two men had both been Presidents of the Mechanics' Institute, which throughout Britain was the real forerunner of public libraries, museums and mass education, and she was for many years a member of the Burnley School Board as well as, in later years, of the Art Gallery and Museum Committee.

Towneley Hall was a large medieval courtyard house but lost its east side in about 1700. There were three major periods of post-medieval building. The first was early in the seventeenth century; the second dated from about 1725 to 1730 when the superb Baroque entrance hall was built; the third involved the creation of a new drawing room and dining room in the south range by Jeffry Wyatt in 1812–19. Thus Burnley was able to innovate not only with a rural setting for its art gallery but also with one of the first country-house art galleries. In practice few country houses are suitable for displaying paintings, and Burnley Council rebuilt the bedrooms on the upper floors, removing many room partitions and installing new and higher roofs with glazing to provide top light for viewing the paintings beneath. Two large new picture galleries were created in 1908 and 1923 and, although such radical changes would probably

not now be permitted under planning regulations protecting historic buildings, anyone who has tried to study great paintings hanging in a more authentic country-house setting will applaud the vandalism of the Burnley Council.

In fact the Council received few important works of art when it bought Towneley Hall in 1902 but it has been very successful in returning to the Hall many great works of art formerly associated with it but later dispersed. The most remarkable of these is John Zoffany's *Charles Towneley and his Friends in the Towneley Gallery, 33 Park Street, Westminster* (FIGURE 10) of 1781–83. Here the prosperous Lancashire squire sits with his dog Kam under his chair discussing some erudite detail with friends and experts among the great collection of ancient marbles which he had formed in his London house. Zoffany's enormous descriptive ability and command of grouping and incident make this apparently casual arrangement of a rich profusion of classical sculpture, interspersed with its late-eighteenth-century collectors and interpreters, into a magnificent epitome of the great age of English connoisseurship. Charles Towneley was planning to bring the collection to Towneley Hall but in fact it was bought by the British Museum after his death for £28,200 to form the nucleus of the Museum's splendid classical collections. Richard Cosway's *Group of Connoisseurs* of 1771–75 was also commissioned by Charles Towneley and shows a very much less reverent and erudite attitude to antiquity. Originally the painting showed the connoisseurs watching one of them stroking a nude statue of Venus and even in its final state the sexual interest is clear. Towneley stands second from the left, the only figure not more or less preoccupied with the nude female torso, placed at a convenient height for close inspection.

Charles Towneley's superb collection of classical sculpture was bought out of the rents from his extensive Lancashire estates and George Barret's *Towneley Hall* was commissioned by Towneley in 1777–78 primarily as a landscape with the Hall barely visible among the rolling hills. Like much of Barret's later work it reflects the ideal, classical landscapes of Richard Wilson, with the Lancashire moors almost transformed into the sunny Roman Campagna. There is also a watercolour of Towneley Hall by J.M.W. Turner together with two others of his watercolours, painted to be engraved by J. Basire in T.D. Whitaker's *History of the Parish of Whalley* of 1800–1801, a project probably suggested by Charles Towneley.

The Towneley family were devout Catholics and suffered for their faith through repeated imprisonment and confiscation of property after the Reformation. Even at the Dissolution of the Monasteries in 1536 Sir John

FIGURE 10

Charles Towneley and his Friends in the Towneley Gallery,
33 Park Street, Westminster
by John Zoffany
(Towneley Hall Art Gallery and Museums, Burnley)

Towneley is said to have taken into safe keeping, at the risk of his life, the High Mass vestments of Whalley Abbey, magnificent examples of English medieval embroidery dating from around 1390–1420. Much later Charles Towneley, the great collector, installed in the Towneley Hall chapel an oak altarpiece carved in Antwerp around the early sixteenth century. The six principal panels represent the Passion of Christ and with its crowded scenes, affected poses and rich ornamentation, it reflects the style of the Antwerp Mannerists. It is curious that when purchasing art as a pious Catholic for devotional use Towneley should have favoured a style as remote as possible from the serene classicism which he admired in his famous marble statues.

All these works of art associated with the Towneley family had to be purchased back from the family by Burnley Corporation after it bought Towneley Hall in 1902. The only major work of art which came with the Hall was the large *Noli Me Tangere* or *Christ and the Canaanite Woman*, attributed to Annibale Carracci and probably bought by Charles Towneley in Italy. The funds for these acquisitions were provided by a bequest in 1921 of about £100,000 under the will of Edward Stocks Massey, a wealthy Burnley brewer, in favour of the arts generally in Burnley. He was not a collector, nor did he have any great interest in art, but he died without children. The reason for his philanthropy may lie in a clause of his will deducting an appropriate sum from his bequest each time that one of his public houses in Burnley lost its licence. Later in the same decade Wilfred Dean, a Burnley manufacturer of wash boilers and a member of the Art Gallery and Museum Sub-Committee of the Burnley Town Council, gave to Burnley many paintings from his own collection. Thus the creation of Towneley Hall Art Gallery and Museums represents a combination of benevolence from the inherited landed wealth of the Towneley family and from the new money of Burnley commerce and industry. Within a year of the Edward Stocks Massey bequest, the Whalley Abbey vestments had been purchased from it and in the following year the smaller of the two art galleries on the upper floors was created with money from the same source. Even before the Edward Stocks Massey bequest and Wilfred Dean gifts the art gallery had been buying works of art and holding temporary exhibitions throughout the year. Three exhibitions in 1922–23 attracted over 150,000 visitors.

Among the more remarkable early purchases were Henry Moore's *A Breezy Day off the Isle of Wight*, bought in 1913 from the McCulloch Collection, by far the greatest collection of late Victorian and Edwardian art ever formed. Henry Moore's low viewpoint and intensely wet waves give a sense of the immediate and physical presence of the sea all round and almost over the

FIGURE II

The Picture Gallery
by Lawrence Alma-Tadema
(Towneley Hall Art Gallery and Museums, Burnley)

spectator. C.N. Hemy's *Crabber's Bait* came from the same sale. There was also J.W. Waterhouse's *Destiny,* painted for the Artists' War Fund of 1900 in support of the Boer War soldiers: a girl drinks to departing warriors whom she sees in a mirror; distant meadows appear beyond the arches and columns of her loggia behind her mirror which reflects the space on the other side of the loggia. The ambiguities of space, distance and meaning are typical of the poetic side of Pre-Raphaelite art, which seems far removed from the horrors of war. Generally the policy, as elsewhere in Lancashire public collections at that date, was to buy recent landscapes of a rather conservative style appealing to provincial taste, of which B.W. Leader's *By Mead and Stream* is a large and notable example. There are also two French river scenes by the distinguished critic P.G. Hamerton, who was brought up in Burnley; his enthusiasm for French landscape painting eventually played a large part in ending Pre-Raphaelite tendencies in British later-nineteenth-century art. Lawrence Alma-Tadema's *The Picture Gallery* (FIGURE 11) re-creates a dealer's gallery of the later Roman Empire in which some of the greatest paintings of classical Greece and Rome are for sale. Many of these paintings were only known from written descriptions or from crude copies which have survived to the present day and Alma-Tadema has used these sources with great erudition to re-create the lost originals. The figures were modelled on the leading dealers of Alma-Tadema's own period and Ernest Gambart, the artist's principal patron in his early days, is the man standing in the centre of the composition. The fall of light in the top-lit gallery and the actual textures of individual surfaces are rendered with the artist's usual technical brilliance. This imaginary gallery makes a fascinating contrast with Zoffany's actual gallery painted one hundred years earlier. Both artists were supreme masters of descriptive painting but while Zoffany presents a relaxed atmosphere reflecting the satisfaction of ownership and the confidence of erudition, the mood in Alma-Tadema's commercial gallery seems more tense and uncertain, for all the artist's archaeological expertise. *The Picture Gallery* was bought from the Richard Haworth Gallery in Blackburn, the source for many paintings acquired by Burnley and by other Lancashire public art galleries between the 1920s and the 1950s. Sadly the centralisation of the art market in London in more recent years has left English provincial cities with very few serious fine art dealers. The money for the purchase of *The Picture Gallery* came from the Caleb Thornber bequest and Burnley, like other Lancashire art galleries, benefited from a wide range of donors, enabling the cost of all its acquisitions to be met from private finance after the Edward Stocks Massey bequest of 1921.

Contemporary paintings were purchased from the Royal Academy

Summer Exhibitions in the 1930s, while in the 1950s the curator, Harold Thornton, favoured British eighteenth-century portraits. English watercolours were bought or given on a considerable scale between these dates. Some broadly Realist nineteenth-century French art, most notably *The Midday Meal* by L.A. Lhermitte, was acquired around 1950. This painting combines Lhermitte's early austere social realism with the sentimentality of his later, more emotional family scenes. These were all trends in acquisition policy noticeable throughout art galleries in Lancashire.

Bury Art Gallery and Museum

Thomas Wrigley was born in 1808 in a house near his father's Bridge Hall Paper Mills at Bury. He inherited the mills in 1846 and became largely responsible for making Bury one of the greatest paper-making centres in the world. He was also interested in railways, pioneering the Manchester to Bury line. He was a Unitarian, a Liberal and a strong supporter both of free trade and of compulsory education. He wrote pamphlets on paper making and free trade, on railway management and on education; he noted with approval as early as 1855 that in Germany parents were obliged to send their children to school up to the age of fourteen. He generously supported Bury charities, with £10,000 to the hospital alone and considerable help for the parish church to demonstrate his wide religious sympathies, and it was in this spirit that in 1897 his sons and daughter presented to Bury Town Council his picture collection on condition that the Council built an art gallery to house it as a public memorial to their father. Sir Henry Tate had made a similar offer to the British Government in 1889 and it took them three years to accept it, even with Tate's subsequent offer of £80,000 to cover the cost of a building for his great collection. The Bury Council, however, unanimously and immediately accepted Wrigley's collection and only two years later work began on the Bury Art Gallery and Free Library, designed by Woodhouse and Willoughby of Manchester at a total cost of over £21,000 for the building alone. The style adopted was 'the English Renaissance of the eighteenth century, freely treated'. The insistent use of a great wealth of varied and erudite classical detail, together with the sculptural friezes, gives the building a consciously artistic character appropriate to its purpose. The figures in the friezes by J.J. Millson of Manchester represent the Seven Arts and Sciences, the Nine Muses, some of the Cardinal Virtues, Painting, Architecture, Vase Painting, Sculpture, Drawing, Design, Woodcarving, Modelling, Heraldry, Needlework, Building Crafts and other artistic activities, not forgetting figures holding encaustic flooring tiles and others engaged in wallpaper work and repoussé.

In fact the Bury Society of Fine Arts, which had been holding exhibitions since 1878, had been trying for some years to persuade the Town Council to erect a public art gallery. In 1896 at one of their functions James Kenyon, the Member of Parliament for Bury, had offered a thousand guineas towards the

costs of the gallery and had stated that, if only it was built, paintings would soon be given to fill it. The Wrigley gift, coming only a year later, made him seem like a prophet. The Council appointed an Art Gallery Committee to oversee the new building but official approval for such a large sum for its construction from the ratepayers was only possible if a public library was included, and thus Bury's new arts centre followed the usual pattern of a top-lit first-floor art gallery over a public library on the ground floor.

Wrigley's collection is probably the best single surviving collection of Victorian paintings among those formed by the Lancashire merchants and manufacturers of the later nineteenth century; it is perhaps matched only by George Holt's collection which can still be seen at Sudley, his Liverpool home. Like Holt, Wrigley was advised by the great dealers Thomas Agnew & Sons, who were originally based in Manchester, and again like Holt his most splendid painting is by J.M.W. Turner. *Calais Sands at Low Water: Poissards Collecting Bait* (FIGURE 12) is apparently a scene from everyday life with fisherwomen gathering bait on the beach, but the real subject is the grand sunset behind Fort Rouge which dominates and illuminates the limitless expanse of sand, water and sky in shimmering reflections of subtle blends of red and yellow. 'It is literally nothing in labour, but extraordinary in art', wrote a contemporary critic, but, for all its splendour of colour and light, the gradually drying sands are in fact described with meticulous care and precision. Some critics have felt sadness in the painting, reflecting the death of Turner's father in 1829 just before it was painted, but there is no doubt about the desolation in Edwin Landseer's *A Random Shot* (FIGURE 13), the most powerful visual indictment of mindless hunting ever produced. Real sportsmen would never shoot a hind with her young but ignorant and thoughtless tourists with a gun will aim at anything. The mother was not killed outright, but has staggered dying and bleeding to a bleak and freezing mountainside. Her fawn vainly seeks her milk and is also doomed. Night, representing death, is approaching and the light is cold and sinister. Landseer has brilliantly contrasted the sharp, hard, blueish surface of the snow with the rich, soft, red texture of the deer. It is said that the painting had been commissioned around 1847 by Prince Albert who found it too painful to live with and sold it on to Wrigley. If this is true, *A Random Shot* must have been one of Wrigley's first acquisitions. Did it represent the attitude of a Lancashire Nonconformist manufacturer with a strong social conscience to cruel aristocratic sporting habits?

Wrigley's other Victorian paintings are not at this level of intensity. Briton Riviere succeeded Landseer as the leading British animal painter and his

FIGURE 12

FIGURE 13

Apollo, illustrating a scene from *Alcestis* by Euripides, shows his concern to turn animal painting into high art. High art comes close to parody in Thomas Webster's *The Boy with Many Friends*, where contrasting physical and moral types of schoolboys are shown reacting not to a great event but to the appearance of one of their number with a well-stocked tuck-box. A similar rich variety of physiques, expressions and occupations in social interaction is the theme of John Phillip's *Drawing for the Militia*, set in the eighteenth century. Stuart court life of the seventeenth century is presented nostalgically in Frederick Goodall's *An Episode in the Happier Days of Charles I* and critically in E.M. Ward's *The Fall of Clarendon*, where the austere and conscientious statesman has been dismissed, to the delight of the frivolous and pleasure-seeking courtiers. Alfred Elmore's *The Novice* is concerned with conflicting social and religious pressures – a subject appealing perhaps to a broadminded Unitarian. The influence of German Romanticism and Purism on British art is reflected in Wrigley's paintings by Daniel Maclise, J.R. Herbert and Noel Paton, but Wrigley did not collect Pre-Raphaelite art. Closest to it perhaps is William Mulready's *The First Voyage* in which a baby sets out over a river in a small tub, guided precariously by members of his family, symbolising of course the great Voyage of Life on which he is also embarking. His landscapes included major works by John Linnell, containing a stronger sense of the heroic than Linnell usually achieved, while Thomas Creswick's featureless *Showery Day* is notable for its realism and defiance of established principles of composition. Wrigley's watercolours, however, were exceptional, with two of Ehrenbreitstein by Turner, a Romantic subject which always brought out his great imaginative powers, and a remarkable group by David Cox.

FIGURE 12

Calais Sands at Low Water: Poissards Collecting Bait
by J.M.W. Turner
(Bury Art Gallery and Museum)

FIGURE 13

A Random Shot
by Edwin Landseer
(Bury Art Gallery and Museum)

The Bury Art Gallery therefore had a splendid start. A detailed catalogue of the Wrigley Collection partly written by Whitworth Wallis of Birmingham, the leading provincial curator of his period (and perhaps of any day), was published by the Gallery, which even remained open to the public late into most evenings. Further bequests soon arrived. Thomas Aitken owned cotton mills at Irwell Vale, Chatterton and Bacup, and lived at Ramsbottom a few miles north of Bury. He was a strong Anglican and Conservative – unusual for a Lancashire manufacturer. At his death in 1911 he left nearly a hundred paintings and watercolours to Bury Art Gallery. Among them was a very important early work by George Clausen, *Spring Morning: Haverstock Hill*, showing very clearly the artist's debt to J.J. Tissot and to Jules Bastien-Lepage, together with a superb flower painting by Henri Fantin-Latour. Other local men giving paintings included James Kenyon and Henry and Robert Whitehead, whose *Listed for the Connaught Rangers* was the first and one of the most moving paintings by Lady Butler exploring social and military conflict in late-nineteenth-century Ireland from a nationalist perspective; it was also her first use of the bleak Irish landscape to add emotion and expression to her paintings. The George Clough bequest of 1941 was particularly rich in watercolours by George Clausen, Henry Tuke, Robert Allan, Alfred East, Walter Langley and other early-twentieth-century artists inspired by France, and it did contain a few oil paintings. Bequests in the form of money and Council grants enabled some paintings to be purchased, most notably Albert Moore's very early and, unusually for him, very expressive *Elijah's Sacrifice*, acquired in 1908 for only £105 from Whitworth Wallis himself.

More often contemporary fashionable paintings were bought from the Summer Exhibitions of the Royal Academy, giving Bury Art Gallery a very good representative collection of British art from about 1850 onwards. Indeed, it is probably true to say that no other industrial town of modest size and in the shadow of a much larger city possesses a collection and gallery of this quality.

Tullie House Museum and Art Gallery

Art in Carlisle has a long history. In 1822 a group of local artists, in which sculptors were of particular importance, founded the Society for the Encouragement of Fine Arts, and in the following year the Carlisle Academy of Art opened in Finkle Street to provide accommodation for an art school and for exhibitions of work by Old Masters and by local artists. Later exhibitions even attracted artists from London but lack of local support caused the Academy's closure in 1833. It was replaced in 1841 by the Carlisle Athenaeum, which held three exhibitions of contemporary works of art for sale in 1843, 1846 and 1850. The art school was revived in 1854 and moved to various locations in the city, before finding a home at Tullie House in 1893. The Athenaeum housed the museum of the Carlisle Philosophical Society until the collections were seized for non-payment of rent and transferred to the City Council during the 1860s. The Council placed them in the old Finkle Street Academy of Art, where they were again put on display to the public in 1877. In 1890 Tullie House, a dilapidated but fine Carlisle city house of 1689, was bought for the Council to house the art school, a city library and a museum of science and art. Thanks to public subscriptions an extension was built for the library, a lecture theatre, a technical school, art school and picture galleries, while Tullie House itself accommodated the museum and art collections. Since then the library and schools have moved out, leaving the Museum and Art Gallery to occupy the entire buildings, which were again extended in 1990.

Neither the old Academy of Art, nor the Athenaeum, nor the Council's Finkle Street Museum had made any serious attempt to assemble an art collection, and the new Tullie House Museum and Art Gallery was scarcely more active until Mrs Maud Scott-Nicholson, a co-opted member of the Museum and Art Gallery Committee, suggested the introduction of a new purchase scheme in 1933. She was the daughter of Sir Benjamin Scott, the head of a local firm, Hudson Scott & Sons Ltd, whose boxes and other packaging achieved high standards of design. It was natural therefore that the committee should turn for advice on acquisitions to Sir William Rothenstein, the Principal of the Royal College of Art, which had as its special mission the improvement of standards of design in British factories. Rothenstein was given £100 each year (later raised to £200) to buy principally work by young

and little known artists at his absolute discretion. He received no pay for the work involved, which carried on until 1942. With the modest amount at his disposal, Rothenstein concentrated on small works, often watercolours, drawings or prints, rather than oil paintings. His taste was catholic. He bought three simple, unpretentious studies by G.F. Watts, of whom he wrote: 'His construction is often faulty and his subjects are admittedly didactic, yet he is likely to take his place finally as one of the most richly endowed artists of the English School.' But he also acquired for Carlisle a hard and angular *Portrait of the Artist's Wife* by the Vorticist, Wyndham Lewis. There was a visionary but also child-like *Washing Peter's Feet* by Stanley Spencer, originally intended as a predella for his *Betrayal*, now at Belfast, together with one of Paul Nash's best First World War watercolours, *Ruins of a Church, Vormezeele*, desolate in mood and subject, but still reflecting the beauty of nature. Rothenstein bought from the 1933 New English Art Club exhibition a *Portrait of a Girl* by Edward Le Bas which he regarded as the most distinguished painting there, apart from Wilson Steer's work; no doubt he admired the delicacy of its chiaroscuro and the softness of its modelling. Of course he also acquired works by students and colleagues at the Royal College of Art; perhaps the best of these is *Granary*, a drawing by Barnett Freedman of the interior of an ordinary barn, but transformed by strong contrasts of light and shade and by powerful shapes into an almost Surrealist fantasy. Rather apologetically he included two of his own paintings, a *Self Portrait* (FIGURE 14) of 1917, in which he stands at his easel staring blankly at the spectator, and his *Wych Elm in Winter* of 1919, one of his most decorative and carefully organised landscapes. There were, of course, drawings by Augustus John, whom Rothenstein regarded as the most gifted artist of his generation, particularly as a draughtsman, and lithographs by Charles Shannon, which seemed to Rothenstein 'the loveliest things being done at the time'. Rothenstein was the closest of Charles Conder's artist friends and Conder's fragile and poetic beauty is represented by both a watercolour and a lithograph. Rothenstein was no modernist and his taste and style became increasingly insular and conservative. Indeed his buying was probably less adventurous and more academic than the purchases being made at the same time by Manchester City Art Gallery. The same reservations have often been made about the purchasing policy of his son, John, at the Tate Gallery, of which he became Director in 1938. On the other hand he knew everyone in the artistic world and the hundred works which he bought for Carlisle sum up the mainstream of English art between the two World Wars even without the inclusion of any major works. As buyer for Carlisle, Rothenstein was succeeded first by Edward Le Bas, then by Carel Weight and

Self Portrait
by William Rothenstein
(Tullie House Museum and Art Gallery, Carlisle)

finally by Roger de Grey. The scheme was terminated in 1975 on Roger de Grey's retirement. Later purchases were less interesting but notable works by Walter Russell, Carel Weight, Lucien Pissarro, John Nash, Charles Ginner, Peter Blake, L.S. Lowry, Sandra Blow, Norman Adams and Elizabeth Blackadder were acquired.

Rothenstein was a close friend of Gordon Bottomley, the poet and dramatist, whose fragile health compelled him to live away from large cities in the Lake District near Carnforth. This friendship was probably an important element in Bottomley's decision to leave his collection to Carlisle on his death in 1948. He hoped 'to add something permanently valuable to north-country imaginative experience' and it was the poetic, visionary and symbolic aspects of British nineteenth- and early-twentieth-century art which most attracted him. He was the only child of a Yorkshire accountant, who had, surprisingly, a good library. Banking proved uncongenial as a career but he remained a good businessman and, despite his rather limited literary fame, he always had modest amounts to spend on paintings and drawings. The work of D.G. Rossetti first introduced Bottomley to the visual arts and he wrote:

> My business has seemed to be to look for the essentials of life,
> the part that does not change. In this I conceive I was guided
> and fostered by Rossetti, instinctively learning that art is a
> distillation of life and nature – not a recording or a
> commenting, and only incidentally an interpretation.

Bottomley acquired a notable Pre-Raphaelite collection concentrating on Rossetti, Burne-Jones and the poetic side of the movement, although by a strange coincidence he owned an important oil study for *Found*, Rossetti's only Realist painting, which for that reason the artist was never able to complete. Like Rothenstein he could not afford major oil paintings, but his drawings and watercolours are often of exceptional importance thanks to his expert knowledge of the movement; for example, he owned Burne-Jones's very early *The Goldfish Pool* which conveys so well the Aesthetic rapture of the painter's life with William Morris at the Red House around 1861. Similarly *The Borgia Family* is one of the first of Rossetti's claustrophobic drawings where enclosure within a confined space heightens the emotional drama and intensity of the figures in the scene.

The Pre-Raphaelites looked back to William Blake and his followers as the principal earlier group of British artists concerned primarily with the imagination, and Bottomley collected their work for the same reason. Samuel Palmer's *The Harvest Moon* lacks perhaps the intensity of some of his earlier

The Rift in the Lute
by Arthur Hughes
(Tullie House Museum and Art Gallery, Carlisle)

Shoreham visionary masterpieces but it delighted Bottomley, who wrote: 'it is all brown and gold trees and moon and corn, with the little gleaners in bright Russian colours'. Edward Calvert, the most pagan of Blake's followers, is represented by one of his late pastoral and arcadian nudes, *A Dryad*, and Bottomley owned Simeon Solomon's *St Michael of Good Children*, dedicated by the artist 'to the memory of William Blake', together with Solomon's important *Allegory of Life*, which demonstrates Rossetti's influence over the young artist.

The dominant influence on Bottomley as a collector was that of the artist, illustrator and aesthete Charles Ricketts, who also assembled a major collection which he bequeathed to the Fitzwilliam Museum in Cambridge. Bottomley owned Ricketts's most important early drawing, *Oedipus and the Sphinx*, commissioned by Frederic Leighton in 1891 as part of Leighton's campaign to encourage young artists – even those working in a style remote from his own. It is clearly influenced by Gustave Moreau and must be one of the first strictly Symbolist works of French inspiration by a British artist. Bottomley also owned Ricketts's painting, the *Betrayal of Christ*, rightly described by John Masefield as 'the finest imaginative picture of our time'.

Among the other paintings in the Bottomley bequest are Arthur Hughes's *The Rift in the Lute* (FIGURE 15), a moral subject but treated symbolically with the doomed lute and verses from Tennyson; *The Music Room* by C.H. Shannon, Ricketts's friend and companion, a dark mysterious interior suggestive of the most esoteric sounds, and an evocative but assertive *Self Portrait* by Charles Conder. Bottomley's Liverpool friend, James Hamilton Hay, is represented by his *The Long Room Audlem*, in which the influence of Whistler is giving way to Symbolism, but among Bottomley's friends Paul Nash was pre-eminent. Their correspondence runs to nearly 300 pages when printed and is a vital source for the study of the relationship between literature and art in the early twentieth century. Among the drawings and watercolours by Nash in Bottomley's collection, *Wittenham Clumps*, one of Nash's favourite subjects, is one of his most clearly Symbolist landscapes; Nash was searching for 'the strange character of the place, one image which, in its form, would contain the individual spirit', and this watercolour conveys powerfully the grand and solitary nature of the clumps.

Carlisle had a number of landscape artists in the nineteenth century. W.J. Blacklock cultivated a photographic realism influenced by the Pre-Raphaelites, but the self-taught and somewhat bohemian Sam Bough rapidly cultivated a more lively style, with dramatic skies, a vigorous loose technique, and an assertive character, splendidly demonstrated in his *Self Portrait with Dog*,

Madame Sacchi of about 1866 – he had named his bulldog after a famous dancer. However, Blacklock moved to London and Bough went to Scotland, complaining in 1844 that, despite the very early Carlisle Academy of Art and the Carlisle Athenaeum with their exhibitions of works by local artists,

> There is little chance of ever growing fat by landscape painting in Carlisle. Indeed all the painters here talk of departing from a shabby place that cannot afford an exhibition and does hardly support a drawing school.

Grosvenor Museum

Charles Kingsley was a Canon of Chester Cathedral between 1869 and 1873. Although he only spent three months each year at Chester in the summer, he began to organise botany classes there, reflecting his conviction that the natural world was a divine creation reflecting the beauty of God. Their success induced him to summon a meeting of interested and influential citizens under the chairmanship of the Mayor at his house in Abbey Square, and there the Chester Society of Natural Science was inaugurated with Kingsley as its first President. Kingsley soon left Chester but the Society prospered, adding Literature to its name and activities in 1888–89 and Art in 1898–99. Art was, however, seen primarily as an aid to the recording of natural history, which in any event could then be more easily achieved by photography, and it never became a major interest of the Society.

Meanwhile in 1873 the Society had combined with the Chester Archaeology Society and the Chester School of Science and Art to raise money for a new building to house all three institutions. Land in Grosvenor Street was bought and £11,000 raised, largely thanks to a gift of £4,000 from the first Duke of Westminster, the principal landowner in the area. The new Grosvenor Museum was opened in 1886. Chester City Council took over the management of the Museum in 1915 and achieved total control of the staff, collections and displays in 1938.

The Museum is rich in Romano-British art, and post-classical art is largely confined to local views and to paintings by local artists, many of which have been acquired in recent years. *Beeston Castle* of 1770 by George Barret Senior is in the English topographical tradition with the castle as a dark mass standing out dramatically against the sky; tourists are admiring it and local peasants are ignoring it. W.J.J.C. Bond and William Huggins were both strongly influenced in their early work by the Liverpool Pre-Raphaelites. Bond's *Poole Hall* of 1890 and Huggins's *Sheep by a Mountain Stream* of 1880 are both late works largely free of Pre-Raphaelitism, but Huggins still has sharp, bright colours and concentrates on a small patch of countryside rather than composing a view. John Finnie was the most significant artist in Liverpool after the Pre-Raphaelites left the city with the collapse of the Liverpool Academy. He was head of the art school and his *Chester with St John's Church* is a good academic landscape of 1879. Its cool colours, luminous water, traditional composition, mass of blended foliage, tonal harmony, melting distances and sense of atmosphere are all very post-Pre-Raphaelite. Henry Pether's *Chester Castle by Moonlight* was painted by the last of a dynasty of moonlight specialists and shows what they could achieve with a congenial subject.

Brantwood

Brantwood, then a modest house of about ten rooms, was the home of the Radical wood engraver and writer William Linton in the 1850s. In 1867 he emigrated to America and four years later sold Brantwood to John Ruskin (see below), who bought it for £1,500 without even seeing it. Ruskin, who particularly admired the views over Coniston Water, built a turret on the south-west corner of the house from which he had a magnificent view to the mountains beyond, and he also extended the house considerably in other directions. He moved to Brantwood his remarkable collections of books, illustrated manuscripts, minerals, Turner watercolours and Pre-Raphaelite paintings, as well as his own watercolours and drawings. His cousin, Joan Agnew, and her husband, the artist Arthur Severn, moved in around 1873 and helped to look after Ruskin and the house. After Ruskin's death in 1900 Joan and Arthur Severn remained at Brantwood and began to sell Ruskin's collection, principally to John Howard Whitehouse (see p. 83), a fervent admirer of Ruskin's work and teaching. In 1932 Whitehouse bought the house as well for only £1,750 and opened it to the public in 1934. He was able to return to it many of the paintings and drawings which Ruskin had hung there and which he had bought from Arthur Severn. Long before his death both house and collections became the responsibility of a charitable trust which he set up. A selection of the watercolours and drawings, particularly those by Ruskin himself, are on display at Brantwood, and a few can be hung in the positions originally selected for them by Ruskin. Some of Ruskin's collection of paintings and drawings by his friends, notably W.H. Hunt, Samuel Prout and Edward Burne-Jones, are also displayed. Ruskin's love of nature was perhaps his deepest instinct and at Brantwood it can be seen simultaneously in Ruskin's works of art and through his own windows over Coniston Water.

Ruskin Museum

W.G. Collingwood met John Ruskin at Oxford as a student in 1872 and was soon Ruskin's pupil and friend. In 1881 he became Ruskin's assistant and secretary at Brantwood (see above) and remained in the Lake District for most of the rest of

his life. He had studied art at the Slade School and he was not only an accomplished watercolourist but also a significant local historian, translator of Nordic Sagas and archaeologist. The Anglo-Saxon cross designed by him over Ruskin's grave in Coniston churchyard clearly reflects his great book, *Northumbrian Crosses*. On Ruskin's death in 1900 he and Arthur Severn organised a Ruskin Exhibition at the Coniston Institute, which had been built in the 1870s with Ruskin's help as an educational, social and artistic centre for the village, then a centre of copper mining. The gift and sale of some of the works of art at the exhibition, particularly watercolours and drawings by Ruskin himself, enabled Collingwood and Severn to build a permanent Ruskin Museum attached to the Institute. Collingwood gave to the Museum the works of art by Ruskin and others which Ruskin himself had given to him and thanks to Severn was able to make a selection from Ruskin's collection at Brantwood. The sensitive *Portrait of Collingwood* by Severn is the best record of this friendship. A Heritage Lottery Fund grant permitted the total re-display of the collection in 1998–99. It now shows a wide range of Ruskin's activities with the use of Ruskin's own sketchbooks, lecture diagrams and book illustrations, together with many of his fine watercolour studies of landscape, architecture, botany, geology and skies. Parts of Ruskin's collection of minerals are also on display as well as objects relating to his many interests. Collingwood's portrait of Ruskin at work at his desk at Brantwood with the lake and mountains visible through the window is one of the great icons of late-nineteenth-century British art, and there are also on view many more conventional landscapes and other watercolours by Collingwood and other members of Ruskin's circle.

GRASMERE

Wordsworth and Grasmere Museum

The Museum is adjacent to Dove Cottage, Wordsworth's home from 1799 to 1808, where he wrote some of his greatest poetry. It was opened in 1981 to display manuscripts, books, memorabilia, paintings, drawings and watercolours relating to Wordsworth and his circle, and to hold temporary loan exhibitions on subjects related to British Romantic poetry. The permanent collection includes a growing group of watercolours and drawings of the Lake District with which Wordsworth's life and poetry are so closely associated – most notably Francis Towne's *Elterwater* with its schematic, block-like forms and Thomas Girtin's

Borrowdale, which, despite its sketchy technique, well expresses the grandeur of Lake District scenery. Among the landscapes in oil are *Ullswater* (FIGURE 16) by Joseph Wright of Derby with its calm, reflective evening light and the dramatic *Peele Castle in a Storm* by Sir George Beaumont. *Ullswater* shows the view described by Wordsworth in the boat-stealing episode of *The Prelude* at Patterdale as it was in 1794–95 – not long after the event itself from Wordsworth's youth; Beaumont's painting inspired the poet's *Elegiac Stanzas* lamenting the death of his brother. A portrait by Henry Raeburn of John Wilson, a celebrated literary critic and admirer of Wordsworth, achieves a monumental grandeur through powerful lighting and strong brushwork. B.R. Haydon's drawing of Wordsworth was a study for his *Christ's Entry into Jerusalem* and was much praised as a portrait by William Hazlitt. The Museum, with its loan exhibitions and lecture programmes, is a remarkable achievement of the Wordsworth Trust, which also preserves Dove Cottage for the public.

FIGURE 16

Ullswater
by Joseph Wright of Derby
(Dove Cottage and the Wordsworth Museum, Grasmere)

Abbot Hall Art Gallery

Abbot Hall, a distinguished large mid-eighteenth-century house next to the parish church, was bought in 1897 by Kendal Town Council for £3,750 together with its extensive grounds along the River Kent. The Kendal Savings Bank contributed £2,500 with the proviso that the grounds be opened to the public as a park. The park was laid out but the house was abandoned – a fate characteristic of many large suburban houses bought by local authorities primarily for the use of their grounds as public parks. However, in 1957 the Lake District Art Gallery Trust was formed to restore the house and convert it into a public art gallery. Kendal had not been prosperous in the nineteenth century and so Abbot Hall had not suffered extensively from Victorian improvements. Even by 1957 it was not a large or wealthy town and the success of the Trust was largely due to the Scott family. James Scott (or Schott) was an immigrant from Frankfurt who made a fortune from cotton spinning in Bolton. In 1896 he bought an estate in Westmorland and converted the old lakeland farmhouse into a large country house. In business he moved from cotton to insurance and established the Provincial Insurance Company in Kendal. James's younger son, F.C. Scott, became Chairman of the Company which, together with the Charitable Trust he also set up, provided much of the money for the restoration and conversion of Abbot Hall into an art gallery and has continued to provide substantial financial support for the Gallery, which opened in 1962.

The new art gallery decided to concentrate on buying paintings by local artists, especially George Romney, who had been born near Barrow-in-Furness in 1734 and began his career as a portrait painter in Kendal before moving to London in 1762. He studied in Italy between 1773 and 1775 and his best work was done on his return to London between about 1773 and 1780. Among his most ambitious portraits of that period was *The Gower Family: The Children of Granville, Second Earl Gower* (FIGURE 17) of 1776–77. The graceful curves and easy poses of Roman sculpture, together with the idea of the eldest daughter as a Bacchante, are derived from Italy, but perhaps the importance of the rhythmic flowing line was Romney's own contribution. While Reynolds had to rely on classical poses, architecture, dress and accessories in order to elevate his portraits to the level of history painting, Romney relies more on

FIGURE 17

The Gower Family
by George Romney

(Reproduced by courtesy of Abbot Hall Art Gallery, Kendal, Cumbria,
acquired with the assistance of the National Art Collections Fund)

composition and line. Here the frieze-like arrangement of the figures and the way in which the eldest daughter nearly fills the full height of the canvas show Romney's command of compositional skills. The Gowers were among the richest and most fashionable families in Britain, and this conception of their children engaged in a type of peasant dance, which Romney would have seen in Italy, must have seemed novel, even daring, in 1777. The associations of the dance would however have been classical and arcadian rather than popular, thus lending the necessary respectability. Character and expression were not Romney's aims; as a highly successful society portrait painter it was image and status that he sought. This portrait is perhaps his supreme achievement. In the nineteenth century the folk dances of Italian peasant women were a favourite subject for Anglo-Italian painters such as Thomas Uwins, who owe an unexpected debt to this group portrait by Romney.

William Hayley was a popular poet, man of letters and patron of art. He infuriated William Blake but remained a close friend of Romney, and wrote his biography. In Romney's portrait, *The Four Friends: William Hayley, Thomas Hayley, William Meyer and George Romney*, Hayley is seated at a table with his hand resting on Cicero's *Essay on Friendship* with Romney himself close to him, and they are recommending the virtues of friendship to the two young men in the painting, Thomas Hayley, who was William Hayley's son, and William Meyer, whose father, Jeremiah Meyer, had introduced William Hayley to Romney twenty years earlier. The group portrait is therefore concerned with literary and artistic friendships and more generally with those links between poetry and painting which were such an important element in neoclassical art; neoclassicism claimed for art a philosophical, moral and literary status to which rococo art never aspired, and the earnestness of this portrait reflects these ambitions. Abbot Hall also has some early Kendal portraits by Romney and by his master, Christopher Steele, reflecting the style of Arthur Devis of Preston (see p. 152). More interesting are some drawings by Romney in which he was able to indulge his taste for sublime and heroic subjects, employing a style of Expressionist violence and horror.

The other main specialism for Abbot Hall has been Lake District views, of which by far the most interesting are *Belle Isle, Windermere, in a Storm* and its pair, *Belle Isle, Windermere, in a Calm* by P.J. de Loutherbourg of 1785–86. The popularity of the area rested on its combination of Romantic horror and sublimity with pastoral calm and order, and these two paintings establish the contrast. In the first a boat is wrecked on rocks amidst violent waves under a threatening sky, while in the second tourists admire a golden and idyllic view from a sailing boat in a gentle breeze and farmers with their horse form a quiet

FIGURE 18

Flight 1945
by Kurt Schwitters
(Reproduced by courtesy of Abbot Hall Art Gallery, Kendal, Cumbria,
acquired with the assistance of the National Art Collections Fund)

and ordered procession into a ferry. The two paintings were purchased by John Christian Curwen (1756–1828), an important patron of the arts and the owner of Belle Isle, which was probably the first substantial house in the Lake District to be built for the picturesque views to be enjoyed from it. Abbot Hall has also a considerable number of watercolours and drawings of the Lake District, most notably *The Falls of Lodore* by J.R. Cozens. His characteristic cool and melting blue-green and grey colours are used to portray rocky mountains of Alpine scale and splendour, contrasting sharply with the placid cottage, lake and trees in the foreground. Edward Lear's Lake District views date from his tour there in 1836, during which he effectively became a landscape painter instead of an illustrator of books on natural history. W.J. Blacklock's *Devock Water* of 1853 has a Pre-Raphaelite intensity and calm but also a strong sense of form and structure in the mountain ranges.

The most famous resident of the Lake District in the late nineteenth century was the great art critic, historian and philosopher John Ruskin. On his death in 1900 his collection at Brantwood on Coniston Water was gradually dispersed (see p. 61), and R.E. Cunliffe, who moved to Ambleside from Manchester in 1899, began to acquire watercolours and drawings by Ruskin himself from the collection, although until then Cunliffe had shown no interest in collecting. A part of his collection is now at Abbot Hall, demonstrating well Ruskin's deep and religious interest in natural forms, whether geological or botanical, whether on a large scale or on a small scale.

Twentieth-century art has not been neglected at Abbot Hall. Ben Nicholson is represented by two compositions of the 1930s, both of Cubist inspiration, reducing reality to two-dimensional geometrical forms but still rich in symbols. Kurt Schwitters lived in Ambleside for three years after spending the years of the Second World War in England as a refugee from Nazi Germany. He had established a reputation in the 1920s for collages and constructions in which very disparate objects and materials were assembled together for visual and aesthetic effect, often in the context of an overall idea, conception or even joke. His *Flight* (FIGURE 18) of 1945 contains a piece of driftwood suggesting flight through its winged shape; there is an old rubber tyre from a toy, also perhaps indicating a part of an aircraft, and hints of bombers and targets as well as of insects, butterflies and flowers.

Tabley House

Sir John Leicester (1762–1827) was the first important patron of British art. Of course many portraits by Reynolds, Gainsborough, Romney and others had been commissioned by other collectors earlier in the eighteenth century, but Leicester systematically collected landscapes, history paintings and scenes from literature and everyday life by contemporary British artists while declining to buy Old Master and foreign works of art. His example was followed by most of the later-nineteenth-century merchants and manufacturers of Lancashire, whose collections formed the basis of the art galleries of north-west England, and later by the art galleries themselves, making his taste an important element in the creation of the art collections of the area even if his wealth was derived from land, not from cotton, coal or trade. His father, Sir Peter Leicester, inherited Tabley in 1742 and built Tabley House between 1761 and 1769 to the designs of John Carr of York. Carr was a provincial and conservative architect who provided Leicester with a strictly Palladian house including the usual projecting portico, pediment, rusticated basement and staircase on a central rectangular block and low side pavilions attached by curving brick corridors. The plasterwork was, however, of exceptional quality. In 1770 Sir John Leicester inherited from his father this house and a group of family portraits and of views of the house and park – an art collection of a type to be found in many large country houses of the period. The five paintings of Tabley House, Tabley Park, the Mere and Tabley Old Hall by Anthony Devis lack the classical composition and golden atmosphere of Richard Wilson, who also painted the house from the Mere, but their topographical accuracy and use of unusual viewpoints make them a valuable record of the appearance of park and house around 1770. Anthony Devis was the half-brother of Arthur Devis; they were born in Preston and, despite working mainly in London, relied to a large extent on their connections in north-west England for patronage. The paintings by Devis are still at Tabley, although Wilson's view was sold in 1827. The family portraits inherited by Sir John Leicester included one of the most ambitious examples of English Baroque art, William Dobson's *Portrait of John, first Lord Byron*, a royalist general in the English Civil Wars complete with colossal columns, horse and black page.

The young Sir John Leicester inherited his estates at the age of seven, was taught to draw and paint by Paul Sandby among others, studied at Cambridge

and went on the Grand Tour to Italy in 1784. He bought few works of art there and soon returned to Tabley in 1786, complaining of the discomforts of travel but remarking on the beauty of the scenery. In 1789 he bought Gainsborough's large *Greyhounds Coursing a Fox* and eight years later the *Mountain Landscape with Peasants Crossing a Bridge* by the same artist. Neither of these paintings is still at Tabley, nor is the watercolour he bought from the young J.M.W. Turner in 1792, but there remain at Tabley four of the many paintings which Leicester bought from James Northcote. *Vulture and Snake* has the primitive violence and savagery which the Romantic Movement admired in scenes of terrifying animal conflict, here carried out on a bleak mountainside against a dark threatening sky. *Lafayette in the Dungeon of Olmutz* shows one of the leaders of the French Revolution as a chained prisoner of the Austrians meeting with his distraught family. The expressive possibilities of prison scenes, with human anguish against a black and sinister background, were also much cultivated by Romantic artists, although neither Northcote nor Leicester seems to have had any great sympathy with the French Revolution. Indeed James Ward's magnificent *Portrait of Colonel Sir John Leicester Exercising his Regiment of Cheshire Yeomanry on the Sands at Liverpool* shows Leicester at the head of one of the regiments involved in the Massacre of Peterloo in 1819. Ward's *Fall of Phaeton*, concentrating on the terrified horses hurtling to earth in spectacular attitudes of horror and despair, is a dramatic and striking account of the disaster almost worthy of Rubens. Many of Leicester's grandest history paintings are no longer at Tabley, but William Hilton's *Mermaid of Galloway* shows the climax of an old Scottish legend in which the lovely mermaid magically seduces a young hunter to his death on her rocks against a stormy sky and sea. Hilton's high art attracted very few patrons during his lifetime but Leicester, who also commissioned a *Rape of Europa* from him, was sufficiently committed to British art to buy from him. When the *Mermaid of Galloway* reached Leicester the patron criticised both the arrangement of the mermaid's hair and the fall of light and shade in the painting; Leicester promptly corrected these errors in watercolour over the painting, and Hilton meekly adopted these improvements by turning Leicester's watercolour into oil. As for landscape, Leicester's favourite artist was A.W. Callcott. He owned at different times seven of his paintings and one of the best and largest, *Landscape – Market Day*, is still at Tabley. Its meticulous finish and rather artificial composition, with a winding road and a variety of different scenes separated by trees, shows its dependence on Dutch seventeenth-century landscape, although the stormy sky and strong contrasts of light and dark are more modern. John Constable studied the painting carefully and thought it 'a fine picture, but treated in a

FIGURE 19

Tabley, the Seat of Sir J.F. Leicester Bart: Windy Day
by J.M.W. Turner
(Tabley House, Knutsford, University of Manchester)

pedantic manner, every part seeming to wish to shew itself, that it had not the air of nature'; it was 'too much a work of art and labour, not an effusion'. It is perhaps significant that Leicester bought no paintings by Constable, whose naturalism was probably too extreme for him. Leicester did, however, appreciate the genius of Turner and acquired in 1818 one of Turner's first great imaginative paintings of sun, sky and water, the *Sun Rising through Vapour: Fishermen Cleaning and Selling Fish*, now in the National Gallery. Of the many paintings by Turner owned by Leicester, only *Tabley, the Seat of Sir J.F. Leicester Bart: Windy Day* (FIGURE 19) can still be seen there. Turner came to stay at Tabley during the summer of 1808, just as Callcott had in 1806, and there he painted both this highly imaginative view and another showing the same view but on a calm day – although one of his companions accused him of spending most of his time at Tabley fishing. A contemporary critic described the paintings 'which in any other hands would be mere topography, touched by his magic pencil have assumed a highly poetical character'. His ability to transform an ordinary view into a rich and splendid composition reminiscent of the Old Masters gained him many similar commissions soon afterwards.

In 1805 Leicester bought a London house in Mayfair at 24 Hill Street and immediately created a picture gallery there from the former library. Around 1808 he created another large picture gallery at Tabley House from four of the principal rooms on the west side of the main floor. In 1814 sky and clouds were painted on the ceiling and stars on the doors. The extra space enabled him to expand his collection rapidly and he was now buying important paintings by Gainsborough, Reynolds and Richard Wilson, as well as by contemporary artists. In 1818 he opened his gallery at 24 Hill Street to the public during the London 'season' in the spring and early summer, and this encouraged a more formal, academic and institutional approach in his collecting with the acquisition of large history paintings by Benjamin West, Henry Fuseli and William Hilton, displaying the competence of British artists even in this difficult field. Various catalogues of the collection were published and it was the fame of the gallery at this time that encouraged other aristocratic collectors to buy British art as well as Old Masters. In 1823 Leicester offered to sell his collection to the state to form the nucleus of a National Gallery of British Art but Lord Liverpool, the Prime Minister, declined, and it would be another 74 years before the Tate Gallery opened as a National Gallery of British Art.

Despite this reverse Leicester continued to acquire paintings, even those in new styles. C.R. Leslie's *Anne Page and Slender* of 1819 is one of the first of many small, witty and charming pictures of literary and historical incidents painted rather in the style of scenes from everyday life by Leslie, W.P. Frith,

C.W. Cope, W.M. Egley and others over the following forty years. John Martin acquired a European reputation in the 1820s and 1830s for his melodramatic and spectacular visions of cataclysmic events on an enormous scale filled with tiny figures dwarfed by the power and extent of their surroundings, whether natural or man-made. *His Destruction of Pompeii and Herculaneum*, bought by Leicester around 1826, is a small version of one of his first and most influential paintings of this type.

On his death in 1827 Leicester's financial affairs proved to be in confusion, and his executors sold his London house and all the paintings in it. The Tabley pictures remained with the family at Tabley until 1976 when the executors of Colonel John Leicester Warren sold them, together with the house and the estate, to Manchester University. The house was then a school but in 1990 became residential accommodation for the elderly, with the paintings on view to the public during the summer months. Enough of one of the most influential collections of British art ever assembled remains at Tabley to satisfy both students and visitors.

Tatton Park

In 1729 Samuel Egerton, who was eventually to inherit Tatton from his elder brother, was apprenticed as a clerk by his uncle and guardian, Samuel Hill, to Hill's business associate in Venice, Joseph Smith. Hill was himself a wealthy man, having inherited the Shenstone Estates in Staffordshire, and he was also a picture collector. Through Joseph Smith, who was to become Canaletto's principal agent in negotiations with English patrons, he had ordered two views of Venice from Canaletto in the late 1720s during one of his visits there. They must therefore have been among the first of Canaletto's many Venetian scenes to reach England. Canaletto was slow to complete Hill's paintings, and letters of 1730 from both Smith and Egerton in Venice to Hill describe their efforts to persuade Canaletto to complete the commission. The two paintings were *The Doge's Palace and Riva degli Schiavoni, Venice* and *The Grand Canal from the Piazzetta, Venice*. They were both painted from the same viewpoint but looking in opposite directions. They have the animated figures, scintillating colour, brilliant sunlight and free brushwork of Canaletto's early work and it is not surprising that the artist received large commissions in the 1730s from other English patrons, notably the Duke of Bedford, Sir Robert Hervey and the Earl of Carlisle. Hill died childless and his fortune passed to his nephew, Samuel Egerton, and thus the two paintings now hang at Tatton. Despite Egerton's close contacts in Venice with Smith and Hill, he was not himself a collector, although Bartolommeo Nazzari did paint him there with the entrance to the Grand Canal as a background in about 1732. This rare portrait of an English merchant in Venice also hangs at Tatton.

The most important collector among the owners of Tatton Park was Wilbraham Egerton, great nephew of Samuel. He bought, principally at auction, a wide variety of paintings ranging from a superb classical *Landscape* by Gaspard Dughet and a damaged *Noah's Sacrifice* attributed to Nicolas Poussin to early Netherlandish panels derived from Rogier van der Weyden's *Descent from the Cross* and *The Cheshire Hunt* by Henry Calvert, the local sporting artist. His most unusual acquisition was J.S. Chardin's *La Gouvernante* (FIGURE 20). The boy is about to set off for school with his books; his toys are abandoned on the floor; the housekeeper or maid is brushing his hat, but breaks off to say something to him, probably a reprimand. This simple

FIGURE 20

La Gouvernante
by J.S. Chardin
(Tatton Park, Knutsford, National Trust Photographic Library/Rodney Todd-White)

and everyday, but very touching, scene is conveyed entirely by the pose and attitude of the two figures and by the objects around them. Their faces have only the most restrained expressions of concern and affection. There is understanding between the two figures of very different ages and social class but it is shown with the oblique and quiet domestic poetry of which Chardin was the greatest master. Like most collectors of his period, Wilbraham Egerton also bought Dutch seventeenth-century landscapes and scenes from everyday life but none with the dignity of Chardin's masterpiece. His greatest acquisition was undoubtedly Van Dyck's *Stoning of St Stephen* (FIGURE 21). The first Christian martyr has been taken out of Jerusalem to be stoned to death. Here, as related in the Acts of the Apostles, he kneels down and cries aloud: 'Lord, lay not this sin to their charge.' The light catches his face as he looks up to heaven with an expression both of pathos and of ecstasy; even as a great boulder is just about to come crashing down on his head angels descend with wreaths and the palm of martyrdom for the Saint. His red deacon's vestments, kneeling pose and imploring gestures separate him out from the determined and powerful half-naked executioners towering above him. The Counter-Reformation ideal of bringing directly before the faithful the awesome actuality of Biblical events is achieved here with a dramatic power and emotional conviction astonishing in an artist of only about twenty-four. The painting certainly impressed Van Dyck's Italian contemporaries as P.F. Mola copied the stone-thrower in the left foreground in a drawing now in the British Museum. Among the Italian Baroque paintings bought by Wilbraham Egerton, Guercino's *Mars* is notable above all for the soft and evocative light playing over and bringing out the different textures of the various surfaces, flesh, armour, sash, cloak and feather.

Perhaps the most unusual and unexpected example of Wilbraham Egerton's liking for Baroque art is Benjamin West's *The Three Marys going to the Sepulchre*. This was painted around 1783 as a design for one of the side compartments of a new great east window commissioned by George III for St George's Chapel at Windsor. The window was destroyed in 1863 and West's religious paintings have generally found few admirers but his adoption of a Neo-Baroque style, after his early rigorous neoclassicism, did impart some feeling, fervour and movement into his art and could be seen as an essential prelude to Romanticism. In any event Wilbraham Egerton paid £54.12s.0d. for this painting at the sale of West's picture gallery in 1829 where many of his most famous works went unsold. There seems indeed to have been a persistent tradition at Tatton of acquiring Baroque paintings as William Egerton, Wilbraham's son, bought Annibale Carracci's *The Holy Family with St Francis* of about 1584 as late as 1874; by then Ruskin's influence had made Baroque art

FIGURE 21

The Stoning of St Stephen
by Anthony van Dyck

(Tatton Park, Knutsford, National Trust Photographic Library/John Hammond)

very unfashionable, enabling Egerton to pay very little for it. It is a devotional painting of great emotion and intensity, inviting the spectator to meditate on the cross which the Infant Christ reaches out to touch. St Francis appears in a similar context in other early paintings by Annibale Carracci, and they may all reflect the patronage and piety of the Franciscan Order, which was such an important element in Counter-Reformation art.

It was, however, Wilbraham Egerton who was the major figure in the building of the present Tatton Park. Samuel Egerton had built a new west wing to the designs of T.F. Pritchard of Shrewsbury around 1760, but little more was done until in 1781 his nephew William went to Samuel Wyatt, brother of the more famous James Wyatt, for plans for an ambitious house with a Corinthian portico at the centre of a front eleven bays wide. Work began in 1789 but only the western part of the project was completed. When Wilbraham inherited the house in 1806 he asked Lewis Wyatt, Samuel's nephew, to complete the work on a reduced scale as Samuel himself died in 1807. On the outside Tatton Park has all the usual characteristics of the Wyatt style – smooth ashlar surfaces, windows cut into them without mouldings, tripartite windows with blank segmental arches above and small low relief panels of garlands or medallions. The neoclassical austerity of the exterior is matched by the magnificence of the interior; there are porphyry scagliola columns and black marble fireplaces contrasting with the stone of the entrance hall, while the music room and drawing room have sumptuous red silk wall hangings. The staircase hall is lit dramatically from a shallow dome above. On the landing above the staircase hall are the ten full-length portraits known as *The Cheshire Gentlemen*. They were acquired by Wilbraham Egerton's son, William, in 1869 from Ashley Hall which he had purchased. The ten gentlemen, leaders of Cheshire society, had met at Ashley in 1715 to decide whether to support the Stuarts or the Hanoverians during the Jacobite rebellion of that year. Cheshire had a strong Royalist tradition of support for the Stuart cause, but by the time the meeting took place the rebels were in retreat and the ten gentlemen prudently selected the winning side. They commissioned these portraits in 1720 to celebrate their sound judgment. The portraits are not great art but they well represent the power, influence and stability of the landowning class of the area.

Exactly the same message is conveyed in a quite different context by B.W. Leader's *The Excavation of the Manchester Ship Canal: Eastham Cutting with Mount Manisty in the Distance* of 1891. Wilbraham Egerton, the first Earl Egerton, was William's son, and, although he derived his wealth from land, was deeply interested in the commercial and industrial prosperity of Lancashire and Cheshire. During the 1880s plans were made for building a ship canal into the centre of Manchester to reduce the costs of the transport of cotton and other goods

to and from the overseas markets on which Manchester depended. Even N.M. Rothschild & Sons had difficulty raising the capital for this enormous enterprise until Earl Egerton became the chairman of and the single largest investor in the Ship Canal Company. He sold the land on which the Manchester Docks were built, and in 1887 he cut the first sod for the new canal at Eastham where it leaves the Mersey. This painting was commissioned by him to commemorate the start of the construction work on the canal. Both patron and artist had canals in their blood as Egerton's most distinguished ancestor was Francis Egerton, the third Duke of Bridgewater and the first great promoter of canals in late-eighteenth-century England, while Leader's father was Chief Engineer to the Severn Navigation Commission and his younger brother had several canal jobs before becoming Engineer to the Manchester Ship Canal. It was this influential brother who recommended Leader to Egerton as the best artist to paint the excavation of the canal. Leader had begun his career painting highly finished and very objective landscapes directly from nature according to the principles of Pre-Raphaelitism; later he developed a more atmospheric and romantic approach, particularly with his flat and rather desolate winter evening landscapes of his native Worcestershire, of which his *February Fill Dyke* at the Manchester City Art Gallery is the most famous example. He was therefore an ideal choice for the subject, which after all involved filling a dyke on an enormous scale, and his well-known skill with 'rain-filled rutty roads' and with cold light on still water was an added advantage. The steam excavators in Leader's painting could fill 640 wagons with soil in only 12 hours and Mount Manisty in the distance was in fact a heap of earth cut from the workings and named after the leading contractor's agent. To emphasise the contrast, Leader painted at the right Eastham Woods, a famous local beauty spot. The woods are much more prominent in Leader's initial sketch for the painting (also at Tatton) and the machinery is much less conspicuous. Perhaps Egerton insisted on the engineering rather than the picturesque element, and Leader had to comply in the large final version. The visitor of today may therefore seek refuge in Tatton Park from the noise of the aircraft flying to and from Manchester Airport, only to be confronted with one of the most potent symbols of an earlier technology of transport.

The rich diversity of the Tatton collections shows that they were not assembled by one owner, but rather represent a continuous tradition of aristocratic collecting over nearly two centuries by men of very different types. All, however, felt the need to enrich their walls with the art of the past or of the present. On the death of the last Lord Egerton in 1958, Tatton Park passed to the National Trust. Cheshire County Council maintains and manages it under a lease from the Trust.

Lancaster City Museum

The Lancaster cotton industry did not prosper in the mid-nineteenth century and from the 1850s onwards the Storey brothers, most notably William and Thomas, set up in its place factories manufacturing oilcloth and baize, mainly intended to cover tables. Design was an important element in this business, and it was therefore not surprising that, when Thomas Storey rebuilt the Lancaster Mechanics' Institute as the Storey Institute between 1887 and 1891, an art gallery and art school were provided as well as facilities generally for the 'study and practice of science and the arts, especially as applied to manufactures'. The building was designed by Paley and Austin in a loosely Jacobean style at a cost of about £12,000 to Thomas Storey. In 1906 H.L. Storey, Thomas's eldest son, provided a further £10,000 towards extensions and alterations to the building carried out again by Paley and Austin.

The art gallery's permanent collection was provided by gifts from Storey and from his family and friends, together with a few purchases and other gifts. They concentrated on two local artists. Samuel John Birch was born near Birkenhead in 1869 but moved first to Manchester and then to Lancaster in search of work as the family was poor. He was largely self-taught but his paintings were exhibited at the Storey Institute and found buyers locally. In 1895 he went to Paris for study and it was an exhibition at the Storey Institute on his return that established his reputation in Lancaster. He spent most of his later life in Lamorna on the Cornish coast and became known as Lamorna Birch. His early work is notable for delicate, soft, low tones. Later in his career he used stronger colours and a firmer, more architectural, structure in his landscapes. *Lancaster from the Lune* has his concern for subtle tonal harmonies which a burst of light in the centre of the composition only serves to emphasise. William Hoggatt was much more closely associated with Lancaster. He studied art at the Storey Institute and his success there persuaded H.L. Storey to send him in 1901 to Paris for three years to study there at Storey's expense. In 1903 Hoggatt returned to Lancaster but he eventually settled in the Isle of Man. His *St Augustin, Boulevard Malesherbes, Paris* of 1903, a sketchy twilight scene with street lamps and lighted windows visible through the gloom, is a record of his life in Paris. His *Morning Sunlight* of 1905 shows his decorative and compositional skills but in most respects is

FIGURE 22

Portrait of Mrs Fuller Maitland
by W. Blake Richmond
(Courtesy of Lancaster City Museums)

firmly in the English tradition of landscape. Like Lamorna Birch he came from a poor family, and his instinct on his return from Paris must have been to paint landscapes acceptable to conservative Lancaster patrons. Not all the paintings in the Storey Institute were by local artists. Edward Johnson, a local house furnisher, gave a *Sacrifice of Isaac* attributed to Guercino. The dramatic intervention of the angel is emphasised by the compressed close-up composition and by the powerful modelling and facial expressions.

Meanwhile in 1923 Lancaster City Council opened its own museum in the old Town Hall and began to assemble a modest art collection by gift and occasional purchases, concentrating again on local artists. In 1968 the Storey Institute collection was transferred to the City Museum and selections from both collections are now displayed in the old Town Hall, with a few paintings at the Maritime Museum. Although the collections concentrate naturally on landscape in an area of great natural beauty, there is one portrait of exceptional importance. J.A. Fuller Maitland and his wife lived near Carnforth. He was an eminent musician, musical critic and musicologist as well as a close friend of Gordon Bottomley (see p. 56). William Blake Richmond's portrait of Mrs Fuller Maitland (FIGURE 22) of 1888 is one of his finest Aesthetic portraits. The profusion of flowers, the ornate oriental fan, the tapestry background, her elaborate dress and the open illustrated book to indicate her literary interests all identify her as a woman of feeling and soul while her upward gaze confirms that she is primarily concerned with higher things. There are other good things at Lancaster, two evocative paintings by Clara Montalba, one of which was presented by H.L. Storey, and P.R. Morris's *The Reaper and the Flowers*, in which, as an allegory of the plague years, five young girls joyfully greet the old reaper, blissfully unaware of his grim mission.

Ruskin Library, Lancaster University

John Ruskin was the most influential critic and historian of art in the nineteenth century. Above all he asserted the moral and religious significance of art and denied that it could be judged simply by formal or aesthetic criteria. This philosophy of art became profoundly unfashionable in the early twentieth century, but enthusiasm for Ruskin and his ideas survived thanks to a few disciples, most notably John Howard Whitehouse. In 1873 Whitehouse was born in Birmingham, the son of an electro-plate worker. He left school at the age of thirteen or fourteen but carried on his education at the Midland Institute, where he won many prizes. In 1896 he founded the Ruskin Society of Birmingham and he met Ruskin for the first and only time in 1899. He was interested in both politics and education, and, between 1910 and 1918, he was Member of Parliament for Mid-Lanark; in 1919 he founded Bembridge School on the Isle of Wight as a very progressive Public School emphasising art and craft as much as more academic subjects. Meanwhile he had been collecting books, manuscripts, drawings and paintings by Ruskin on a considerable scale and at very small expense, as Ruskin's work and teaching were by then so unpopular. In 1929 he built a gallery and library to the designs of Baillie Scott at Bembridge School for his Ruskin collection which was extensively used for teaching purposes – and later for research purposes as Ruskin's reputation began to revive. He died in 1955 but a former pupil, J.S. Dearden, became its curator in 1957 while serving as printing master at the school. Dearden wrote extensively about Ruskin, Whitehouse and the collection, adding greatly to its fame. In 1996 the School closed following a general reduction in demand for boarding education, and the Ruskin collection was placed on long-term loan at Lancaster University, which built a new Ruskin Library for it, designed by Richard MacCormac and largely financed by the Heritage Lottery Fund. Lancaster University is close to Brantwood (see p. 61) where Ruskin spent the last 28 years of his life and has a distinguished record in nineteenth-century studies. There are now in the new Library about 1,700 works of art by Ruskin and his circle, Ruskin's extensive diaries, 8,000 of his letters, 200 manuscripts, 3,500 books and 1,000 original photographs. The Library provides changing displays mainly devoted to drawings and watercolours by Ruskin. They reflect his work generally on architecture, art and natural history but are more particularly the best and most moving testimony to his belief in absolute truth to nature.

Walker Art Gallery

During the severe economic depression of 1816 William Roscoe, Liverpool's most eminent citizen, went bankrupt. He was celebrated as a historian, as a botanist, as a philanthropist, as a Radical politician, as a lawyer and as a businessman, but this could not save his bank from collapse and his remarkable art collections were sold to pay its creditors. He had played a leading part in the establishment of exhibitions of contemporary art for sale in Liverpool – on the model of the Royal Academy in London – and was largely responsible for founding Liverpool's other artistic, literary and scientific institutions. His most important works of art were his early Italian and Netherlandish paintings of about 1300 to 1550. He had collected these paintings – then very unfashionable – not because he thought them beautiful, but as illustrations of that period of which he was a distinguished historian with his books on Lorenzo de Medici and on Leo X. He had always intended that his collection should be kept together for public display, and, at its sale in 1816, a group of Liverpool merchants, mostly Nonconformist in religion and Radical in politics like him, bought many of his paintings – particularly the early works which, representing very advanced taste in early-nineteenth-century England, fetched very little. These friends of Roscoe then presented them to the Liverpool Royal Institution, a newly founded cultural club for the town's wealthier merchants, but with some wider artistic and intellectual obligations reflected in its royal charter and its modest subsidy from the Town Council. A detailed catalogue based on Roscoe's own research was published in 1819 and it stated that the motive behind the gift of the paintings was 'the hope that, by preventing the dispersion of a collection interesting to the history, and exemplifying the progress of Design, they may contribute to the advancement of the Fine Arts in the Town of Liverpool'. Perhaps for the first time in Britain a public art gallery was deliberately created to improve the education of the artist and the taste of the citizen – motives which lay behind the formation of every later public collection. In fact, the Royal Institution's collections were technically the property of its proprietors (or members), but the general public were admitted subject to an entrance fee with concessions for students and women – and, crucially, the proprietors did not have the power to sell any of the paintings.

Although Roscoe acquired his early paintings primarily as documents of history and not as works of art, among them – either by design or by good fortune – were some of the greatest masterpieces of the fourteenth and fifteenth centuries. Simone Martini's *Christ Discovered in the Temple* (FIGURE 23) of 1342 was probably painted for the private devotion of a pope or cardinal at the papal court of Avignon. Its graceful pattern of linear rhythms and of rich colours are typical of the international Gothic art of the period, but far more remarkable are the poignant expressions of tender care and questioning doubt on the part of Mary and Joseph – and of firm resolve on the part of Christ. Gesture contributes to the emotional drama with the outstretched pleading hands of the parents and with the very determined crossed arms of Christ. This painting was one of the first to bear the name of the artist and its date on it; the Latin inscription was probably inserted after Simone Martini's death, but it certainly reflects the early fame of the painter and the new status of the artist – pictures were beginning to be valued not just as aids to devotion but as creations of great artists. No less moving is another of Roscoe's pictures – Ercole de Roberti's *Pietà* (FIGURE 24) of about 1495. The poignant subject, the dead Christ lying in the lap of the Virgin, was introduced into Italy from northern Europe around 1450 and reached its Italian climax with Michelangelo's great marble group in St Peter's at Rome. Here the thin emaciated body of Christ, with one arm dangling loosely down and its starkly realistic head seen against the sharp jagged outline of the Virgin's black robes, provides a devotional image summarising Christ's Passion with enormous emotional and dramatic power. The painting was originally part of the predella (a series of narrative paintings under the main altarpiece) of the church of San Giovanni in Monte at Bologna. Among Roscoe's Netherlandish paintings, perhaps the most remarkable is the *Lamentation over the Dead Christ* of about 1486 by the Master of the Virgo inter Virgines. Again the atmosphere is bleak, the body of Christ is painted with pathological detail to express suffering and grief, not beauty and triumph, and the mourning figures staring down at it have an almost hypnotic power and intensity. These three paintings are not typical of the 37 early paintings acquired from Roscoe's collection for the Liverpool Royal Institution in 1816. There are other less emotionally charged works by Spinello Aretino, Rosso Fiorentino, Jan Mostaert, Jean Clouet and others. The *St Bernardino Preaching* attributed to the studio of Vecchietta and the *Legend of St Andrew* by Bartolommeo di Giovanni both offer charming and closely observed insights into fifteenth-century Italian social and religious life which must have appealed to Roscoe as a historian. Hans Baldung Grien's *Mercenary Love* of 1527 is another scene from contemporary life but sharp

FIGURE 23

Christ Discovered in the Temple
by Simone Martini
(Board of Trustees of the National Museums
& Galleries on Merseyside, Walker Art Gallery)

FIGURE 24

Pietà
by Ercole de Roberti
(Board of Trustees of the National Museums
& Galleries on Merseyside, Walker Art Gallery)

satire is more evident than tender observation. Love is reduced to a casual transaction. The young woman is attractive and the old man has money. The enormous popularity of scenes from everyday life in the seventeenth century largely derived from these moralising paintings of the sixteenth century. But Roscoe, despite his admiration for the poetry of Alexander Pope, was also part of English Romanticism and he was the most important patron of Henry Fuseli, whose terrifying *Death of Oedipus* and Expressionist *Death of Cardinal Beaufort* also passed from Roscoe's collection to that of the Liverpool Royal Institution.

The Royal Institution continued to acquire Old Master paintings, including some of high quality rather in the spirit of Roscoe's collection, such as Lukas Cranach's *Nymph of the Fountain* with its erudite classical subject matter and rich humanist symbolism. Between 1840 and 1843 it erected a new purpose-built art gallery to house its sculpture and paintings. The collection did not, however, prove popular, despite the publication of a series of well-researched catalogues, and in 1850–51 the Liverpool Town Council attempted to take over the Institution and its collections as the nucleus of a new free municipal museum and art gallery. The Institution's members, however, wanted to retain some powers over their collections and the negotiations collapsed. Eventually the collections were deposited on loan at the Walker Art Gallery in 1893 and finally presented to the Gallery in 1948.

Meanwhile the Town Council had also been concerning itself with modern art. Exhibitions of contemporary art for sale had been held in Liverpool in 1774, 1784, 1787 and in 1810 to 1814, largely thanks to the enthusiasm of Roscoe; the later shows in particular had attracted notable artists from London and elsewhere. These exhibitions continued at first with the support of the Liverpool Royal Institution and later under the sole control of a group of local artists known as the Liverpool Academy; they became more regular and ever more ambitious after 1822 but they terminated in 1867 following bitter disputes over both artistic styles and management structures. In 1871 the Town Council revived the exhibitions with the new title, the Liverpool Autumn Exhibitions, under its own management and sited them in its new museum, presented to Liverpool by Sir William Brown. They were immediately successful, and the profits were used by the Council to start building up a permanent collection by purchasing a few paintings each year from the exhibitions themselves. In 1873 the local brewer, Andrew Barclay Walker, gave the Council £25,000 for the erection of a new public art gallery and from 1877 onwards the Council could use this gallery for the display of the exhibitions and of the permanent collection which was gradually being built up from

them. An extension costing Walker a further £11,720 was added on in 1884. Between 1871 and 1938 about 250 paintings and sculptures were acquired for the Walker Art Gallery in this way. The best were bought before 1895 when Philip Rathbone died; he was a younger son of one of the Radical and Nonconformist families who dominated Liverpool's trade and cultural life and he largely controlled both the exhibitions and the municipal purchases from them.

These acquisitions represented the first sustained attempt to assemble a representative public collection of contemporary British art. The Trustees of the Chantrey bequest in London did not start buying works of art for the future Tate Gallery until 1876 and serious collecting in the other major provincial cities only began in the 1880s – and then heavily influenced by Liverpool's example. Rathbone himself was probably inspired by the success of French national and local museums which had been for many years acquiring paintings and sculptures from the Paris Salons and from local exhibitions with generous state funding. However, he had to rely on admission charges and profits from the commission on sales at the Liverpool Autumn Exhibitions, and the populist element in his collecting policy was the result. In 1888 the Curator of the Walker Art Gallery summed up Rathbone's acquisitions policy thus:

> While endeavouring to secure works of the highest technical skill the fact has not been lost sight of that the public, for whose edification and instruction the institution in a great measure exists, delight in subjects of a popular character, and with this end in view pictures have from time to time been added which, by appealing to common feelings and sentiments of our daily life, have afforded a fine moral lesson, and given great pleasure to the numerous visitors to the Gallery who are uninitiated in the higher forms of art...

W.F. Yeames's well-known *And When Did You Last See Your Father?* – effectively a late and rather weak St John's Wood School painting popularised by a waxworks replica at Mme Tussaud's – was the result of this insidious policy. Rathbone did, however, buy some contemporary British paintings of exceptional importance. He himself owned Albert Moore's early and transitional *The Shulamite*, which he ultimately bequeathed to the Gallery, and so it was natural for him to acquire Moore's late *A Summer Night* for the Gallery in 1890. The intensity and symbolism of Moore's final years are just apparent in a work otherwise more notable for the decorative rhythms and colour patterns of his middle years. By contrast Hubert Herkomer's *Eventide*,

a scene in the Westminster Workhouse, represents the social realism of the 1870s, rendered yet more moving by the violence of its perspective and the eccentricity of its composition. W.H. Thorneycroft's *The Mower* is probably the first life-size statue of an anonymous manual worker to be made in England – even if the scythe is idle and the mood is one of reverie and reflection. S.J. Solomon's *Samson* is the most remarkable and successful British example of the sensational academic 'machine' popularised by the Paris Salon exhibitions of the period. Pre-Raphaelitism was represented both by J.E. Millais's *Isabella*, one of the first and most characteristic examples of the awkward, hard-edged, intense phase of that style, and by D.G. Rossetti's *Dante's Dream*, typical of that artist's visionary and Symbolist art. Holman Hunt's *The Triumph of the Innocents* adds a note of literalist realism to a treatment of the subject otherwise rigorously mystical. Rathbone's most remarkable and most inexpensive purchases were, however, the progressive naturalist paintings of the Newlyn School, the Glasgow School and of the New English Art Club. These groups were inspired by advanced French contemporary art, particularly that of Jules Bastien-Lepage. Stanhope Forbes's *A Street in Brittany* was acquired when the artist was only 25 years old. Fred Brown was only 35 when his *Hard Times* was acquired and E.A. Hornel was 28 on the date of Rathbone's purchase in 1892 – against much local opposition – of his *Summer*. The only missing element in the Walker Art Gallery's panorama of British late-nineteenth-century art was Frederic Leighton's classicism. The City Council refused to ratify Rathbone's purchase of his *Captive Andromache* on the grounds of expense, but fortunately A.G. Kurtz, a Liverpool collector and major patron of Leighton, presented his *Elijah in the Wilderness*, the nearest British equivalent to a great altarpiece by Guido Reni. Rathbone was also a pioneer collector of contemporary foreign art. Giovanni Segantini's *Punishment of Lust* shows the painful redemption of young women guilty of abortion or child neglect in the lyrical but icy setting of the Swiss Alps, representing a Buddhist Nirvana.

Local art and artists had never received much favour at the Autumn Exhibitions but, inspired by the celebrations surrounding the seven hundredth anniversary of the foundation of the Borough of Liverpool in 1907 and by the local researches of the new curator, Rimbault Dibdin, the Gallery concentrated in the early years of the twentieth century on the acquisition of historic Liverpool art, more often by gift than purchase. James Smith, a wine merchant, bequeathed to the Gallery a notable collection of paintings by the Liverpool Pre-Raphaelites, D.A. Williamson and W.L. Windus, and of sculptures by Auguste Rodin. George Stubbs's *Horse Frightened by a Lion*, in which the artist's precise

and accurate anatomy contributes to a scene of Romantic conflict and terror, was the most notable purchase, at only £22.10s.0d.

Contemporary paintings of national importance were still being acquired each year from the Autumn Exhibitions, but attendances and sales at the exhibitions were declining, and, after Rathbone's death in 1895, the standard of selection, as well as the funds for it, declined. James Smith's bequest of 1923 had included some 28 paintings by G.F. Watts; most notable among them was the visionary *Four Riders of the Apocalypse*, perhaps the most powerful visual symbols of Victorian pessimism. At much the same time George Audley, who dealt in beer and whisky rather than in wine, was buying Victorian paintings, by then both unfashionable and cheap, in order to present them to the Gallery. These included major works by 'progressive' artists influenced by France, including George Clausen and Stanhope Forbes, as well as more traditional and classical paintings by Frederic Leighton and Albert Moore. But influential local critics pointed out that the Gallery still held a representative collection only for academic British art between about 1870 and 1900, and that it should now attempt to be more comprehensive at least for British art. This programme was accepted by Frank Lambert as Director and Vere Cotton as Chairman, and the Walker Art Gallery became in the 1930s for the first time primarily a permanent collection rather than an exhibition hall. Later-eighteenth-century English paintings, most notably by Richard Wilson and John Zoffany, were acquired together with some very much more important Camden Town Group pictures, above all W.R. Sickert's *Bathers Dieppe*, with its marvellous abstract arrangement of shapes, colours and lines, and Harold Gilman's *Mrs Mounter*, a programmatic demonstration of the principles of French Post-Impressionism. Lambert was buying Camden Town pictures some twenty years after they were painted. The advantages of this approach to the acquisition of works of art for public galleries lies in giving time for the qualities of particular styles and paintings to emerge and to be critically examined and digested. It lacks the more instinctive and immediate appeal of buying straight off the artist's easel but generally leads to a more discriminating, if perhaps less exciting, collection. These acquisitions were made possible by the institution in 1929 of a regular annual picture purchase grant from the City Council. On the other hand a major extension at the back of the Gallery in 1931–33, which nearly doubled its display space, was largely provided by private generosity, as the original Gallery had been, and it is generally true that Merseyside has not greatly depended on public funds for its art galleries and collections. Indeed, a gift of £20,000 in 1933 from Walker's son, Lord Wavertree, was as significant as the City's purchase grant in funding acquisitions over the following twenty years.

During the Second World War the Gallery was used as the local food office and it did not re-open until 1951. The Autumn Exhibitions did not start again, leaving the whole of much the largest art gallery in north-west England for its permanent collection, except for the provision of space for occasional loan exhibitions. The Gallery broadened its acquisition policy once more, aiming now to build up a representative collection not just of British but also of European art. B.E. Murillo's soft and sweet *Virgin and Child in Glory* was followed by P.P. Rubens's *Virgin and Child with St Elizabeth and the Child Baptist* (FIGURE 25). Both paintings demonstrate marvellously but in very different ways the synthesis demanded by the Counter-Reformation between everyday naturalism and transcendent holiness. Salomon van Ruysdael's *River Scene with a Ferry Boat* has the same compromise between realism of detail and grandeur of composition within a landscape setting. Rembrandt's *Self Portrait as a Young Man* has the dramatic lighting, rich costume and self-conscious facial features of a young artist experimenting with a mirror in search of expression. These seventeenth-century masterpieces were all acquired with the help of local and national private, corporate and institutional help, and in 1961 an appeal specifically aimed at industry and commerce on Merseyside was launched to raise money for the purchase of French Impressionist and Post-Impressionist paintings – the type of art then most likely to appeal to provincial businessmen. Over £70,000 was raised and notable but scarcely characteristic works by Georges Seurat, Edgar Degas, Claude Monet, Paul Cézanne, Henri Matisse and others were bought. Degas's *Woman Ironing* is a splendidly luminous compositional exercise in painting a working-class woman against the light. Cézanne's *The Murder* belongs to a small group of early dark and violent subjects inspired by the naturalist novels of Emile Zola.

Meanwhile the need to strengthen the holdings of British eighteenth-century art had not been forgotten and William Hogarth's *David Garrick as Richard III* was bought in 1956. Although it portrays Garrick playing the part of Richard III in Shakespeare's play, this is perhaps the first great English history painting thanks to its dramatic force and narrative power, with the terrified king's open hand highlighted right in the centre of the painting against the gloom behind. In 1975, after the death of the last Earl of Sefton, Thomas Gainsborough's portrait of the first Countess was acquired by the Gallery. The aristocratic ease of its pose and its shimmering virtuoso paintwork would have impressed visitors to the first Royal Academy exhibition in 1769, where it must have been intended to establish the artist's reputation as the most technically gifted portrait painter in England.

FIGURE 25

Virgin and Child with St Elizabeth and the Child Baptist
by P.P. Rubens

The Earls of Sefton at Croxteth Hall, the Earls of Derby at Knowsley Hall and the Blundell family at Ince Blundell Hall formed the three great Merseyside collections derived from the ownership of land in Lancashire and beyond. From the Blundell collection the Gallery was given the eighteenth-century marbles which formed part of Henry Blundell's enormous accumulation of classical sculpture, and in 1981 it bought from Blundell's heirs Joos van Cleve's *Virgin and Child with Angels*. The tender charm, extravagant costumes and profusion of accessories, many rich with symbolic meaning, are characteristic enough of this distinctive Antwerp Mannerist, but the distant landscape shows a real knowledge of the pioneering work in this area of Patinir, while the forms and expressions of the angels display the artist's debt to Leonardo da Vinci. From the superb collections of the Earls of Derby, the Gallery bought Nicolas Poussin's *Landscape with the Ashes of Phocion* (FIGURE 26) of 1648. In the extreme foreground a woman of Megara is piously gathering the ashes of the great Athenian general whose body had been burnt outside his native city after an unjust trial and execution. But the grand and solemn landscape, composed layer by layer into depth and exactly balanced from side to side with solid, almost geometrical forms, transforms a mundane and inconsequential act into a great occasion rich with moral and historical significance. Never before had the expressive powers of landscape been so powerfully demonstrated. From another great collection beyond Merseyside, the Methuen collection at Corsham Court, came Elsheimer's *Apollo and Coronis* which relates with great tenderness and feeling the tragic consequences of love and infidelity between a god and a mortal. She must die, but Apollo, moved by the sight of her naked and pregnant body caught in a burst of sunlight, vainly searches for herbs to revive her, and her unborn son, removed from her womb by Apollo, will become Aesculapius, the god of healing.

Although the Liverpool Autumn Exhibitions did not revive after the Second World War, the Gallery did not entirely abandon its commitment to contemporary art. The Liverpool Academy started to hold regular exhibitions in the Gallery as soon as it re-opened after the War and in 1957 the first John Moores Liverpool Exhibition was held. These biennial exhibitions (which, unlike those of the Academy, still continue) were open to all British artists and had two distinct and not entirely compatible aims. The first was to give the Merseyside public an opportunity to see the best contemporary British art available, and the second was to encourage young and 'progressive' artists. The jury was changed for each exhibition but was carefully selected to give the exhibitions a Modernist bias sympathetic to recent developments in Paris and

FIGURE 26

Landscape with the Ashes of Phocion
by Nicolas Poussin

(Board of Trustees of the National Museums & Galleries on
Merseyside, Walker Art Gallery, acquired with the assistance of
the National Art Collections Fund)

(increasingly) in New York. Prizes were awarded to encourage eminent artists to exhibit outside London and some of these were purchase prizes by which the winning picture entered the permanent collection of the Walker Art Gallery; the Gallery also bought with discrimination other paintings in the exhibitions – and indeed paintings in the Liverpool Academy exhibitions while they survived. Thus the tradition of the Autumn Exhibitions was revived and once again regular exhibitions of contemporary art were used to provide new acquisitions for the Gallery. In the early years of the John Moores exhibitions the results were impressive and some very important paintings were acquired for the Gallery. R.B. Kitaj's *The Red Banquet* of 1960 is of exceptional significance in the development of Pop Art. Allen Jones's *Hermaphrodite*, which did not win a prize in 1963, demonstrates the artist's early interest in erotic images of the female body treated with witty sophistication. In 1965 Clement Greenberg was chairman of the jury and the first two prizes went to Michael Tyzack and Michael Kidner, whose abstract hard-edged paintings were acquired for the Gallery. David Hockney's *Peter Getting Out of Nick's Pool* of 1966 is an evocative image of the relaxed and leisured Californian way of life so much admired in Britain of the 1960s, then still emerging from post-war austerity and provincialism. Later exhibitions and the purchases from them were less distinguished. The Royal Academy and the London commercial galleries began to include 'advanced' artists, who thus had no immediate incentive to exhibit in Liverpool, while the exclusion of all art forms except pure painting deprived the John Moores Exhibitions of the work of much of the next generation of young artists with their commitment to 'multi-media'. Nonetheless, through these Exhibitions the Gallery has assembled one of the most distinguished collections of British later-twentieth-century art in the provinces, with the added advantage that the acquisition of each painting reflects the taste and attitudes of that particular year and jury.

In recognition of the quality of its collections the Walker Art Gallery became a national institution in 1986. Increased funding from national rather than local taxation enabled it to acquire the very substantial part of William Roscoe's collection of Old Master drawings which had been purchased at his sale by the Blundells, thus continuing the Gallery's tradition of buying works of art closely associated with Liverpool, but generally it followed the national trend by which acquisition enjoyed a progressively lower priority. Its collections were certainly already by far the most important and extensive in north-west England. However, although successive committees, curators and directors undoubtedly aspired to a representative collection of western European art, the Walker Art Gallery is the home of extremes rather than

averages, of the unusual rather than of the representative. Its great paintings by Simone Martini, Ercole de Roberti, Nicholas Hilliard, Nicolas Poussin, William Hogarth, George Stubbs, J.E. Millais, Ford Madox Brown, Frederic Leighton, G.F. Watts, S.J. Solomon, Paul Cézanne, Giovanni Segantini, W.R. Sickert, Harold Gilman, Lucian Freud and many others are generally typical neither of their period nor of their artists' work. Expression is more evident than beauty and the Gallery will never be a great teaching collection. But it does offer a very distinctive, even disturbing, aesthetic experience to the visitor already familiar with more comprehensive collections.

Sudley House

By 1900 Liverpool, Manchester and other Lancashire towns were ringed by the newly built mansions and villas of their merchants and manufacturers, many containing substantial collections of nineteenth-century British art. Aristocratic collectors had earlier favoured Old Master paintings; the new men preferred new art; the artists whom they patronised were able to build their own houses in Kensington, Bayswater and St John's Wood almost rivalling those of their northern patrons. Very few of the great houses of the men of industry and trade in Lancashire, and even fewer of their collections, survive. Their wealth was lost to unsuccessful speculation, to the division of property among too many children, to generous charitable giving and to death duties, while their collections were discredited by the modernist art criticism of Roger Fry, D.S. MacColl and George Moore. Aristocratic collections by contrast still attract millions of visitors to country houses throughout Britain.

The survival of almost all the paintings collected by the Liverpool ship-owner and merchant George Holt (1825–96) at Sudley, his suburban home, is therefore exceptionally fortunate and is entirely due to his only child, Emma Holt, who, remaining unmarried, inherited the collection together with the house and presented both to the City of Liverpool in 1944. Holt was not, however, typical of the art-loving Lancashire merchants and manufacturers. Despite his wealth Sudley is a very modest house, and it was not built by Holt, who merely extended a neoclassical house of about 1824 which he bought in 1883 – and which by then must have been regarded as very unfashionable. Ostentation was not a fault of his and the visitor will be amazed to find in his relatively small dining room, drawing room, morning room and library – rooms of little decorative importance and originally containing only utilitarian furniture – some of the greatest British paintings of any period. Four or five of them must have together cost him more than the entire house.

He had begun collecting contemporary British art in middle age around 1868 before he moved from West Derby to Sudley, specialising in unremarkable but highly competent landscape and genre paintings by artists of the calibre of J.B. Pyne, John and William Linnell, Henry Stacy Marks, Frederick Goodall, Copley Fielding, Thomas Creswick and Thomas Faed. He had, however, noticed the new importance of Frederic Leighton's classical genre paintings which, with their

considered cultivation of beauty for its own sake, their repudiation of anecdote and subject and their absence of contrived expression, were an early sign of the Aesthetic Movement, and he bought Leighton's *Weaving the Wreath* from the second Liverpool Autumn Exhibition of 1872. A later acquisition, *Study: At a Reading Desk* by the same artist, is of the same type but with an Eastern rather than a classical setting, showing how unimportant factual context was to Leighton's art. In 1878 he bought William Dyce's *The Garden of Gethsemane* (FIGURE 27), in which the anguish of the small and inconspicuous figure of Christ, looking out of the painting at one side of it, is expressed by an intense and detailed twilight landscape of great stillness, poignancy and emotion – as far removed as possible from Leighton's pagan generalisations.

On moving into Sudley, however, Holt began immediately to buy on a much larger and more ambitious scale. He had already bought two small late Margate scenes then attributed to J.M.W. Turner and thought to have come from the collection of Mrs Booth, the artist's mistress and housekeeper. The attribution of these two ghostly, even sinister, luminous paintings, of which one at least is an emigration scene, is still controversial but there is no doubt about the status and importance of Turner's *Schloss Rosenau, Seat of H.R.H. Prince Albert of Coburg, near Coburg* (FIGURE 28), painted in 1840–41 in an unsuccessful attempt to gain for the artist royal patronage and favour – Queen Victoria had married Prince Albert in 1840. Solid form has been dissolved into colour and light by the sun shining directly at the spectator. Brilliant and dazzling reflections, much praised by John Ruskin, play across the water. Loose luminous paint makes even the trees resemble visions. Hostile critics in 1841 described the painting as 'a wild extravaganza, a vision of an unreality' or as 'the fruits of a diseased eye and a reckless hand', while the only sympathetic reviewer saw it as 'luminously splendid in colour, and, though overcharged, not unnatural in effect, if viewed at a proper distance'. Two years later in 1888 Holt bought an even more remarkable example of Turner's late style. *The Wreck Buoy* was a seascape of about 1807 repainted in 1849 to add the wreck buoys and a new sky. Pessimism marked Turner's old age; the wreck buoys warned ships of old wrecks that could still endanger them; the rainbow for the aged artist was a symbol of fallacious hope, not of the covenant between God and humankind; the rough murky sea, the dark sinister sky, the men perhaps ship-wrecked themselves in the small boat and the central spectral ship with its white sail mysteriously illuminated by the rainbow as if in a dream convey the same message of gloom, transience and mystery. The pictorial and emotional extremism of these two paintings by Turner are, however, not at all characteristic of Holt's taste for early-nineteenth-century British art. R.P. Bonington's *Fishing Boats in a Calm* shows his debt to Dutch seventeenth-century marine painting, with the poetic stillness of the

FIGURE 27

The Garden of Gethsemane
by William Dyce
(Board of Trustees of the National Museums
& Galleries on Merseyside, Sudley House)

FIGURE 28

Schloss Rosenau, Seat of H.R.H. Prince
Albert of Coburg, near Coburg
by J.M.W. Turner
(Board of Trustees of the National Museums &
Galleries on Merseyside, Sudley House)

ships and of their reflections in the water and the subtle evocation of limitless space beyond bounded only by a distant horizon and lit by soft glowing sunlight. The careful arrangement of simple vertical and horizontal elements is as far removed as possible from Turner's visionary compositions.

Among early-nineteenth-century genre paintings, David Wilkie's *Jew's Harp* shows his reliance on Dutch seventeenth-century low-life paintings, to which he adds his own rich stock of incident, expression, wit and charm. William Mulready adds in a rather Victorian social and moral dimension to his *A Dog of Two Minds* – painted, however, in 1829, well before Queen Victoria's coronation: will the dog attack the respectable studious boy as directed by the less reputable errand boy on the right – or is he too frightened by the first boy's whip?

William Holman Hunt's *The Finding of the Saviour in the Temple* is a sketch for a painting of 1854–60 now in the Birmingham Art Gallery and Museum; Hunt then 'completed' the sketch so that it too could be sold. His research on location in Palestine and in Jewish sacred literature enabled him to reconstruct the event exactly as he believed it must have occurred in the first century AD; the combination of piety, symbolism, ethnology and highly detailed descriptive realism in technique results in a remarkable combination of Victorian science and faith. The virtuoso brushwork and eighteenth-century charm of J.E. Millais's *Vanessa* (Esther Vanhomrigh, who fell in love with Jonathan Swift) of 1868 shows the very different stylistic development of another Pre-Raphaelite artist. Otherwise Holt's Pre-Raphaelite paintings are not remarkable, but as an old man he became a personal friend of J.M. Strudwick, a late follower of Edward Burne-Jones, and commissioned four paintings from him. The most notable is *Love's Palace* showing, through elaborate symbolism, the power of love over men and women – the dominant theme of the poetic branch of Pre-Raphaelitism originating with D.G. Rossetti.

The last twenty years of the nineteenth century witnessed a sudden collapse in confidence in contemporary art among British collectors. Established values were challenged by new movements – J.M. Whistler and his followers, the New English Art Club and progressive French art generally. The reaction of most collectors was not to follow these new trends but to retreat to later-eighteenth-century and early-nineteenth-century British art with its rich suggestions of stable values, aristocratic glamour and national tradition – a reaction facilitated by new legislation permitting great families impoverished by agricultural depression to sell their heirlooms. Holt followed this new trend – as did William Hesketh Lever at Thornton Manor on the other side of the Mersey with resources far greater than Holt's (see page 137). Within a few years after his purchase of Sudley, Holt had bought portraits by Joshua Reynolds, George Romney and

FIGURE 29

Elizabeth, Viscountess Folkestone
by Thomas Gainsborough
(Board of Trustees of the National Museums & Galleries on
Merseyside, Sudley House)

Thomas Lawrence. Mrs Charlotte Sargent was a friend of Romney and her portrait commemorates her marriage in 1778 – a relief representing the marriage of Cupid and Psyche appears in the background. Her porte-crayon identifies her as an amateur artist and the book celebrates her learning or her skill. She is placed right at the front of the painting and looks at the spectator, confronting him or her with a directness rare in eighteenth-century formal female portraits. Even richer in expression and characterisation is Thomas Gainsborough's *Elizabeth, Viscountess Folkestone* (FIGURE 29) bought by Holt in 1896, the year of his death, for £3,150 and by far his most expensive picture. Gainsborough is generally admired for his loose dazzling brushwork, applied to portraits of self-assured aristocrats dominating their surroundings, but revealing little of their individual personalities. Here, however, we have the portrait of an old woman emerging from and blending in with the darkness behind her, clutching her own dress and suggesting rather the loneliness and sadness of old age than the confidence of youth or maturity. By contrast Henry Raeburn's *Girl Sketching* has a suggestive mixture of innocence and eroticism – the girl's half-open mouth and revealing undress make the spectator wonder why she has abandoned her sketch, but her expression is soulful and her upturned eyes are child-like, while the fall of light on her flesh is of exceptional tenderness and softness.

Although Sudley is best known for its British art, there are three animal paintings by Rosa Bonheur, the most famous – and the most masculine – female artist of the nineteenth century, showing her grasp both of the characteristic static poses and of the ways of movement of her animals, together with two powerful landscapes by her brother Auguste. His *Paysage d'Auvergne* has the dramatic contrasts of light and shade, and the bleak scenery of that backward, primitive but highly romantic part of France; it was owned by the Duc de Morny, friend of Napoleon III and one of the greatest collectors of the Second Empire. The very different *Ruth and Naomi* is by Ary Scheffer, now largely forgotten but by far the most famous contemporary French artist in mid-nineteenth-century Lancashire.

Victorian art has often been criticised for its domestic bias and undemanding subject matter, for its lack of high ideals and of monumental scale, for its failure to concern itself with universal truths and great ideas. Collectors like Holt have often been blamed for these inadequacies and at Sudley a balanced judgment can be made.

Upstairs the Holt family portraits demonstrate the family's lack of concern for personal ostentation and status. The other paintings on the upper floor, together with the sculpture and furniture throughout the house, were never owned by the Holt family and have been lent to Sudley by the Walker Art Gallery.

Tate Liverpool

Tate Liverpool does not have its own collection but displays works of art from the modern collections of Tate Britain in London within carefully grouped exhibitions. Tate Britain is of course exceptionally rich in British art of the last hundred years and has substantial collections of American and French paintings and sculpture of this period. Tate Liverpool was converted in 1986–88 by James Stirling from a section of the Albert Dock, originally built between 1841 and 1848 by Jesse Hartley. Funds were provided by the Merseyside Development Corporation, by the Minister for the Arts and by many private benefactors.

University of Liverpool Art Gallery

The University art collections contain some notable paintings by artists who spent some part of their early life in Liverpool. Joseph Wright of Derby was painting portraits of the merchants and of their families there between 1768 and 1771; his *Portrait of Mrs Thomas Case as a Shepherdess*, despite its pastoral charm and refinement, represents a woman whose father and husband were tough Liverpool merchants both probably deeply implicated in the slave trade. John James Audubon arrived in Liverpool in 1826 from New Orleans. He brought with him a portfolio of about 400 watercolours, representing with scientific precision most types of North American birds, and he came to England to seek sponsorship for the publication of a series of ornithological volumes based on them. He exhibited a selection of his drawings at the Liverpool Royal Institution, then a centre for adult education and the principal precursor of Liverpool University. The exhibition was successful in raising over £100 and Audubon also received hospitality and support from Liverpool's leading families connected with the Institution. In return he painted large oil versions of two of his watercolours, the *American Wild Turkey* and the *Hawk Attacking Partridges*, together with an original composition also in oil, *Otter Caught in a Trap*. These he either exhibited in Liverpool or gave to his friends there; all except the first version of the *American Wild Turkey* are now in the University Art Gallery. Audubon was a hunter before he became a naturalist and this may explain the rather sadistic quality of the *Otter* and *Partridges* paintings. He soon moved on to Manchester and Edinburgh seeking more backers for his books and he did eventually publish his watercolours as his famous *Birds of America* between 1827 and 1838.

Augustus John was in Liverpool for about eighteen months in 1901 and 1902 teaching at the progressive art school established by the University in 1895, and he painted some five portraits of University personalities for the University Club, which was essentially a pressure group set up to create an independent, self-governing university in Liverpool. The leading spirit in the Club – and in the University – was Professor J.M. Mackay, whose personal charisma was more remarkable than his ability in teaching, administration or research. In John's portrait (FIGURE 30) he seems to be searching for his ideals in the far distance with little concern for everyday life. It is a striking and

FIGURE 30

Portrait of Professor J.M. Mackay
by Augustus John
(University of Liverpool Art Gallery)

sensitive portrait of a visionary and enthusiast turning towards the light in search of enlightenment. In contrast John's much later *Portrait of Charles Reilly* shows a man whose shrewdness, self-publicity and determination created one of the most successful schools of architecture in Britain. John was not the only outsider of talent recruited by the University for its art school. In 1898 Herbert MacNair became the Instructor in Design. In Glasgow he had been closely associated with C.R. Mackintosh, and both he and his wife Frances shared with Mackintosh a liking for attenuated, gently curved forms rife with symbolism and mysticism. After he left the University he and Frances concentrated on drawings and watercolours, some of which can be found both in the University Art Gallery and in the Walker Art Gallery.

On the other hand J.M.W. Turner's *The Eruption of the Souffrier Mountains in the Island of St Vincent* has no connection with Liverpool except that it may have been presented to the University to assist with the teaching of geology. Turner was following a strong eighteenth-century tradition of volcano and earthquake painting which suited his pessimism and taste for disaster. Turner did not himself see the eruption but relied on a sketch by an eye-witness.

Turner is also well represented in a group of classic English watercolours presented to the University by Sydney Jones, a Liverpool ship-owner with a deep concern for education and a very generous benefactor of the University.

The Oratory

The Oratory is in fact the former chapel of St James's Cemetery which lies beneath it. The cemetery was established in 1826 to replace churchyards which by then were overcrowded with too many burials in a rapidly expanding city. The Oratory, designed by John Foster and completed in 1829, provided space for the funeral services conducted before the burials took place in the cemetery below. Foster's father was the Liverpool Corporation's Surveyor and Architect for many years; Foster inherited this post in 1824 and retained it until 1835. In his youth he travelled widely in Italy and Greece, participating in archaeological excavations on the sites of ancient Greek temples and making careful drawings of a very wide range of classical buildings. On his return to Liverpool in 1816 he became the leading architect there of the Greek Revival, designing the city's market, customs house, station frontage and seven churches, as well as providing for Liverpool a network of wide regular streets. Nearly all these buildings have been destroyed and the Oratory is of exceptional importance as the one surviving example of his severe and archaeological Greek style. It is based on the temples of the Acropolis in Athens and, like them, it is sited dramatically on the edge of a steep rocky hill. Following the example of Greek temples all the light inside comes through windows in the stone roof. The absence of side windows provides both excellent spaces for sculptural monuments along the walls and an ideal lighting system for them. Within about twelve years of its completion seven important monuments to distinguished Liverpool citizens had been erected within it.

John Gibson was Liverpool's most celebrated neoclassical sculptor. He came from a lower-middle-class Welsh family and was apprenticed to a firm of monumental masons in Liverpool, where he was encouraged to become a sculptor by a group of cultured Liverpool merchants, most notably by William Roscoe and by the family of Solomon d'Aguilar. In particular Solomon d'Aguilar's daughter, Mrs Emily Robinson, improved his education, manners and taste and, deeply attracted by her character and beauty, he evidently thought that she was in love with him. On her death in 1829 he erected the monument in the Oratory to her (FIGURE 31) at his own expense. Its design follows closely the arrangement of ancient Greek *stelai* with a seated figure in profile. Gibson particularly admired her 'beautiful Greek profile'. His slightly

FIGURE 31

Monument to Emily Robinson
by John Gibson
(Board of Trustees of the National Museums
& Galleries on Merseyside, The Oratory)

later monument to William Hammerton is also remarkable for the simple flowing lines and contours of the figures and again the format is Greek with a pediment at the top. Hammerton gave generously to local charities and Gibson has therefore shown an act of charity on Hammerton's monument: a man is giving food to a poor mother and her two children. The classical dress emphasises and reveals the human forms beneath while the blank background, flat unadorned design, severe expressions and simple pattern of poses and gestures provide an appropriate element of gravity and solemnity. 'The expression of cheerfulness and gaiety is beneath the dignity of sculpture', declared Gibson. The last of Gibson's sculptures in the Oratory is the monument to William Earle, a wealthy Liverpool merchant whose family firm traded with Italy where he spent some of his last years. Much earlier he too had helped Gibson to train as a sculptor and the old man, who lived to the age of 79, is sympathetically shown reading while resting his head on his hand. The contours of the figure and the lines of the drapery are here even more simple, flat and austere, while the whole body is exactly in profile parallel to the blank background behind. The resulting image has that easily memorable, compact, distinct outline and shape so characteristic of neoclassical design. Francis Chantrey's Nicholson family memorial has the simple, repeated profiles familiar from Gibson's work but with rather less severity and austerity. William Nicholson, who lived in Everton, is mourning the death of his six children and in his sorrow hides his face behind his hand. Beneath him is a figure of grief holding a broken lily, symbolising youth cut off in the first bloom of life.

Quite different in style is Joseph Gott's monument to William Ewart. Ewart moved to Liverpool from Scotland and became a successful merchant and close friend of John Gladstone, father of the great prime minister who was named after him. He is shown sitting in a realistic comfortable pose, cross-legged and entirely at his ease. He is wearing modern dress and the sculptor has delighted in the creases, details and textures of his clothing. He seems to be talking to the visitor and the whole effect is of casual informality. This was the style that was to replace Gibson's strict, linear neoclassicism later in the nineteenth century. Generally, however, it can be said that in no other comparable building is there such a close stylistic unity between most of the monuments and the surrounding architecture, making the Oratory one of the most powerful and concentrated embodiments of the austere neoclassicism of the early-nineteenth-century Greek Revival. This series of monuments to Liverpool's great men was continued in the grand and enormous space of St George's Hall after its completion in 1856, but this later Pantheon had its

modest beginnings in the Oratory. Indeed the Ewart monument, free and relaxed in style and pose, detached from the wall and naturalistic in dress and face, well represents the type of monument which first appeared in churches, chapels and cathedrals but which only received its final development as public sculpture in streets, parks and town halls.

A few more monuments were added before the closure of the cemetery and its chapel in 1936. By that date Liverpool Cathedral, not the cemetery, dominated the area. In 1980 Merseyside County Council took over responsibility for the maintenance of the Oratory and some other monuments, rescued from redundant and demolished churches and elsewhere, were added to the display. Among these are the Agnes Jones monument of 1869 by Pietro Tenerani, whose angel of the Resurrection well represents the later soft and rather sentimental phase of Italian neoclassicism. Under the guidance of Florence Nightingale, Agnes Jones had introduced trained nurses into the hospital of the Liverpool workhouse, a practice rapidly followed elsewhere in the country. The National Health Service hospitals developed ultimately from workhouse infirmaries and Agnes Jones should be seen as one of the great pioneers of the National Health Service. She died at the age of thirty-five from typhus contracted in the course of her duties. Inscriptions on monuments often use inflated language. This one, written by Florence Nightingale and the Bishop of Derry, does not: 'Her only desire for herself was that at the Resurrection her Lord might say "she hath done what she could"'.

The bronze statue of William Huskisson by John Gibson of 1847 originally and most appropriately stood on the steps of Foster's Liverpool Customs House, which was demolished immediately after the Second World War. The statue is another great Liverpool icon as it was Huskisson who, as Member of Parliament for Liverpool and President of the Board of Trade between 1823 and 1827, introduced the free trade policies which made Liverpool one of the great centres of world trade. In accordance with his neoclassical principles, Gibson represents Huskisson wearing a classical toga rather than modern dress.

In 1986 the Oratory passed into the care of the National Museums and Galleries on Merseyside.

West Park Museum

The Brocklehurst family were one of the leading families in Macclesfield, involved in both silk manufacture and in banking. Marianne Brocklehurst, who had formed a notable Egyptian collection after three expeditions there between 1873 and 1891, played the principal part in the establishment of the West Park Museum on the edge of Macclesfield in a public park laid out as early as 1854. Her family provided the funds for the erection of the Museum between 1897 and 1898 to the designs of Purdon Clarke of the Victoria and Albert Museum, and her Egyptian antiquities are its main feature. A number of paintings from Brocklehurst houses are there, and these include works by Rosa Bonheur, Leghe Suthers, Henry Detmold and others. The *Banks of the Nile* by Théodore Frere is perhaps a souvenir of Marianne Brocklehurst's Egyptian trips.

The Museum is also assembling a collection of the works of Charles Tunnicliffe, who was born in 1901 near Macclesfield. There he remained, apart from a period of study in London, until 1947 when he moved to Anglesey. His later bird paintings are well known, but he began his career as an etcher rather in the style of J.F. Millet, and some of these very atmospheric prints are on display at Macclesfield. When the market for etchings suddenly collapsed in 1929 Tunnicliffe returned to Macclesfield from London. He painted some townscapes in the fashionable hard, sharp and precise style of the period, but he also began to do more sensitive wood engravings with a strong sense of design as illustrations to books by Henry Williamson and others. Many of these involved animals and particularly birds, which he also studied in a more scientific manner in his drawings of dead birds for the curator of the Stockport Museum. His watercolours of birds at the Royal Academy exhibitions made him famous and they became known to a wider public through commercial reproductions.

Manchester City Art Gallery

Manchester was slow to create art galleries and art exhibitions, although its Literary and Philosophical Society dated from 1781 and by 1800 it had several libraries, including the famous Chetham's dating from the seventeenth century. It had no City or Town Council until 1838 and above all it had no cultural and political leader of the calibre of Liverpool's William Roscoe. In 1823 three young Manchester artists, William Brigham, Frank Stone and David Parry, visited Leeds to see the exhibition there of the Northern Society which had been founded in 1809. William Brigham was an amateur topographical artist of whom little is known. Frank Stone moved in 1831 to London where he enjoyed a successful career as a painter of sentimental and historical themes. David Parry came from a dynasty of Manchester artists and also moved to London where he died in 1826 aged only 33. On their return to Manchester they convened a meeting of nineteen local artists. Thomas Dodd, an auctioneer, took the minutes and acted as secretary. The artists formed their own society, the 'Associated Artists of Manchester' but rapidly concluded that the support of the local leading manufacturers and merchants was necessary – as at Leeds where they dominated the Northern Society. A committee of eight 'gentlemen', including William Brigham, was then formed to assist the artists, but they soon decided on not just an art gallery for annual exhibitions of contemporary works of art for sale, but rather 'The Manchester Institution for the Promotion of Literature, Science and the Arts', which would have space for these exhibitions, but would also have a lecture room, a library, laboratories and facilities for the study of science and natural history. Raising sufficient money for the erection and endowment of this ambitious project took some years and the building, known as the Royal Manchester Institution, was not completed until 1834 at a cost of £21,100. The architect was Charles Barry, who later designed the Palace of Westminster, but the Institution was severely Grecian, even if its façade, entrance hall and main staircase were remarkably original in conception and design; Barry was aged only 29 when he won the competition in 1824 and he beat two local architects with established reputations, Thomas Harrison of Chester and John Foster of Liverpool. Meanwhile the artists had not been forgotten and annual exhibitions for them were held in rented premises starting in 1827; from 1829 onwards they took place in the unfinished Royal Manchester Institution building.

As early as 1827, however, the Institution began to form a permanent collection by acquiring paintings from these exhibitions. The most remarkable of these was probably *The Storm* by William Etty, acquired in 1832. Two figures are praying for deliverance in a small boat during a storm. The high viewpoint and dark colours contribute to the Romantic violence and intensity of the subject. It was one of the artist's favourite paintings. Thus while the Liverpool Royal Institution was buying Old Master paintings, the Royal Manchester Institution was buying contemporary British art. In 1856 the Institution changed its policy and bought *The Birth of Pandora* (FIGURE 32) by James Barry, painted between 1791 and 1804. Among all British late-eighteenth-century artists Barry was the most committed advocate of ambitious history paintings concerned with great universal themes. Pandora is receiving gifts and adornments from the pagan gods before setting off for earth with the fatal box which, once opened by her, will spread misery throughout the world. Pandora is therefore the pagan Eve and Barry has painted the great moral turning point of human evolution. Pandora is given everything, but Jupiter, the great sinister statuesque foreground figure, has also given her the means by which he can revenge himself on the human race for Prometheus's theft of fire.

By 1846 the permanent collection was already large enough to justify the publication of a catalogue and regular public open days, but even by 1880 there were still only about 50 paintings and some sculptures in it of very uneven quality, most of which were gifts. Among the gifts was G.F. Watts's grand and moving *Good Samaritan,* presented by the artist in 1852 to commemorate the philanthropic work in Manchester of Thomas Wright, a foundry worker, among discharged convicts.

The educational and scientific functions of the Institution were gradually taken over by the new Manchester University and by the Manchester School of Art, and thus it was possible between 1882 and 1892 to convert the lecture room and other educational areas into display galleries. This provided much more space for the permanent collection and the annual exhibitions, which retained their popularity, although of course much damage was caused to Barry's architecture. In 1882 the building and collections had been given by the Institution to the City Council as a new City Art Gallery in return for a commitment by the Council to spend £2,000 each year for twenty years on acquisitions for it and to allow the Institution's Governors to participate in its management. Thus the Institution received very much more generous terms from the Council than those vainly offered in 1850–51 by the Liverpool Town Council to the Liverpool Royal Institution. Moreover, while the Walker Art Gallery in Liverpool had to rely for its acquisitions on the profits from its

annual exhibitions and on occasional special grants from the Liverpool City Council, the Manchester City Art Gallery had from 1882 a guaranteed £2,000 per year from its City Council on top of any other income.

They spent it very well. In his *Work* (FIGURE 33), Ford Madox Brown endows the labour of digging drains with a heroic quality and contrasts it with the idleness, apparent or real, of other figures in the painting. It was of course mechanised rather than manual work that created Manchester's prosperity, but Brown's painting is still rightly seen as a great icon or symbol of the Industrial Revolution. During the 1880s he was painting murals in the Manchester Town Hall showing the history of the city and naturally therefore the Art Gallery is very rich in his work. His *The Body of Harold Brought before William the Conqueror* is an early work, submitted in 1844 for inclusion on a larger scale as part of the decoration of the new Palace of Westminster. The flatness of the main design reflects its purpose – reproduction on a larger scale as a mural – while the sophistication in the construction of the large foreground group shows what Brown learnt while studying in Paris and Antwerp. The subject demonstrates Brown's enthusiasm for Carlyle's cult of great men. The bright colour and precise detail in *Work* reflect Pre-Raphaelite influence; between about 1880 and 1910 the Pre-Raphaelites generally were very widely admired and collected, not least by Manchester City Art Gallery with £2,000 to spend each year. Holman Hunt's *The Hireling Shepherd* was painted in the open air at Ewell in Surrey using white underpaint and clear pure colours to achieve the brilliance and sharpness of a sunlit landscape. In the usual Pre-Raphaelite manner, naturalism in description is accompanied by symbolism in meaning. The shepherd represents the mid-nineteenth-century clergy who neglected their pastoral responsibilities. The sheep wander off into the corn and the half-eaten apple on the girl's lap identifies her as a new Eve seducing the shepherd from his duties. By contrast, *Autumn Leaves* by J.E. Millais was one of the first of a group of Pre-Raphaelite and Aesthetic Movement paintings deliberately conceived without a subject and intended rather to convey an intense and poetic mood – in this case the introspective grief and tender memories evoked by the end of the year and by the passage of time. Another painting by Millais of feeling and atmosphere is his *Stella* of 1868. Stella was Jonathan Swift's close friend and here she is reading one of his famous touching and tender letters to her. To achieve the right suggestive mood Millais here relied on historical figures for its evocation. His very similar *Vanessa*, depicting another of Swift's heroines, hangs at Sudley in Liverpool (see p. 98). Even late in his career Millais could still manage landscapes of gentle pathos and imagination and his *Winter Fuel*, a gift of 1897 rather than a

FIGURE 32

The Birth of Pandora by James Barry

(Manchester City Art Galleries)

FIGURE 33

Work by Ford Madox Brown

(Manchester City Art Galleries)

purchase, is an example. Meanwhile his *Victory O Lord!*, showing an Israelite triumph from the Old Testament with heroic figures on an epic scale, well demonstrates Millais's diversity. The languid, poetic melancholy of D.G. Rossetti's late work is conveyed by his *The Bower Meadow*, where his very characteristic dreamy female figures dance and play music in a soft, idyllic landscape. Mystical love was the dominant theme of his late work; his *Astarte Syriaca* of 1877, an eastern version of the classical Venus, is a figure of compelling power in absolute control of human passions and emotions. There are other Pre-Raphaelite paintings of exceptional importance at Manchester, particularly by Holman Hunt; notable are preliminary or small versions, but highly finished, of three of his greatest compositions, *The Light of the World*, *The Lady of Shalott* and *The Scapegoat*, for which the final large painting is at Port Sunlight (see p. 137). Hunt's *The Shadow of Death* shows Christ as a humble carpenter upholding the dignity of manual labour – just as Ford Madox Brown did in quite a different context in his *Work*. Hunt's Christ is also demonstrating his sacred mission as he accidentally assumes the pose of the crucifixion. Hunt's painful but comprehensive creation of a new religious iconography is shown more completely at Manchester than at any other gallery. The minor Pre-Raphaelites, John Brett with his seascapes of geological precision, C.A. Collins with his *The Pedlar*, one of the earliest paintings of the Brotherhood to fulfil all its requirements of truth to nature and of an awkward, 'primitive', linear style, Arthur Hughes with his *Ophelia* and many others can also be seen there. With only one or two exceptions all these paintings were bought by Manchester City Art Gallery during the first thirty years of its life, often in competition with Birmingham and Liverpool, which were also forming major Pre-Raphaelite collections at this time. The Pre-Raphaelite enthusiast will look in vain in Birmingham or even in London for paintings comparable with those in the north west.

Students of the late-nineteenth-century classical revival in British art will be equally rewarded. In its great early years Manchester was not only buying major Pre-Raphaelite paintings but also works by classical (or Aesthetic) artists. In 1888 Liverpool had agreed with Frederic Leighton to buy his *Captive Andromache* for £4,000. The City Council, however, repudiated the contract as too expensive, leaving the way open for Manchester to buy the painting for the same sum. Again the contract went to a meeting of the full Council for ratification and by 52 votes to 6 Manchester, with the help of some private subscriptions, bought the painting which Liverpool had spurned. It was the last and greatest of Leighton's great processional paintings. In Homer's *Iliad*, Hector had described the cruel fate in store for his wife, Andromache, if the

Trojans lost the war against the Greeks, and here his prophecy has been fulfilled. Andromache is reduced to the status of a water carrier in Greece. Reversals of fortune, and the moral lessons to be derived from them, were a popular subject among classical painters, most notably Nicolas Poussin, and here Andromache's former status is emphasised by her isolation right in the centre of the canvas and by her statuesque nobility and gravity of pose. Although many of the other women and onlookers are unconcerned, a few of them 'marking thy tears fall shall say: "This is she, the wife of that same Hector that fought best of all the Trojans when all fought for Troy"' – to quote from the passage in the *Iliad* used by Leighton in the catalogue of the 1888 Royal Academy exhibition. The stately but melancholy flow of the composition from left to right and slightly upwards is gently slowed and occasionally nearly arrested by some five carefully arranged and spaced groups, each full of figures rich in incidental interest and in every variety of rhythmic pose. Form and emotion are balanced with a technical accomplishment unrivalled elsewhere in Europe. In J.W. Waterhouse's *Hylas and the Nymphs* of 1896 Hylas, one of the Argonauts, is being seduced away from his military duties by nymphs. The Argonauts will never see him again. The subject, so dear to Rossetti, Burne-Jones and their followers, is of course the supreme power of love and of beauty, and this painting well illustrates the influence of those artists after Waterhouse's early classicism. J.R. Spencer Stanhope was perhaps the most notable of these followers. His classicism was inspired by the early Florentine Renaissance of Botticelli, as indeed was Burne-Jones himself in his *Sibylla Delphica* at Manchester, and Stanhope's *The Waters of Lethe by the Plains of Elysium* illustrates the ancient myth of the river of oblivion, towards which a procession of careworn mortals painfully struggle, bent under the ills of the world. They emerge at the other side of the river refreshed and reborn to dance in the Elysian groves with the city of Florence in the background.

Stanhope's *Waters of Lethe* was, in fact, a gift rather than a purchase and in the first half of the twentieth century the Gallery had to depend more and more on private generosity. The £2,000 purchase grant was reduced rather than increased, and its value was eroded by inflation; only after 1949 did the amount exceed £2,000. Fortunately the Gallery received as bequests in 1917 and in 1940 the collections formed by two brothers, J.T. and G.B. Blair. Their family cotton-exporting firm had come down to Manchester from Scotland; apart from business duties they lived quietly at Whalley House in Whalley Range. Neither married and they could devote their hours of leisure to collecting. Their taste was conventionally Victorian, with landscapes by Constable and Cox, and Aesthetic subject paintings by Albert Moore, Marcus

Stone, C.E. Perugini and others. G.B. Blair particularly liked the work of Ford Madox Brown, and J.T. Blair the landscapes of B.W. Leader – as did J.E. Yates, another Manchester collector in the cotton trade, who left four of Leader's landscapes to Manchester as well as Holman Hunt's small *Lady of Shalott*.

T.C. Horsfall was the son of a prosperous Manchester manufacturer of cards for textile manufacture. He retired from business, however, at the age of 41 and established his own Manchester Art Museum at Ancoats Hall in the Manchester slums. Following Ruskin's example, he wished to demonstrate to the poor children of the area the beauty of nature by displays of natural history and of paintings made directly from nature. There were also galleries devoted to good design in household objects in the spirit of William Morris, to the life of Christ, to local history and to art techniques which were actually taught in the Museum. Pictures and reproductions were lent to local primary schools. There was special provision for the education of the disabled. 'A community ignorant of the beauty of nature cannot possibly have healthy feeling and healthy thought, and without these true welfare is impossible.' Horsfall was supported by those contemporary artists most dedicated to the moral function of art, notably Holman Hunt and G.F. Watts, and it was through him that Watts gave to the City Art Gallery his great *Court of Death*, originally painted for a mortuary chapel to represent death as an integral and even positive aspect of life. Horsfall's Museum was taken over by the City Council in 1918 and finally demolished in 1954, with the collections passing to the City Art Gallery. Their quality is disappointing, although Henry Moore in his Pre-Raphaelite phase and John Brett, together with other artists concentrating on an exact imitation of nature, are represented, and there are interesting and more varied drawings and watercolours, notably by Ruskin and Ford Madox Brown. But the explicit social, moral and educational purpose of Horsfall's Museum also lay directly behind the creation of most of the art galleries of South Lancashire in particular, where deprivation, especially in the higher things of life, was so apparent. Moreover, the education departments of all later museums and art galleries directly reflect Horsfall's vision, which was so much wider than the two more usual supports of the modern art gallery – middle-class leisure and upper-class acquisition.

Educational purpose, but at a rather more sophisticated level, was also the motive behind Charles Rutherston's gift in 1925 of over 800 paintings, drawings, watercolours and prints by 'progressive' artists of the previous forty years. The collection was originally intended to circulate in groups around provincial art colleges, which were then notoriously reactionary in their teaching, and the scope was later widened to include all schools and colleges.

Considerations of security and conservation have more recently largely terminated these loans and led to the integration of the collection within the City Art Gallery. Charles Rutherston's father emigrated from Germany and established in Bradford a very successful woollen factory which Rutherston entered as a young man. The family name was Rothenstein, anglicised by Charles to Rutherston in 1916. His brother, William Rothenstein, was an eminent artist, much influenced at first by Whistler; he later, as Principal of the Royal College of Art, transformed art education throughout Britain. Under his influence Rutherston started collecting paintings by Charles Conder, whom he met in Paris in 1890. Indeed Conder's *Moulin Rouge* commemorates an evening which the two men spent at that enticing spot. Although committed to Modernism Rutherston later collected very widely, embracing the Realism of W.R. Sickert, the Vorticism of Wyndham Lewis and of C.R.W. Nevinson, the English Impressionism of Wilson Steer, as well as the more French variety of Lucien Pissarro, together with Gwen John's subdued, reticent interiors and J.E. Southall's hard and precise late Pre-Raphaelitism.

Inspired by Rutherston's gift Manchester began to buy art more advanced in style than was acceptable at most of the other Lancashire galleries, which were still dominated by the Royal Academy Summer Exhibitions. A Cubist painting by Ben Nicholson, *Au Chat Botté*, was purchased in 1948 and Henry Moore's *Mother and Child*, also deriving from Cubism, was bought in 1939. In fact Rutherston had selected Manchester rather than his native Bradford to receive his remarkable collection because he regarded Manchester as the cultural, political and intellectual capital of northern England, and indeed Manchester City Art Gallery had asserted this position in its collecting policy by 1925. Substantial works by those artists inspired by Jules Bastien-Lepage in the 1880s, notably George Clausen, Stanhope Forbes, Edward Stott, William Stott, H.H. La Thangue and John Lavery, together with paintings by progressive artists of the next generation including Steer, Sickert, E.A. Hornel, Conder, Spencer Gore, Charles Ginner, Henry Tonks, Augustus John and Lucien Pissarro had been bought by 1930 (and most much earlier). It is at Manchester that art by this generation of painters can most comprehensively be admired. P.H. Rathbone in Liverpool may have been the pioneer but for English Impressionism the Walker Art Gallery had largely to rely on George Audley's gifts. Manchester moved easily from concentration on Pre-Raphaelitism to concern for the next great movement in British art, Naturalism, inspired by Paris. William Orpen's *Homage to Manet* (FIGURE 34) of 1909 was bought by Manchester City Art Gallery a year later and admirably sums up the style and its origin. The artists, collectors and critics responsible

FIGURE 34

Homage to Manet
by William Orpen
(Manchester City Art Galleries)

for its fame in Britain are casually grouped under a painting by Manet in a format popularised in Paris by Fantin-Latour, whose penetrating *Self Portrait* Manchester bought ten years later. E.L. Boudin's *Etaples* was purchased in 1908 and Alfred Sisley's *A Normandy Farm* in 1927. By 1930 paintings by Henri Harpignies, J.C. Cazin, Corot and Monticelli had also been bought. To some extent this fascination with Anglo-French art of around 1880–1920 reflected local taste. Samuel Barlow, the owner of a bleach works at Middleton, was collecting French Impressionist paintings as early as the 1870s and one of these, *A Village Street, Louveciennes* by Camille Pissarro, is now in the Manchester City Art Gallery. Some years later C.J. Galloway, whose Manchester engineering company exported steam engines all over Europe, was buying works by Cazin, Boudin, Pissarro, Harpignies, Corot and Fantin-Latour, together with paintings by those British artists influenced by them. Both William Stott of Oldham and Edward Stott of Rochdale were local artists. Manchester's internationalist approach also reflected its free trade policies and its cosmopolitan manufacturers and merchants.

After the Second World War emphasis passed, as at Liverpool, to European Old Master painting, although George Stubbs's *Cheetah and Stag with Two Indians* of around 1765 is an exception. The cheetah had been sent to Windsor as a gift from the Governor of Madras in 1764 and is here about to demonstrate its hunting skills on the stag, which in fact easily won the ensuing conflict. Despite the artificial setting Stubbs's interest in the anatomy of the cheetah's body and the texture of its coat convey a powerful image of the exotic animal's strength, power and elegance. More typical of Manchester's post-war acquisitions was Claude Lorrain's *Landscape with the Adoration of the Golden Calf*, a magnificent ideal landscape of the artist's maturity in which poetic feeling and compositional skill combine to create an image of timeless classical perfection. By contrast Bernardo Bellotto's two views of the Castle of Konigstein demonstrate his skill in cool, accurate and precise description. The arrangement of the buildings and the fall of light on them is, however, as sophisticated and subtle as in Claude's great landscape, and the mundane beauty of everyday life and ordinary things is conveyed by Bellotto with the same feeling on a large scale as Dutch artists achieved on the level of domestic intimacy. This aspect of Dutch art is well conveyed by the Assheton-Bennett bequest of about 100 small cabinet paintings which Manchester received in 1979. Landscape, still life, architecture and flower pieces are well represented as well as genre paintings. Edgar Assheton-Bennett had been born in Manchester in 1873 and, although he left the city sixteen years later, he remembered it in his will. Rather earlier Dr F.G. Grossman, deputy director of

the Gallery and probably the first art historian with an international reputation to work in a British municipal art gallery, had bought a group of small Baroque sketches often related to major decorative schemes.

The richness of all these collections and the ambition and erudition behind their creation were, however, in sharp contrast to the provision of buildings in which to display them. The Royal Manchester Institution was small and not built as an art gallery. Liverpool's merchant princes William Brown, Andrew Barclay Walker, George Audley, Thomas Bartlett, F.C. Bowring and George Holt provided buildings for art galleries, museums and libraries, but Manchester was not so fortunate. The City Council considered many schemes from 1890 onwards for a new art gallery to be built at its expense on various city-centre sites, but no decision was reached due to the costs involved. Indeed, one of the members of the Council's Art Gallery Committee, Councillor Butterworth, lost his seat on the Council at the municipal elections of 1912 on the single issue of the cost to the Manchester ratepayers of a new art gallery. Large parts of the collection were therefore dispersed to unsatisfactory suburban locations. Only with funds from the National Lottery was a solution eventually found, with a major extension to the Royal Manchester Institution building to be completed in 2001.

Whitworth Art Gallery

Sir Joseph Whitworth was a pioneer in the manufacture of machine tools and of exact measurement in engineering. He standardised screw threads and greatly improved the design and making of gun barrels. He was a scientist as well as a manufacturer and, on his death in 1887, he left part of his immense wealth for the creation of schools of technology and of art in Manchester, to which an art gallery and technical museum were to be attached. His will was drafted very vaguely and great discretion was left to his Trustees, whose powers were so extensive that they were in effect legatees. The most notable of these and the real founder of the Whitworth Art Gallery was Robert Darbishire, Whitworth's solicitor and son of one of the founders of the Manchester Athenaeum and of Manchester New College. It was presumably due to his influence that the proposed technical museum was soon abandoned. The schools were taken over by Manchester City Council but the art gallery remained independent, with its own Governors and Executive Council. Whitworth's Trustees had hoped that the City Council would assist with the management and maintenance of the art gallery, but the Council was more concerned with building a new art gallery for its own collections, and there was uncertainty about the powers of the Trustees and the control of Whitworth's estate.

A piece of land just south of Manchester's city centre was acquired and laid out as Whitworth Park, and between 1894 and 1908 a gallery was built to the designs of J.W. and J. Beaumont within it. One of the first Governors was William Agnew, the leading London art dealer whose firm originated in Manchester, and he persuaded G.F. Watts to give a version of his *Love and Death* to the new Gallery as its first acquisition. Inspired by the early death of the Marquess of Lothian, the painting shows the massive figure of Death entering a doorway and pushing past a winged Cupid representing Love. Death was intended to suggest 'solemnity, power, irresistible and unconquerable, also an echo of that mystery which veils the unknown'. Love symbolised 'beauty, tender passion and the struggle of unavailing anguish'.

But the Whitworth Institute, as it was then called to emphasise its didactic rather than merely aesthetic mission, was not to specialise in large contemporary paintings, often with a moral and philosophical dimension, in

the manner of most of the other galleries of north-west England. Agnew was Chairman of the Committee controlling the Manchester Royal Jubilee Exhibition of 1887, to which Watts had contributed 34 works including a version of *Love and Death*, and that Committee gave the new Institute some £42,000 from the exhibition's profits, which helped to finance the purchase of about 40 important English watercolours including works by J.R. Cozens, J.M.W. Turner, Peter De Wint, Samuel Prout and W.H. Hunt. The greatest of these was Turner's *The Lake of Lucerne, Moonlight, the Rigi in the Distance*, one of his most imaginative late watercolours, in which the grand and majestic Alps seem to be suspended over the luminous lake, dramatically lit by the rays of the setting sun shining directly at the spectator through the evening mist. In 1891 Agnew himself gave one of Turner's largest and most spectacular watercolours, *The Chapter House, Salisbury Cathedral* (FIGURE 35). This is one of those early church interiors in which the young artist demonstrated both his skill in perspective and his command of powerful effects of light and shade, thus transforming the English topographical tradition into high art. The Whitworth Art Gallery's collection of English watercolours was, however, principally launched by the gift of 154 works between 1891 and 1893 from the collection of J.E. Taylor, owner of the *Manchester Guardian*. These included a large group of watercolours by Turner and by Thomas Girtin, but also William Blake's *The Ancient of Days*. In this famous design, creation is achieved in a scientific and mathematical way using compasses, thus stifling the imagination and the spiritual element, an act deeply hostile to Blake's Romantic inspiration. Also included in the gift was *The Lake of Nemi looking towards Genzano* by J.R. Cozens, one of his most poetic and evanescent evocations of the Campagna around Rome and rich in his soft grey and blue tonalities. Taylor's collection at his London house was by no means confined to British watercolours; there were also Renaissance bronzes, Chinese porcelain, nineteenth-century English paintings, French furniture and Greek and Roman antiquities; he asked for the watercolours 'to be selected from his own collection with a special regard to the aim of the Institute at developing the exhibition of the history of the art of water-colour painting in England'. Taylor was a Governor of the Art Gallery from 1895 until his death in 1905, and his editor at the *Manchester Guardian*, C.P. Scott, was on the founding Whitworth Committee appointed in 1887. At the opening of the Gallery in 1890, it was the *Manchester Guardian* that complained:

> The basis of the ordinary provincial art gallery is the collection of contemporary English oil paintings. The same ominous preference appears already in this small collection... There are

no watercolours, and that though watercolour is the one art in
which England holds, or has held, the primacy.

Before the completion of the first phase of the new Whitworth Art Gallery in
1898, space for the display and storage of the collections was restricted to
Grove House, which stood in Whitworth Park and had been acquired with it.
The house was not large and considerations of space alone may have resulted
in the decision to concentrate on watercolours rather than oil paintings. In any
event these early gifts were soon followed up by later benefactors who often
gave watercolours and drawings quite outside the classic British landscape
tradition. Sir Michael Sadler, an educational pioneer while Vice-Chancellor of
Leeds University early in the twentieth century but also an important early
patron of French Post-Impressionist art, was generous, but the gifts of A.E.
Anderson, who lived in Surrey and never once visited the Gallery or even
Manchester, were yet more remarkable. In 1928 he presented a 'Blue Period'
watercolour by Picasso entitled *Poverty* of 1903. This is one of his isolated
family groups, tired and depressed by poverty and rendered in blue tones
suggestive of sadness and despair. Anderson's tastes were wide and he also
gave to the Gallery more conventional drawings and watercolours by Cozens,
J.S. Cotman, Samuel Palmer, Thomas Rowlandson and others. Following the
decision to concentrate on watercolours and drawings, it was natural for the
Whitworth Art Gallery to collect prints as well. In 1921 G.T. Clough gave his
fine collection of Renaissance and seventeenth-century woodcuts, engravings
and etchings which he had built up over many years with exacting scholarship.
It included impressions of many of the most famous works by Dürer,
Mantegna, Pollaiuolo and Rembrandt. Other gifts of quite different types of
print followed, giving the Whitworth Art Gallery by far the most important
collections of prints and watercolours in north-west England.

Despite these magnificent gifts and many purchases in related areas, the
Whitworth Art Gallery, was soon in financial difficulties. As at the Lady Lever
Art Gallery, income from the original and very generous endowment failed to
keep up with inflation, and there was no grant from the City Council.
Eventually in 1958 Manchester University, which had developed rapidly just to
the north of the Gallery, took over the Gallery, and during the following ten
years largely rebuilt the interior. The collections, rich not only in prints and
watercolours but also in textiles, were of a specialist and scholarly nature
appropriate to the collections of a University which was planning to teach the
history of art on a considerable scale.

However, although neither the first Professor of the History of Art, who also
acted as Director of the Gallery, nor the first Keeper of the Gallery was a specialist

FIGURE 35

The Chapter House, Salisbury Cathedral
by J.M.W. Turner
(Whitworth Art Gallery, The University of Manchester)

in modern art, the Director decided to concentrate on the acquisition of contemporary British art, thus reverting to the policies followed by most of the galleries of north-west England in their early days but generally abandoned by the larger of them long before 1958. Many of these acquisitions were of exceptional importance. Francis Bacon's *Portrait of Lucian Freud* of 1951 was the first of a series of portraits by Bacon of Freud whom he knew well. The distortions here are not as extreme as in Bacon's later portraits, but already there is a strong sense of the irrational and the disturbing in this image of the rootless, drifting artist, with the bare room, the sinister shadows on the unfinished foreground and the arbitrary splashes of paint. The first abstract painting to enter the collection was Alan Davie's *Elephant's Eyeful* acquired in 1960. Peter Blake's *Got a Girl* (FIGURE 36) of 1960–61 is an early example of Pop Art. Along the top are magazine images of pop stars. The record stuck on to the top left-hand corner supplies the title of the work, which is taken from a pop song of 1960. The song relates the difficulties of a boy whose girlfriend is more interested in the pop stars than in him. Beneath is a design based on fairground decorations, another ingredient of popular culture. Eduardo Paolozzi was fascinated by machines and their components, and he then assembled them into suggestive forms. In *The Twin Towers of the Sfinx, State I*, the massive, squat, rectangular shapes seem to represent an anonymous bureaucracy stifling individual freedom.

There are also notable oil paintings by W.R. Sickert and the Camden Town group, as well as important pictures by Stanley Spencer and Paul Nash, but it is only for British modernist art of the 1960s that the Whitworth Art Gallery holds a reasonably comprehensive collection. It is particularly rich in Pop Art, of which it probably has the best holdings outside London. Most of the major artists of around that period are represented, notably Richard Hamilton, Patrick Caulfield, R.B. Kitaj, Patrick Procktor, Bridget Riley, Anthony Hill, David Hockney, Peter Lanyon, Henry Moore, Barbara Hepworth and many others. Acquisition of contemporary art has continued up to the present day with impressive results, but rising prices and declining budgets – despite help from appeals and from the short-lived Greater Manchester Council – have inevitably reduced the scale of later purchases.

Even after 1958 the British watercolour collection continued to expand, especially with the purchase of sketchbooks by J.R. Cozens and by Thomas Girtin. Their importance for the understanding of the career, style and methods of these artists makes them particularly appropriate for a University collection. In the same context the University's History of Art Department gave to the Gallery in 1960 its substantial collections of British drawings and of prints assembled primarily for teaching purposes.

Oldham Art Gallery and Museum

The Oldham Library, Museum and Art Gallery was built in 1882–83 under the provisions of a local Improvement Act of 1865 without reference to the series of Acts of Parliament in the later nineteenth century authorising local authorities to build museums and galleries. Its most vigorous supporter was Dr James Yates, Mayor in 1880–81 and Chairman of the Libraries, Art Gallery and Museum Committee from 1880 to 1883. He was the son of a wealthy cotton spinner but practised as a doctor with a strong commitment to the improvement of public health. He was also a member of the School Board and concerned with the cultural and educational advancement of Oldham. In politics he was a Liberal, in common with most supporters of public art galleries in Lancashire. He was strongly supported by Samuel Buckley, a self-made man and head of a local engineering works. Buckley succeeded Yates as Chairman of the Libraries, Art Gallery and Museum Committee and was three times Mayor of Oldham. They evidently made a formidable pair of campaigners as there was strong local opposition to the new Library, Museum and Art Gallery, and its eventual cost was £26,748 as against the original authorised estimate of £8,000, leading to its popular designation as 'Yates's Folly'. The architect was a local man, Thomas Mitchell. The structure is simple and unpretentious, at least by comparison with similar buildings at Bury or Blackburn. A park site was considered but rejected in favour of the town centre. The building was extended in 1894 at an additional cost of £8,640 from the designs of another local firm of architects, Winder and Taylor, providing the Art Gallery with a new large extra room and a total of six galleries on the top floor. For a town of Oldham's size this was generous and in 1910 the Art Gallery had over 70,000 visitors.

The art collections were developed with the same energy. There was an annual budget of £500 and from 1888 Spring Exhibitions of contemporary art for sale were held each year (with a few gaps) until 1935. From these exhibitions 136 works of art were bought for the permanent collection, providing an incentive for established London artists to exhibit in Oldham. The annual purchase grant from the Council of £500 was unusually high. Acquisition through local annual exhibitions was practised at large centres, notably Liverpool, and in towns with exceptionally spacious art galleries such

as Southport – and Oldham certainly fell into that category. The exhibition provided a focus and publicity for the process of acquisition and enabled Oldham people to make their own judgments on the quality of the selected painting by reference to the rest of each exhibition. Occasionally sections of the exhibition were devoted to the work of one artist or to a group of artists; for example, following the early death of William Stott of Oldham in 1900, the Spring Exhibition of 1902 contained a large display of his paintings.

Indeed, the success of local artists provided a stimulus for Oldham Art Gallery. One of its first acquisitions was Charles Potter's *A Winter's Tale*, presented in 1882 before the Gallery was even completed. Potter was a self-taught Oldham landscape artist who worked principally in North Wales. He was a friend of the first Curator of the Gallery and contributed numerous paintings to its Spring Exhibitions. *A Winter's Tale*, showing two dead sheep on a bleak snow-covered mountain, was in fact intended to represent the artist's struggles against great difficulties in his career and can scarcely itself have been an encouragement to any form of artistic activity. William Stott on the other hand was the son of a wealthy Oldham mill-owner and studied at Manchester and Paris. In Paris he was immediately successful, winning medals for two of his paintings at the 1882 Paris Salon. He was then painting carefully organised landscapes, delicate in tone and permeated by a pensive and poetic melancholy, but still within the naturalist tradition of the followers of Jules Bastien-Lepage. This stage of his career is sadly not well represented at Oldham but his later Symbolist period can certainly be admired there. Its most sensational example was his *Venus born of the Sea Foam* (FIGURE 37) of 1887, a circular painting in which sea and shore are reduced to abstract, rhythmic shapes but containing as Venus a nude female model, whom Whistler easily recognised as his mistress. In *Hollyhocks* of about 1890, figure and plant are almost fused together in a synthesis of fantasy and nature. His alpine scenes such as *Morning in the Alps – the White Mountain*, although based on direct personal experience of the mountain peaks, have a soft, luminous and visionary quality, very far removed from the naturalism of his youth.

Generally Oldham bought well and, within limits, progressively. H.H. La Thangue's *The Last Furrow* (FIGURE 38) is a rural counterpart of Herkomer's *Last Muster* at Port Sunlight (see p. 138). The old ploughman has reached the last furrow of his field, but collapses into it in order to die. It was indeed his last furrow. The statuesque ploughman, posed exactly parallel to the plane of the picture, has great formal beauty enhanced by the compressed foreground, sharply receding middle distance and high horizon, all characteristic of the English followers of Jules Bastien-Lepage. The painting, with its powerful combination of

FIGURE 37

Venus born of the Sea Foam
by William Stott
(Oldham Art Gallery, by courtesy of the Oldham Evening Chronicle)

FIGURE 38

The Last Furrow
by H.H. La Thangue
(Oldham Art Gallery)

Symbolism and realism, is probably La Thangue's masterpiece, carrying far more pathos than his better known, but more sentimental, *The Man with the Scythe* in the Tate Gallery of a year later. It was purchased in 1896 only a year after its completion for £315, not from the Oldham Spring Exhibition but from an exhibition in Bradford, demonstrating Oldham's willingness to look beyond the town for its acquisitions. Edward Stott's *The Ferry* of 1887, bought by Oldham in 1889 for £100, is another scene of peasant life but idyllic in mood and suffused with Stott's soft warm light. It must have been one of the first paintings by Stott to enter a public collection – and this was Stott of Rochdale, not Stott of Oldham. Equally enterprising was the purchase of William Rothenstein's *A Corner of the Talmud School* in 1908. This was one of a small group of paintings based on the Spitalfields Synagogue and employing those sharp and intense contrasts of light and shade used by Rembrandt in painting similar subjects. The artist wrote: 'What appeals to me is the devotion of the Jew. It is that that I have endeavoured to put on to canvas – the spirit of Israel that animates the worshippers, not the outward trappings of the ritual.' Henry Moore's *Westward*, bought in 1893 for £500, was a more conventional choice but the painting was apparently deeply admired by Ernest Meissonier, widely regarded as the greatest artist of his day, and it is technically a virtuoso study of light on water and of the splendid colour effects of sky, clouds and sea. Moore studied the formation and structure of waves and the appearance of foam and spray more closely than any other marine artist, while also conveying a strong sense of the immensity and loneliness of the oceans. Oldham did not only buy realist and naturalist art. Large sensational and sensual subjects from medieval, ancient or biblical history dominated the exhibition galleries of Paris and London in the late nineteenth century, and John Collier's *Cleopatra*, showing the dead queen and her dying maids under huge and sinister statues of her and of Mark Antony, is a magnificent and highly accomplished example.

In the twentieth century Oldham was more enterprising in its acquisitions than most of the other smaller galleries of the Manchester area. W.R. Sickert's *Barnet Fair* of 1930 was bought in 1936 for £130 and after the Second World War Oldham was one of the few public galleries to take advantage of the John Moores Liverpool Exhibitions in their best years, the early and mid-1960s. It bought, for example, notable paintings by Michael Sandle from the 1961 exhibition and by Terry Lee from the 1963 exhibition at a time when many Lancashire galleries were relying exclusively on the Contemporary Art Society for their modern acquisitions.

Oldham's collections were greatly enriched by Charles Lees. His grandfather and father established one of the largest businesses in Oldham, originally involved in the manufacture of machinery but later primarily concerned with

cotton. The family was Liberal in politics, Nonconformist in religion and immensely rich. Charles Lees left over £900,000 and his father over £800,000. He was educated privately in Paris and Hanover. In 1888 he gave to Oldham Art Gallery 80 of the finest examples from his large collection of over 300 British drawings and watercolours. It was a representative group including works by most of the major artists from J.R. Cozens and Paul Sandby to J.W. North and Adrian Stokes. Samuel Prout and John Constable were particularly well represented but there are also interesting works by artists less fashionable in the late-nineteenth-century, such as John Martin and Francis Danby. He also collected oil paintings and some of the best of these were presented to the Gallery long after his death by his daughter, Marjory – as was his Rossetti watercolour, *Horatio Discovering the Madness of Ophelia*, so rich in passionate love and emotional tension. Charles Lees himself was not active in public life but Marjory and her mother Sarah were major figures in Oldham politics as councillors, as pioneers of women's rights and as supporters of many schemes for social, educational, recreational and medical welfare. In 1952 Marjory presented to Oldham Fantin-Latour's *Roses*, probably bought by her father at one of the first of Oldham's Spring Exhibitions, *Phyllis* by George Clausen, a very early portrait much influenced by Whistler and apparently acquired by her father as early as 1881, and, above all, *Circe Offering the Cup to Ulysses* by J.W. Waterhouse, purchased by her father from the artist at the 1892 Oldham Spring Exhibition. The beautiful but malicious witch Circe has changed all the companions of Ulysses into swine by giving them a magic drink; one of them lies at her feet; she is now offering the same poisoned cup to Ulysses; he is able to resist its effects and compels her to change his companions back to men; he cannot of course resist her beauty and they become lovers. The theme is the power of love in the hands of a beautiful but remorseless woman, the 'femme fatale', as so often with D.G. Rossetti and his followers. Circe seated on her throne in her palace dominates the composition, but her power springs also from her irresistible body clearly seen through her transparent robes. Ulysses can just be seen advancing towards her in the mirror behind her; Waterhouse always delighted in the ambiguities of space and meaning provided by mirrors.

Oldham has other remarkable paintings. In 1895 one of Samuel Colman's huge apocalyptic melodramas, *Belshazzar's Feast*, was presented to it with an attribution to John Martin. At another extreme Joseph Southall's *Along the Shore*, a group of fashionable women walking along the beach, is an amazing combination of brightly coloured Edwardian period elegance of costume with frozen poses and intense expressions of mysterious power. Few other towns of Oldham's size have collections of such diversity and quality.

Lady Lever Art Gallery

The collections and building are, with a very few exceptions, the work of one man, William Hesketh Lever, the first Lord Leverhulme. He was born in 1851, the son of a prosperous Bolton wholesale grocer; he left school at the age of sixteen and joined the family firm which he considerably enlarged. In 1886 he started to manufacture soap, at first in Warrington and then on a new greenfield site at Port Sunlight. The factory was immediately successful, and he was soon exporting his soap, and soap products, as well as setting up factories, all over the world. He was personally more interested in marketing than in manufacture and in 1887 he started to buy from the Royal Academy rather sentimental, modern paintings of everyday life, generally including children, to reproduce as advertisements for his soap. W.P. Frith's *New Frock* is among the most accomplished, and most notorious, as the artist understandably objected strongly to the use of his painting as an advertisement with *SUNLIGHT SOAP, GOLD MEDAL PARIS 1889, So Clean* written in large letters over the background of the painting. Despite this rather unpropitious initiation into art patronage, Lever soon followed the example of many other later-nineteenth-century northern business leaders and began to acquire more important contemporary paintings by the leading artists of the day. His two favourite artists were Frederic Leighton and J.E. Millais, successively Presidents of the Royal Academy. *Fatidica* shows Leighton at his most Olympian with its references to Michelangelo's Sistine Chapel ceiling. Despite its source in Tennyson's *In Memoriam*, Millais's *Little Speedwell's Darling Blue*, acquired by Lever a year later in 1896, is, however, a less serious work still reflecting Lever's earlier interest in small and pretty girls. Lever continued to buy rather conservative and usually classical late Victorian and Edwardian masterpieces until his death in 1925. The greatest collection of this type was assembled by the Australian mining millionaire, George McCulloch. Lever spent over £20,000 in acquiring from it two of Leighton's greatest paintings, the *Daphnephoria* of 1874–76 and the *Garden of the Hesperides* of 1891–92, together with another four major late Victorian masterpieces. The Daphnephoria was an ancient Theban festival and here forms the subject of the most important of Leighton's three great processional paintings. The measured, forward rhythm of the composition, group by group, figure by

figure, elevated physically on a stage and tonally by the great grove of trees behind, with the two magnificent semi-nude central male figures forming a moment of pause, a break, a caesura in the steady and stately onward movement, constitute perhaps the most compelling Victorian evocation of the pagan and physical beauty of Greek life. *The Garden of the Hesperides* (FIGURE 39) also shows a moment of absolute classical harmony and perfection. The daughters of Hesperus, assisted by the dragon (or snake) Ladon, are guarding the golden apples given to them by Jupiter and Juno on their marriage. The sinuous, curving lines of the girls' bodies and arms, of the snake, of the tree and of the picture frame interlock to represent this classical harmony in visual form. The magnificent luxuriance of the garden and the sense of absolute repose and stillness in it contribute to the feeling of effortless and total completeness and perfection. Eventually Hercules will break in, kill the dragon and steal the apples but this only enhances the nostalgic sense of a golden age of languor and plenitude.

Classicism in the Lady Lever Art Gallery is not always at this exalted level. Fred Walker's *The Bathers* shows a Victorian painter of everyday life suddenly inspired by the Elgin Marbles to paint a group of boys undressing for a swim in the Thames in grand poses derived from classical sculpture. George Mason's *The Gander* is also an idealisation of a trivial incident but with more poetry and feeling than in Walker's heroic boys. Hubert von Herkomer's *The Last Muster* appears to be a random snapshot view of a small, oblique group of retired soldiers at a church service in Chelsea Hospital. In fact one of them has just died; for him it was the last muster, but he and the others retain their military discipline and bearing even confronted by death. Technically the painting is a masterpiece of perspective and of the arrangement of space, as well as a triumph in the rendering of a vast range of facial expression and physiognomy. Passion is an element lacking in these controlled and organised paintings, but it is certainly the essential element in two paintings by Edward Burne-Jones, of whose work Lever had a very large collection. In the *Beguiling of Merlin* (FIGURE 40) Nimue (or Vivien), having learnt the skills of enchantment from Merlin himself, is now bewitching the magician into a long sleep. Her expression of malice, power and love and his limp resignation directly reflect the artist's own tempestuous affair with the very emancipated Maria Zambaco, and the hawthorn tree behind also symbolises love. The *Tree of Forgiveness* has a similar theme with a classical rather than Arthurian setting. Demophoön failed to return the love of Phyllis. She killed herself and the gods turned her into an almond tree. The remorseful Demophoön embraced the tree which immediately burst into flower with Phyllis emerging from it back

The Garden of the Hesperides
by Frederic Leighton
(Board of Trustees of the National Museums & Galleries
on Merseyside, The Lady Lever Art Gallery)

FIGURE 40

FIGURE 41

into life. Again, the focus is on the passionate exchange between the two figures, with once more the woman dominant, her arms clasping the man as he seems to try to escape, yet turning back to her as his love for her overcomes his fear. A more mystic and poetic love is the subject of Rossetti's *Blessed Damozel*, who, in the artist's poem with the same title, looks down from heaven to her mortal lover yearning for him to join her.

Lever collected the realistic as well as the poetic Pre-Raphaelites, although it must be said that *Spring* by J.E. Millais does show that artist's occasional concern for symbolism. The girls and the apple blossom represent youth, promise and new life; only the scythe is a reminder of time and transience; the modern dress, the picnic accessories, and some coarseness of handling seem alien, however, to this intense allegory. More moving perhaps is Millais's rather later *Lingering Autumn*, where photographic realism and minimal human presence powerfully depict the bleakness and poetry of the end of the Scottish year. Holman Hunt's *The Scapegoat* (FIGURE 41) is, however, the most extraordinary mixture of realism and symbolism, or of 'Protestant truth with Catholic imagination'. The scapegoat, cast out into the wilderness and carrying with it there the sins of the people, is here represented as a forerunner or type of Christ, who performed the same function but of course on a transcendental

FIGURE 40

Beguiling of Merlin
by Edward Burne-Jones
(Board of Trustees of the National Museums
& Galleries on Merseyside, The Lady Lever Art Gallery)

FIGURE 41

The Scapegoat
by William Holman Hunt
(Board of Trustees of the National Museums
& Galleries on Merseyside, The Lady Lever Art Gallery)

scale. This rather abstruse symbolism is actually rendered in the painting as a goat sinking to its death in the salt and mud of the shores of the Dead Sea; both goat and landscape are painted with extreme realism and attention to detail thanks to sketches made on the spot by the artist during his visit to Palestine in 1854–55. The result is one of the most original and moving religious images of the nineteenth century. Hunt's *May Morning on Magdalen Tower* represents a Victorian reconstruction of the primitive, pagan worship of the sun devised by High Church Oxford Anglicans. The subject is more generally spiritual illumination, symbolised by the innocent young faces of the choirboys as the sun rises on them. Symbolism is also the principal element in Ford Madox Brown's *Cromwell on his Farm*. The future Lord Protector is riding around his farm, long before his rise to power. His oak sapling represents his future great career; he stares at the fire which burns away the dead wood of the past; wrapped up in his own thoughts, he is oblivious to the bustling, chaotic activity of the farm around him.

Lever was not, however, entirely preoccupied by Victorian art. Around 1896 he met James Orrock, who had begun his career as a dentist but had later turned to watercolour painting, dealing and collecting. Under Orrock's influence Lever followed the fashion for later-eighteenth-century British painting, by then well established by other collectors and dealers. The lucid, carefully constructed, Italian landscapes of Richard Wilson and the imposing portraits of Joshua Reynolds and of George Romney were the most remarkable results of this policy. For example, Reynolds's *Elizabeth Gunning, Duchess of Hamilton and Argyll* of 1760 is one of the first of his great portraits in the grand manner, rich in classical allusions. The doves and the low relief of the judgment of Paris relate the Duchess to Venus. Her dress, with her peeress's robes almost discarded, is of classical simplicity. She dominates her surroundings with effortless aristocratic ease and grace. The rather later *Mrs Peter Beckford* is even richer in more obvious references to ancient Rome and Greece as she makes a libation to the Greek goddess of health, Hygeia. The self-portrait by George Stubbs and his haymaking scenes, painted on Wedgwood ceramic plaques, probably relate primarily to Lever's passion for Wedgwood pottery, although they too have carefully posed statuesque figures based on classical examples, even in a rustic environment.

Lever started forming these magnificent collections for his various homes at Thornton Hough, near Port Sunlight, at Rivington, near Bolton, and in London, but many of his less valuable paintings, including some bought especially for the purpose, could be seen by 1911 in his pioneering folk museums at Hall i' th' Wood and Rivington Hall, near Bolton (see p. 37), and

in staff restaurants attached to the Port Sunlight factory. In 1911 Hulme Hall ceased to be the Port Sunlight female canteen and was opened permanently to the public as the Hulme Hall Art Gallery, containing a much more substantial part of his art collections. At about this time his soap-making firm, Lever Brothers, began to recover from the financial problems associated with the abortive soap trust of 1906, and he began to buy works of art again on a considerable scale. Above all, in 1913 he acquired a group of very large and grand Victorian paintings from the McCulloch collection which would not fit easily either in a private house or in a converted factory canteen. His architects, William and Segar Owen, had received instructions in 1911 to enlarge Hulme Hall for the collections within it, but this work was postponed and in 1913 they were asked to plan a new building to include a large art gallery, a public library and a Masonic lodge. The library and Masonic lodge receded in importance as the planning proceeded, and this building became the present Lady Lever Art Gallery. Lever's wife had died shortly after his decision to proceed with the new gallery, which was therefore dedicated to her, although she played no part in its formation or in the making of the collections. Having decided that a substantial part of his collections would be on permanent public display in a new art gallery of considerable size and quality, Lever widened his horizons as a collector to include paintings and sculpture plainly intended by their artists for public edification rather than for private gratification. Indeed, between 1913 and his death in 1925 he was probably buying British art on a more lavish scale than any publicly funded art gallery. He continued, however, to collect paintings for his own private pleasure and in the last year of his life he added a large modern picture gallery to his principal home, The Hill at Hampstead.

His commitment to the permanent public display of his art collections reflected a deeper concern for all aspects of the welfare of his employees. Lever Brothers, over which he had total control as his brother died young and had little interest in the company, was a pioneer in profit sharing, in the training, health and safety of its staff, in providing a shorter working week for them and, above all, in their housing. The Lady Lever Art Gallery dominates Port Sunlight Village, rather as a medieval church would have overshadowed its surrounding buildings. The Village was built by Lever to high standards of construction and design together with ample provision of community buildings and of open space as a model village, in order to demonstrate what a conscientious employer ought to do to improve the physical and hence also the moral environment in which his employees lived. Lever never saw the Village as an investment but as a gift to his workers. It was immensely influential on the improvement all over the world of working-class housing estates and, largely unaltered today, is one

of the most important architectural and social achievements of early-twentieth-century Europe. What the Village provided for the physical needs of his employees, and by example for people generally, the Gallery at its centre provided for their moral and spiritual welfare. 'The harmony in art and the beautiful,' he said, 'suggest silently and with extreme sensibility the ideal for conduct in our daily life. Art and the beautiful civilise and elevate because they enlighten and ennoble.' On another occasion he remarked: 'All the beauty of Venice, all the art of Venice, was the result of the foresight and energy of her merchants; it was not the result of an idle, wealthy class. If the merchants and manufacturers of Lancashire had done as the merchants of Venice did and introduced Art at the same time as they carried on their industries, I venture to say our industries would have benefited as well as our towns and cities.'

The Lady Lever Art Gallery was built between 1914 and 1922 entirely at Lever's expense in a restrained and scholarly classical style, providing a splendid and appropriate background for the works of art inside it. Building was, with art collecting, Lever's principal passion outside business and he always regretted that he had not been an architect. He therefore played a considerable part in planning the buildings as well as in the arrangement and display of his collections within it. His personality is indeed firmly stamped on all aspects of the Gallery. Many wealthy businessmen forming great collections with little leisure for the study of the history of art or for frequent visits to salesrooms relied heavily on expert advisers. With the notable exception of James Orrock, Lever generally only sought advice from his dealers and usually insisted on seeing and evaluating every object either directly or in the form of a photograph before acquiring it. For this reason the Gallery's collections lack perhaps the coherence and the uniformity in type and quality which expert opinion might have provided, but they do directly reflect Lever's own vision.

In one area of collecting, however, Lever probably did rely heavily on friends. He knew well two of the most eminent sculptors of his generation, Edward Onslow Ford and William Goscombe John, and for this reason the modern sculpture collections at the Gallery are less inclusive than the holdings of paintings and are strongly concentrated around the so-called 'New Sculpture' movement of about 1870–1920, in which Onslow Ford and Goscombe John played a major part. Most of Lever's magnificent Victorian and Edwardian paintings are works of an earlier generation. His sculpture was bought from artists of his own period. The 'New Sculpture' replaced classical stability and balance with a new freedom and variety of precarious and evocative poses, facilitated by the use of bronze rather than marble. Much more attention was devoted to surfaces, where smoothness and simplicity gave

way to vigorous and naturalistic textures, modelling and cutting. Above all a new and expressive poetry was demanded, with a much wider range of imaginative and meaningful subject matter in place of the old classical platitudes. The sculptures by Onslow Ford, Goscombe John, Francis Derwent Wood, William Reynolds-Stephens and F.W. Pomeroy illustrate these characteristics well enough, although perhaps the greatest sculpture commissioned by Lever is Goscombe John's Port Sunlight War Memorial which can be seen from the Gallery steps only a few hundred yards away.

In 1922 the Gallery was complete with the most advanced air conditioning and light control systems then available. Lever transferred to it over a half of his enormous collections, not only fine art but also some of the best collections of eighteenth-century English furniture and of Chinese seventeenth- and eighteenth-century porcelain ever assembled, together with a virtually comprehensive display of Wedgwood pottery, not to mention major collections of ancient sculpture, Greek vases, English embroideries, works of art associated with freemasonry, and ethnology, reflecting his company's role in the third world. Ownership of Gallery and works of art was given to trustees together with a large endowment, making them independent of both the company and of Lever and his family. With this endowment the trustees were able both to keep the Gallery open to the public and even to extend the collections on a small scale after Lever's death in 1925. Sadly inflation necessitated modest sales of works of art from the Gallery in the 1950s, including important Victorian and Edwardian paintings and works by P.P. Rubens, and in the 1970s responsibility for the Gallery and its collections was transferred first to the Merseyside County Council and later, reflecting their exceptional importance, to the National Museums & Galleries on Merseyside.

The Lady Lever Art Gallery is immensely rich in a wide variety of works of art quite outside its major categories, ranging from one of the grandest marble busts of the Italian Baroque to a large group of classical paintings by William Etty and an extensive series of watercolours by J.M.W. Turner and Peter De Wint. The architectural climax of its imaginatively organised room layout is, however, the main hall, and there, within a carefully articulated classical setting of columns, pilasters and entablatures opening out at each end into wider display spaces and overlooked by smaller galleries above offering yet more vistas onto its splendid contents, is the most concentrated and representative, as well as the most evocative and characteristic, display of high Victorian art in the country.

Harris Museum and Art Gallery

The huge classical Harris Library, Museum and Art Gallery, with its inscription over its great portico: 'TO LITERATURE ARTS AND SCIENCES' and, above it, Roscoe Mullins's sculptural group, *The Age of Pericles*, dominates the centre of Preston like a medieval cathedral. Cultural and intellectual, even perhaps spiritual, nourishment for the citizens of Preston now seemed to be the responsibility of the municipal museum and art gallery, not of the Church. In fact, however, Preston was slow to develop museums and art galleries. In 1878 the Council took over the museum in Cross Street, established in 1846 by the Preston Literary and Philosophical Institution, and opened it as a public museum in 1880. There was, however, no room there for art, and in 1883, when the Council received the Newsham bequest paintings, it placed them on public display under the south gallery of the Guildhall. By profession Newsham was a Preston solicitor. He had, however, married an heiress and inherited some £50,000 from his father who was active in banking and in cotton manufacture. He built churches and schools for the Church of England and lived at No. 1 Winckley Square, the best address in central Preston. He had been visiting the Royal Academy Summer Exhibitions each year since 1820 and collected British landscapes and scenes from everyday life, dating from the middle of the nineteenth century. In his taste for genre paintings, Newsham was following the tradition established by John Sheepshanks who presented his collection to the Victoria & Albert Museum in 1857. Like Sheepshanks, he was particularly attracted by C.R. Leslie's paintings and both men collected the small-scale historical and literary subjects painted by those artists, notably Leslie, W.P. Frith and C.W. Cope, better known for their genre paintings, which they also purchased. The high art of the later Romantics, of the Pre-Raphaelites or of the Classical Revival, with their large canvases and pretentious subjects, did not appeal to Newsham, thinking no doubt of his modest town house in Winckley Square. Even when Newsham did buy works by artists notable for grand historical paintings, such as William Etty, J.R. Herbert, Daniel Maclise and E.M. Ward, he preferred a domestic scale. E.M. Ward, for example, portrays *The Royal Family of France in the Prison of the Temple* as a family party. There are some exceptions. J.C. Hook is best known for his coastal scenes and seascapes, but Newsham apparently commissioned from him his early and very

uncharacteristic *Rescue of the Brides of Venice*, one of his few ambitious historical paintings of Italian subjects, inspired by the artist's stay in Italy in 1847–48 as the winner of a travelling scholarship from the Royal Academy. The brides are being saved from the clutches of pirates with grand gestures, heroic actions and dramatic poses. Similarly, the technique, but not the subject matter or sentiment, of *In the Bey's Garden* by J.F. Lewis does have some debt to the Pre-Raphaelites, and Newsham bequeathed to Preston one exceptionally fine watercolour by Holman Hunt, *Back of the Sphinx, Gizeh*. Generally, however, it was the comedy of social and domestic manners in any period or at any income level that appealed to Newsham. In Frith's *Scene from Le Bourgeois Gentilhomme* (FIGURE 42), the artist has marvellously contrasted the ridiculous and ingratiating bow of the clumsy Monsieur Jourdain with the aristocratic ease and contempt of his guests. In landscape Newsham was less successful. Unlike Sheepshanks he owned nothing by Constable and although he bought his landscape by Turner from the artist's favourite dealer, Thomas Griffith, it turned out to be an imitation or forgery. Newsham's favourite landscape painter was John Linnell, whose *Fallen Monarch of the Forest* is a good example of the heroic element and epic scale of his natural forms in the way that the figures are dwarfed by the colossal mass of the tree.

Newsham bequeathed his paintings to Preston largely because he knew that a public art gallery was about to be built there. E.R. Harris was a Preston solicitor like Newsham, but very much richer, partly because neither he nor his brothers had children and thus he inherited the entire family estate. On his death in 1877 he left over £300,000 to build and endow public buildings in Preston. Of this amount, his Trustees allocated over £100,000 to the new Harris Library, Museum and Art Gallery. He was a quiet retiring man with little taste for public life but had been a member of a committee formed in Preston in the 1850s to campaign for a public library. In 1880 the Preston Improvement Act gave the Council powers to acquire a site for the new building at a cost of £30,000, which would be erected using funds from Harris's Trustees, and to provide for its maintenance from the rates. The architect was James Hibbert, a member of the Council, who had played a large part in the campaign for a new library, museum and art gallery. He was Mayor of Preston in 1880–81 and had been commissioned by the Council to write a report on the establishment of the new institution. There was no architectural competition and the Council did not consider any designs apart from those submitted by Hibbert, who also edited the catalogue of the Newsham bequest paintings in 1884. Although Hibbert had worked in both Italianate and Gothic, the Harris Library, Museum and Art Gallery was severely Grecian in a style long abandoned elsewhere in England,

FIGURE 42

Scene from Le Bourgeois Gentilhomme
by W.P. Frith
(Harris Museum and Art Gallery, Preston)

Bird Scaring, March
by George Clausen
(Harris Museum and Art Gallery, Preston)

even for museums and galleries. Building began in 1882 but, due to problems over costs, the museum and art gallery did not open until 1896. There were copies of Assyrian reliefs and of the Parthenon and Bassae friezes, together with inspiring inscriptions from Pericles's funeral oration and from Byron's *Manfred*, while looking down from the sculpture in the pediment by Edwin Roscoe Mullins were Thucydides, Socrates, Pericles, Pindar, Phidias, Aeschylus, Sophocles, Euripides and others. Inside the building and beneath the friezes, large mural paintings were planned by the Council. Puvis de Chavannes and G.F. Watts were approached as soon as the building was open to the public but by then Puvis de Chavannes was seventy and Watts nearly eighty and both declined. In the end John Somerscales, younger brother of Thomas Somerscales, the marine artist, painted scenes from ancient Egyptian and Greek archaeology.

Despite this sad anticlimax art soon became the main feature of the Harris Museum and Art Gallery. In Hibbert's original plans fine art was only to occupy one of the three sides of the second floor, but by 1932 art (including some decorative art) occupied all seven galleries on that floor. Feeling perhaps that Newsham's generally small landscapes and domestic scenes did not entirely live up to the classical grandeur of the architecture, the Council started immediately to buy paintings and particularly sculpture of considerable quality and scale. In 1896, only a year after the opening of the Museum and Art Gallery, Preston bought George Clausen's *Bird Scaring: March* (FIGURE 43) of that year. It marked the artist's new concern for rapid movement and for powerful forms rather than for the doctrinaire naturalism of his earlier years spent under the direct influence of Jules Bastien-Lepage. In 1900 T.C. Gotch's *The Golden Dream* of 1893 was bought. This was one of the first paintings showing Gotch moving away, like Clausen, from simple rural naturalism, but in this case towards an imaginative symbolism, though still retaining an open-air format; it is said that he studied the subject from an apple tree especially gilded for the purpose. S.J. Solomon's *Allegory*, acquired by Preston in the same year, shows a joint triumph of Judaism and Christianity with Christ next to Moses. It is in fact a very modern rendering of the traditional medieval iconography of the relationship between the Old and New Testaments. In 1903 Preston bought *The Last of the Fair*, just painted by Alfred Munnings, then an unknown young artist of twenty-five. It is one of the best of the artist's early horse-fair paintings with the brilliant spontaneous brushwork of that period. The Council paid £150 for this picture but Alderman H. Woods of Preston only paid £25 for Munnings's *A Gala Day* of 1902, since the two men were friends and the sale was agreed after the consumption of much champagne at the Hodder Bridge Hotel north-east of Preston. It has the same technical accomplishment as *The Last of the Fair* and the same independence of

the prevailing influences of the period. Munnings was largely self-taught and spent very little time in London or Paris looking at the work of other artists. There are two other early paintings by Munnings at Preston, *Whitsuntide* and *The Inn Yard*, as well as the mature *The Full River* of 1932, making Preston one of the best galleries for admiring the work of this neglected artist. Harold Knight's *The Girl and the Letter*, bought in 1906, shows clearly his debt to the Newlyn School in his early years – an influence from which Munnings, even while at Newlyn, was largely free. In 1907 G.F. Watts's *The Genius of Greek Poetry* must have seemed an obvious acquisition for so Greek a museum. Edward Stott's *A Cottage Madonna*, bought in the same year, shows the artist's avowed assimilation of religious reference into his intense and intimate scenes of rural life.

Nearly every year until 1971 the Harris Museum and Art Gallery bought notable if rather conservative contemporary paintings from the Royal Academy exhibitions and it is one of the best public galleries for the study of that unfashionable aspect of British twentieth-century art. Occasionally there was a remarkable purchase; Stanley Spencer's *The Hill of Zion*, bought in 1950, is one of his finest visions of the Resurrection seen by him in the Port Glasgow Cemetery, but generally the standard was lower, particularly later in the century. Among gifts to the Museum and Art Gallery was Arthur Melville's *The White Piano*, a portrait of Miss Margerison of Preston. Although there is some debt to Whistler, the flat decorative composition and strongly coloured patterns seem much closer to the Symbolist followers of Gauguin in France. Melville and the Glasgow School generally had few known links with French Post-Impressionism, making this provincial life-size portrait of 1892 a remarkable and innovative achievement.

Perhaps even more remarkable were a series of some eighteen bronze statuettes by the leading artists of the so-called 'New Sculpture' bought by Preston between 1902 and 1907. The 'New Sculptors' introduced unstable and unusual poses, greater realism in textures and in crisp detail, together with a wide range of mythological and everyday subjects, all in pursuit of more poetry and more meaning in British sculpture, which, for the most part, adhered to the bland generalities of neoclassicism long after that movement was generally discredited elsewhere in Europe. The favoured material of the 'New Sculptors' was bronze, which offered both the flexibility required by the new daring poses and, thanks to the lost wax casting process, the sharp detail and variety of surface finishes demanded by their concern for naturalism. Bronze also made possible editions of small statuettes which suited the limited resources and space of middle-class homes. The purchase of this large group by the Harris Museum and Art Gallery must have encouraged visitors to buy their own

versions. Alfred Gilbert's *Comedy and Tragedy* shows a boy running with a mask of Comedy just as he is stung by a bee. The figure, with his long thin legs and slightly curved adolescent body, has all the elegance and refinement of Gilbert's early bronzes, together with his usual grace, poetry and wit. The complicated, twisting pose, which must be admired from different angles, reflects his study of Italian Mannerist bronzes of the sixteenth century. Preston bought the bronze directly from the sculptor in 1903 and it was one of his first works to enter a public collection. Between 1920 and 1922 the Harris Museum and Art Gallery bought another consignment of bronze statuettes, including a number by late-nineteenth-century French sculptors. The quality was not so high but only at Port Sunlight (see p.144) could sculpture of this type be seen elsewhere in British provincial public art galleries on such a large scale.

Few art galleries in Lancashire were interested in the historic art of the county. Around 1900–20 the Walker Art Gallery in Liverpool concentrated briefly on acquiring paintings by the distinguished local artists loosely associated with Pre-Raphaelitism and its curator, Rimbault Dibdin, wrote scholarly accounts of Liverpool art. The Williamson Art Gallery in Birkenhead followed a similar policy on a more modest scale. Preston, however, not Liverpool or Manchester, was the social centre of mid-eighteenth-century Lancashire, and Arthur Devis, who was born in Preston in 1711 and belonged to an influential Preston family, profited from his Lancashire connections in finding patronage for his portrait-painting practice in London. He specialised in the 'conversation piece' – that is, informal small-scale portraits in domestic interiors with the rather stiff figures grouped and posed in accordance both with the principles of polite behaviour and with a sense of easy familiarity. With the appointment of Sidney Pavière as Art Director and Curator in 1926, the Harris Museum and Art Gallery started to buy these portraits by Devis as well as landscapes by his half-brother Anthony. In 1950 Pavière published the first substantial book on the Devis family; he had begun his career assisting W.H. Lever to build up his superb collection at Port Sunlight, and he was one of the first scholar curators in the art galleries of north-west England. Thanks to his efforts eighteenth-century Lancashire art is represented at Preston – although it must be said that Devis left Preston nearly as early in his career as George Stubbs and John Deare left Liverpool.

The Harris Museum and Art Gallery has a distinguished collection of British watercolours particularly rich in the work of William Henry Hunt, whose meticulously detailed still life and genre paintings were particularly appreciated by Preston's two principal benefactors in this category, Richard Newsham and the Reverend John Park Haslam; Haslam belonged to a wealthy Preston family but lived and worked in the Lake District.

Rossendale Museum

Oak Hill, on the edge of Rawtenstall, was built in 1840 for George Hardman on a site overlooking his woollen mill at New Hall Hey. The style is severely neo-classical and the position is superb. In 1900 Richard Whitaker bought the house and the grounds around it in order to create a museum and public park for Rawtenstall. Whitaker was born in poverty at Rawtenstall in 1829; he was one of thirteen children and started work at six in the local mill. He rose to managerial positions in various cotton firms and finished his career as a director of an Accrington company manufacturing mill machinery. The museum opened in 1902 and relied for its collections on gifts from local manufacturers. Auguste Bonheur's *The Ford* was presented by Mrs E.A. Parker in memory of her husband Joseph Hiram Parker, a shoe manufacturer. A woman is gently driving sheep and cattle; the fall of the sunlight through the trees and onto the animals is conceived and handled with poetic sensitivity; all the details are treated with a careful and fluent naturalism but the result is a rural idyll of peace and contentment. Thomas Creswick's *Devil's Bridge on the St Gothard Pass*, on the other hand is an exercise in the sublime. Dark mountains tower over a violent torrent with a destroyed bridge in the foreground; nature is seen as a destructive force in a hostile environment; there is no room for man. Yet this too was a gift from, the wife of a Rawtenstall businessman, Mrs Rowland Rawlinson, whose husband owned a local mill. She also gave Marshall Claxton's sensational and spectacular *The Lifeboat*, a great and dramatic conflict between the forces of nature and human survival. The most remarkable exhibit at Rawtenstall relating to natural violence and struggle is in fact a specimen of natural history, although also a work of art of the Romantic movement. It is a stuffed tiger being crushed to death by an enormous python; the wretched tiger opens its great jaws wide in agony as it dies. This ultra-realist sculpture was part of William Bullock's Museum in London between about 1813 and 1819 and appears as a wood engraving in the 1814 catalogue of Bullock's Museum and as a painting by the French artist A.I. Leroy de Barde. It is an animal sculpture by A.L. Barye brought to life. A more conventional sculpture is the *Infant Bacchus* by B.E. Spence of Liverpool. He sits cross-legged quietly contemplating his grapes, an excellent classical antidote to the *Tiger and Python*. Mr and Mrs H.H. Ratcliffe of Rawtenstall presented the *Infant Bacchus*. The *Tiger and Python* was de-accessioned by the Castle Museum in Norwich in 1930, no doubt in the interests of zoological and political correctness.

Rochdale Art Gallery

Despite building one of the greatest town halls in England, Rochdale was slow to establish a museum or art gallery. In 1898, however, a clause permitting the Town Council to levy an extra rate of one penny in the pound to enlarge its library and to set up and maintain a museum and art gallery was inserted in an Act of Parliament primarily concerned to authorise the Council to acquire the local trams. A new building next to the library was designed by Jesse Horsfall, erected at a cost of £6,533 and opened on 3 April 1903 with a special inaugural exhibition of contemporary paintings; it was extended in 1912–13. There are low reliefs on the exterior representing science, art and literature designed by C.J. Allen of Liverpool and executed by J.J. Millson of Manchester at the expense of three individual members of the council. Following the usual pattern, the ground floor was occupied by the Museum and the grander and more spacious upper floor by the Art Gallery, giving art more space and prestige than museum displays.

Generous gifts and bequests of paintings also contributed to the importance of the art collections. James Ogden had retired from his family firm in the Rochdale furniture manufacture and upholstery trades as early as 1867 and devoted himself to foreign travel, visiting every European capital except Bucharest, but always staying in the cheapest hotels available. As a result in 1900 he was able to endow the new Art Gallery with a capital sum of £4,378; the interest had to be spent on pictures. A plaque in the entrance hall reads:

> IN THE FIRST YEAR OF THE TWENTIETH CENTURY A SUM OF MONEY WAS GIVEN BY A BURGESS OF THIS BOROUGH TO THE CORPORATION OF HIS NATIVE TOWN FOR HIS LOVE OF ART AND TO ENCOURAGE THE APPRECIATION OF ART FOR ART'S SAKE, NOT ONLY AS A MEANS OF ELEVATING AND REFINING THE PUBLIC TASTE, BUT AS A SOURCE OF PLEASURE AND INSTRUCTION TOO OFTEN NEGLECTED IN A MANUFACTURING TOWN.

The first painting acquired with Ogden's money was Edward Stott's *There was No Room in the Inn*, which was bought in 1911 four years after Ogden's death.

The strong contrasts of light and shade together with the sense of mystery around the very simple but indistinct forms show an interest in expression and symbolism characteristic of the period, but also a very real debt to Rembrandt's biblical subjects. Stott was born in Rochdale where his father had been a mayor, but the Council tried to repudiate the purchase on the grounds that £500 was too large a sum to be spent on any work of art. Throughout Britain local authority art gallery committees always had to fear the overturning of their decisions by their councils. Fortunately on this occasion it could be shown that Ogden's will gave the decision on purchase to the Committee rather than to the full Council, and Stott's masterpiece was acquired. Rochdale continued to buy fine paintings with the Ogden bequest. Augustus John's best portraits represent his family and friends, particularly fellow artists. Eve Kirk (FIGURE 44) had studied at the Slade School from 1919 to 1922 but it was John's support and friendship that encouraged her to take up landscape and decorative painting seriously in the late 1920s. John's portrait of her has the directness and simplicity of his earlier work together with his marvellous command of line and rhythm – and of character. Rochdale bought it in 1945 when events far away from the Gallery must have preoccupied most of its staff.

The other major benefactor of Rochdale Art Gallery was Robert Taylor Heape. His family had long been active in the manufacture of flannel at Rochdale and he was of course Liberal in politics and Unitarian in religion, although he played no part in public life. Like Ogden he travelled abroad extensively, even reaching the most northern point of Europe with the British Astronomical Society in 1896 to see an eclipse of the sun. Between 1901 and 1913 he gave nearly one hundred paintings and sculptures to the Gallery, mostly by mid- and late-Victorian artists of the second rank but including works by J.W. Waterhouse, Frederick Goodall, David Roberts, C.W. Cope, E.A. Waterlow and T.S. Cooper. It was these paintings that necessitated the extension to the Gallery in 1912–13, just as it was probably the prospect of receiving the Heape collection as a gift that encouraged the Rochdale Council Art Gallery Committee to build the Gallery in 1898–1903. Waterhouse's *In the Peristyle* contrasts the solemnity of the great classical columns with the everyday activity of a girl feeding pigeons, rather in the manner of Alma-Tadema. E.A. Waterlow's *Mending the Nets, Newlyn* offers a warm, bright and middle-class view of the Cornish fishing village which was generally portrayed in the greyer and more realistic images of the Newlyn School. By contrast the misery and bleakness of rural life are the theme of *The End of her Journey* by Alice Havers. A working-class woman has died by the side of the road. Three other women of rather higher social class and posed with some sense of

FIGURE 44

Portrait of Eve Kirk
by Augustus John
(Rochdale Art Gallery)

classical grandeur look on and tend her. Even the children are statuesque. The painting combines the theme of the procession or progress of life with social realism. Arthur Hacker's *By the Waters of Babylon* is another rather more controlled and static image of female grief with both a classical setting and classical restraint.

In 1921 James Edgar Handley, a Rochdale grocer, died, leaving the residue of his estate, about £3,300, to the Art Gallery Committee for the purchase of pictures (none to exceed £250 in price). With both Ogden's and Handley's modest bequests the Committee were able to make some notable acquisitions over the following fifty years, concentrating on works by Edward Stott. Stott left Rochdale as a young man, studying in Paris and ultimately settling in Amberley, a village in Sussex. Only his very late works have religious subjects but his intensely worked surfaces, his soft, evocative evening light and his simple, expressive figures within an idyllic rural setting convey a sense of the sacred, transcending the everyday routine of country life. Each composition evolved from sequences of carefully studied drawings and sketches, of which the Gallery has a considerable selection, and Stott is an artist of the considered and refined statement, not of the spontaneous impulse. Although often compared to J.F. Millet in feeling he is closer to Samuel Palmer. Vision was always more important to him than description.

In 1974 following the reorganisation of local government the paintings presented by Thomas Kay to the Heywood Technical School were transferred to Rochdale Art Gallery. Kay was born in Heywood in 1841 and made his fortune from the development and manufacture of patent medicine. He had a keen interest in pharmaceutical research and experiment, and he played a large part in the creation of technical schools in Heywood and in Stockport, where he spent most of his life. He was also involved in the formation of literary, musical and scientific societies and was a friend of the artist William Stott of Oldham. His collection of Old Master paintings had a direct educational purpose – to show 'the progress of painting and the decorative arts from an early period'; in the same spirit he noted that 'visible objects teach more than speech does, for what the eye can see reason believes'. It was therefore natural for him to give his collection in 1912 to the Heywood Technical School within which he established an art gallery to display it. He wrote a catalogue of his collection, which also contains an essay on the history of painting and details on the conservation of works of art, reflecting his interest in chemistry. Like the other Rochdale collectors he was a great traveller, enabling him both to collect European art and to write papers on architecture and geography. It was perhaps his scientific background and wide intellectual and artistic interests,

together with his commitment to education, that encouraged him to collect entirely outside contemporary British art, the normal field favoured by other manufacturers and merchants in late-nineteenth-century northern England. His most remarkable painting was *The Crucifixion* by Giovanni di Paolo, a fifteenth-century Sienese artist – although he believed it to date from 1300. At the foot of the cross the grieving figure of St John stands alone, while on the other side the Virgin is being comforted by the three Maries. At the extreme right a group of Jews argue among themselves. Characterisation and expression are powerful even if the artist's style is still dominated by his Sienese predecessors of the fourteenth century and shows little movement towards naturalism.

Norton Priory Museum

In 1115 an Augustinian priory was founded at Runcorn by the second Baron of Halton, William fitz Nigel, and nineteen years later the monks moved to Norton, probably in an ascetic search for greater seclusion. The most famous prior was Richard Wyche, who revived the priory's fortunes and in 1391 secured its elevation to the status of an abbey, headed by an abbot with the rank of a bishop. The huge sandstone *St Christopher Carrying the Infant Christ* was probably carved at Chester or in the immediate neighbourhood for Norton Priory to celebrate this achievement. St Christopher was an important late medieval saint as the patron saint of travellers who had once carried Christ on his back across a river, and the fishes at the base of this statue indicate that he is indeed wading across a river. There was an important river crossing over the Mersey at Runcorn Gap, lending a local significance to the statue. It was said that whoever saw his image would not die suddenly during the day; this, together with the saint's legendary size, may explain the large size of his statues which, placed outside buildings or at gates, could be seen many miles away.

Very few medieval statues of this type survive in Britain due to the Protestant iconoclasts in the sixteenth and seventeenth centuries, and indeed the head of Christ was destroyed probably at that time; it has been replaced by a seventeenth-century restoration. Otherwise, however, the statue is in good condition and the carving remains crisp and sharp. It is one of the most important free-standing late medieval statues produced in England. The sophisticated twisting pose and realistic detail indicate a sculptor of ability and ingenuity.

Norton Priory was dissolved in 1536 by the Commissioners of Henry VIII and nine years later it was bought by the Brooke family, who built a new house on the site and remained there until the 1920s, when all the buildings, except the twelfth-century undercroft of the Priory, were demolished. The Brooke family, however, had admired *St Christopher* and had made him a feature of their new house. After they abandoned the house the statue was presented to Liverpool Museum around 1965, where it was on display for some years. Thanks to the Runcorn Development Corporation, archaeological work began on the site and the Norton Priory Museum Trust was founded in 1975 as a charity to preserve, restore and display the buildings and the site. A museum was opened in 1982, and an extension to it was completed in 1999 to house the St Christopher statue on long-term loan from the National Museums & Galleries on Merseyside.

Salford Museum and Art Gallery

Joseph Brotherton, the Radical Member of Parliament for Salford, was closely associated with William Ewart in the passing of the Museums Act of 1845 which permitted Councils of boroughs with a population of at least 10,000 to establish and maintain 'Museums of Art and Science'. Warrington (see p. 180) had used the Act to create a Public Museum and Library in 1848, arguing that libraries were essential parts of museums, although free admission to the Museum and Library was only available on three days in each week. In the following year Brotherton persuaded E.R. Langworthy, the Mayor of Salford, to follow Warrington's example, and the very progressive and reformist Liberal Salford Council converted the Lark Hill Mansion of about 1795 in Peel Park, which they had acquired in 1845–46, into their Museum and Library. It opened to the public in January 1850. Unlike the Warrington Museum it was open without charge on every weekday for twelve hours. Warrington had only to take into municipal ownership an existing private library and natural history society; Salford had to create its Public Library and Museum from nothing. The Council's General Purposes Committee in its report to the Council of 13 June 1849 summed up the principles and ideals of all the local authority museums and art galleries which were to open throughout Lancashire and Cheshire over the following seventy years:

> Your Committee feel a sanguine hope that the proposed establishment of a Public Library and Museum, vested in and under the direction of the Council, and wholly devoted to the free use of the public, may be in future well sustained and enlarged by donations of books, maps, works of art, natural history specimens, &c., which many persons may feel a pleasure in presenting to a public institution that guarantees the public in the free use and benefit of such presentations.
>
> If such expectations be, as your Committee believe they are, well founded, the proposed Public Library and Museum may be the germ of an extensive, valuable, and highly useful collection, that may offer to future generations a source of instruction and pleasure, tending to enlarge their enjoyments by elevating their tastes and advancing their mental improvement.

A year later Brotherton used his experience at Salford to assist with the drafting of the Public Libraries Act which became law in August 1850.

Peel Park, and the Lark Hill Mansion within it, had been purchased by Salford Council through public subscription in 1845–46 for £13,000 as a public park for its inhabitants. The Salford Museum and Library was therefore not only one of the first public museums to be established by a British local authority but it was also a very early example of a museum in parkland rather than in a town centre. Art rapidly invaded the park, with five statues by Matthew Noble of Sir Robert Peel (1852), Queen Victoria (1857), Joseph Brotherton (1858), Prince Albert (1864) and Richard Cobden (1867). In 1853 a new north wing was added to the original Mansion, with its upper floor devoted to the Museum and Art Gallery, and in 1857 a corresponding south wing was built thanks to public subscriptions amounting to over £7,500, of which Langworthy contributed no less than £5,300. The architects for the new north and south wings were Travis and Mangnall. The paintings were lit by sloping roof lights along the sides and at one end. Cast iron was extensively used in the roof areas and the design was taken from Lord Northwick's famous picture gallery in Thirlestaine House at Cheltenham 'with such improvements as the skill of the architects suggested'. Langworthy bequeathed at his death in 1874 a further £10,000 towards the erection of the Langworthy wing designed by Henry Lord. It connected the north and south wings and contained on its upper floor a huge gallery measuring 35 by 110 feet for the display of paintings and sculpture.

Langworthy himself was born in London in 1797, the son of a prosperous merchant from Somerset. For twelve years he was the representative in Central and South America of C. Taylor & Sons, a London firm, but in 1837 he joined his brother George in Salford where they established a new company, Langworthy Brothers, to manufacture a wide variety of cotton products. He was immensely successful and at his death in 1874 left well over a million pounds. He was a magistrate and briefly Member of Parliament for Salford. He gave large sums not only to the Museum and Art Gallery, but also to Manchester Grammar School and to the future University of Manchester. He was for many years Chairman of the Salford Museums and Library Committee and undoubtedly the principal force behind both the establishment and the growth of the Salford Museum and Art Gallery.

The Langworthy Wing was opened in 1878, giving Salford by that early date a total of over 10,000 square feet for the display of its museum and art gallery collections with over half of this space devoted to fine art; around 1900 the natural history collections were moved out of the Peel Park buildings leaving

even more space for art. Certainly in the 1850s no other British local authority museum and art gallery could compete with Salford's. Even by 1878 Manchester had no public museum or art gallery and the Birmingham 'Corporation Art Gallery' was only a room of about 2,1000 square feet in the public library containing for the most part works of art on loan to the City Council. Liverpool, with its William Brown Library and Museum of 1857–60 and its Walker Art Gallery of 1874–77, was of course by then well ahead, but behind these two buildings were the two men generally regarded as among the wealthiest outside London. The construction of the present Salford Museum and Art Gallery was completed in 1938 by the erection of a new wing to replace the old Lark Hill Mansion which by then was deemed structurally unsound. A modern design was contemplated but in the end the City Engineer, W.A. Walker, provided a slightly simplified replica of the Langworthy Wing built 60 years earlier.

Money from the Langworthy bequest left over after the completion of the new wing was spent on ten paintings and two sculptures. The most remarkable were two works by the historical painter E.M. Ward, who had been commissioned in 1849 to paint eight scenes in the Commons Corridor of the new Palace of Westminster in London, 'illustrative of that great contest which commenced with the meeting of the Long Parliament and terminated in 1689'. These two paintings were intended to hang there but problems with reflections and visibility in the Corridor led to the adoption of fresco rather than oil paint on canvas. They were therefore returned to the artist and ultimately bought by Salford while Ward painted replicas in fresco in the Palace. Ward's paintings were an essential element in the great decorative scheme for the Houses of Parliament as it was the outcome of 'that great contest' which gave Parliament its power and status in the nineteenth century, and eminent historians, most notably the Whig T.B. Macaulay, were asked to advise Ward. It was intended 'to do justice to the heroic virtues which were displayed on both sides' and, despite the strong Parliamentary bias of both Ward and Macaulay, the *Execution of the Marquis of Montrose* (FIGURE 45) is dominated by the great Royalist hero who, in the course of a brilliant campaign in 1644–45, nearly re-conquered Scotland for Charles I with a small army of Irishmen and Highlanders. The executioner is tying around his neck a book describing his great campaign and a Puritan Covenanter displays his incriminating manifesto in support of Charles I, but Montrose only shows his usual courage, arrogance and flamboyance. Argyll on the other hand was a Protestant hero in the struggle against the Catholic James II; he was executed in 1685 for his part in the rebellion aimed at deposing James II in favour of Monmouth. In Ward's painting, *The Last Sleep of Argyll*, he is

FIGURE 45

Execution of the Marquis of Montrose
by E.M. Ward
(City of Salford Museums and Art Gallery)

sleeping soundly on the night before his execution, to the surprise of a visiting clergyman whose own conscience is disturbed by his compliance with James II's despotic regime. These two paintings became well known to every child in England through their reproduction in history textbooks, but they also had a more immediate importance in the founding of the National Portrait Gallery; their use of authentic and original images of the two heroes illustrated the need for a new portrait gallery to preserve images of great men who lived and died for their beliefs.

Paintings and sculptures were rapidly acquired by purchase and gift and the Salford Royal Museum and Art Gallery's *Official Catalogue of the Fine Arts Section* of 1909 lists 385 items. The range was very wide, with Old Master paintings, many portraits, works by local artists as well as by major Victorian painters, statues, busts, plaster casts, but with the usual bias in favour of nineteenth-century art. Agnew's were by far the most successful picture dealers in late Victorian England and the firm originated in Manchester. Thomas Agnew strongly supported the formation of the Salford Museum and Library in 1849 and was a member of the Committee controlling it for over twenty years. He was Mayor of Salford in 1851 when Queen Victoria visited Peel Park and his son William Agnew represented South East Lancashire in Parliament for many years. Both gave generously to local charities generally, and in particular presented paintings and engravings to the Salford Museum and Art Gallery. Thomas gave 36 paintings as early as 1868 and more followed later. Ungenerous critics have suggested that the Agnew family gave to Salford paintings which they discovered to be unsaleable in their gallery, but E.W. Cooke's *Bay of Tangier, Morocco* is a splendid and dramatic view with the artist's usual interest in the details of local boat construction, while J.R. Herbert's *Meeting of the Council of the Anti-Corn Law League in Newall's Buildings, Manchester, 1847,* presented by Thomas Agnew, represents the enormous political importance of this great popular movement based in Manchester. The great cotton manufacturer Benjamin Armitage, who was another Liberal Member of Parliament for the Manchester area alongside William Agnew in the 1880s, presented *The Genius of Lancashire,* a marble statue by Percival Ball showing the Genius beating (or more exactly bending) her sword into a ploughshare so that 'nation shall not lift up sword against nation'. Ball was one of the pioneers of the 'New Sculpture' (see p. 144), but the real importance of this poetic female nude lies in the subject, which was so rich in the Liberal Manchester ideology of free trade, pacifism and international cooperation.

The Manchester engineering company, Mather and Platt, gave a version of G.F. Watts's *The Meeting of Jacob and Esau* in which the two Old Testament

FIGURE 46

A Street Scene: St Simon's Church
by L.S. Lowry
(The Lowry, Salford)

brothers are reconciled after bitter conflicts and jealousies. The contrasting characters of the two men and the emotion of their reunion are rendered with a grand and heroic simplicity, leading Rowland Alston to describe the composition as 'one of the artist's greatest pictures'. J.C. Dollman was one of a group of Victorian animal artists who, following Landseer's example, experimented with Symbolist and allegorical paintings. His *Famine* of 1904 shows a tall, emaciated figure advancing through a ravaged land pursued by hungry wolves and sinister ravens, all lit by a cold and cheerless moon. The effect is sensational rather than profound but it well reflects late Victorian pessimism and is a useful corrective to the general view of late Victorian and Edwardian art as cosy, genial and complacent. The painting was presented by James Gresham of Ashton upon Mersey, one of the most important Manchester collectors of late-nineteenth-century British art.

In 1948 Salford purchased George Clausen's *In the Orchard* of 1881. This was his most important early work and of exceptional importance in showing the naturalist influence in Britain of Jules Bastien-Lepage as early as 1881. The high horizon, very rapid but clearly marked out recession into death, the contrast between the delicate foreground technique and more summary treatment of more distant elements, the pensive mood and the unusual viewpoint were all features of the style that was to dominate British rustic naturalist painting for the following twenty years.

SALFORD

The Lowry

..

Salford is now, however, best known for its large and comprehensive collection of works by L.S. Lowry. Acquisition began in 1936 with *A Street Scene: St Simon's Church* (FIGURE 46) and continued up to the artist's death and beyond with generous gifts from him as well as purchases. In 1941 there was an exhibition of his work at Salford Art Gallery. By then Lowry was already 53 and had a local but scarcely a national reputation. Manchester, Stockport, Southport and Oldham had bought paintings by him in the 1930s, but his first London exhibition, at the Lefevre Gallery, only took place in 1939.

His individual style, often mistaken as naïve or primitive and characterised by sharp outlines, few shadows and small, dark, busy figures silhouetted

against the grim, inhuman settings of the Manchester area, sets him apart from all the artistic movements of mid-twentieth-century Britain. This, and his full-time employment as a rent collector until he reached retirement age, has encouraged much criticism. However, Lowry did have a long and extensive art training, albeit part-time, was aware of artistic movements and was both dedicated and obsessive. The apparent simplicity of his compositions masks considerable sophistication and organisation.

Salford's choice of Lowry in 1941 was merely an extension of the gallery's policy of presenting work of both national and local importance through permanent and temporary displays. However, the subsequent and continuing collecting of the artist's work, together with the dedication of a Lowry Gallery in 1958, then a unique tribute to a living British artist, demonstrated a firm belief in his merit. Only time will prove whether this commitment was justified but Lowry is, despite his critics, firmly on the national stage.

While Salford continued to collect and exhibit art of national and international importance there was a growing realisation that the Victorian dream of 'bringing the world to Salford' could not and should not be sustained, particularly with the close proximity of Manchester City Art Gallery and the Whitworth Art Gallery. Thus Salford has specialised in collecting works by L.S. Lowry. This may be seen as a narrow single-minded pursuit of one artist working quite outside the general stylistic tendencies of his time or as an extremely rare example of a major collection of an artist's work in his own local area.

Salford's large collection of paintings by Lowry is now being displayed in a series of exhibitions, each concentrating on one aspect of his work, at the Lowry, a new arts centre on Salford Quays built by Salford City Council with much help from the National Lottery between 1997 and 2000 at a cost of about £60 million. The architects were James Stirling (until his death in 1992) and Michael Wilford. In the tradition of the Barbican Arts Centre in London the Lowry contains provision for drama, opera, ballet and music, not to mention shops, bars, a café and a restaurant, as well as space for the visual arts. Indeed, although the City Council always wanted Lowry's paintings to be a 'principal element' in the scheme, the space now allocated to them is relatively small and extends to less than half the art gallery area. Nonetheless the provision of sympathetic loan exhibitions of the work of other artists in the rest of the area and the presence of the performing arts all around will greatly enhance the popularity of the Lowry collection. In the past British provincial art galleries were generally associated with libraries and museums; opera and drama are of course much more glamorous.

Atkinson Art Gallery

The ratepayers of Southport decided to provide the town with a public library in 1875 when the Mayor boasted that 'no other watering place' had yet opened a public library. At first it was proposed to rent a building in order to minimise the cost to the ratepayers, but in May William Atkinson offered £6,000 to erect a new building, which would have space for both a library and an art gallery. Atkinson was born in Yorkshire but made his fortune as a cotton manufacturer in Manchester. He retired from business in the 1840s, and in 1862 he moved to Southport where he hoped that the sea air would improve his wife's poor health. The railways allowed many prosperous Lancashire businessmen to live in Southport. He helped with the building of churches and hospitals there and it was his philanthropic instinct, rather than any interest in art, that induced him to provide not only the first £6,000 towards the cost of the new library and art gallery, but also a further £7,500 when building costs escalated during construction. Eventually the Gallery, designed by Waddington and Son of Burnley, had five spacious rooms for the display of works of art, to which three more were added in 1926. The style is classical but treated very freely. The pediment has figures representing Art, Science, Literature and Commerce surrounding the central figure of Inspiration. There are low reliefs on the façade with Homer to represent Poetry, Aeschylus to represent Drama, Thucydides to represent History, Apelles to represent Painting, Phidias to represent Sculpture and Ictinus to represent Architecture. The sculptor was G.W. Seale of Cold Harbour Lane in London who had completed a similar set of panels on Blackburn Library, Museum and Art Gallery a few years earlier; appropriately at Southport, however, there was much less emphasis on trade and industry.

The Atkinson Art Gallery opened in 1878 with a loan exhibition contributed largely by local collectors. Over 1,000 works of art were included and the display spread into the Library as well as the Art Gallery. All Southport citizens thought likely to own any pictures had been circularised. A Miss Ball of Queen's Road, Southport, had lent to the exhibition and in 1879 the Art Gallery received her entire collection of 39 paintings and watercolours as a bequest. They were mainly mid-Victorian landscapes and scenes from everyday life by competent rather than highly gifted artists and must have been typical of the contents of many of the large houses then being erected in

Southport. In 1879 the Atkinson Art Gallery held the first of its Spring Exhibitions, which continued each year until 1966, although the title was changed in later years to the Exhibition of Modern Art. These exhibitions attracted artists from London and elsewhere, all hoping for sales in a town with a large population of wealthy Lancashire manufacturers. The Art Gallery usually selected its acquisitions from the paintings exhibited there, offering a further inducement to artists to exhibit in Southport.

One of Southport's first acquisitions was *The Belle of the Village* by Alice Havers, a surprising choice. One of a group of rural washerwomen has attracted the attention of some men idly watching them pass; the other women are disapproving. The classical dress and sculptural form of the *Belle* make the painting more than an amusing record of rural life and much closer to high art even in its treatment of female sexuality, which is certainly also the theme of John Collier's *In the Venusberg*, bought by Southport in 1902. The medieval knight Tannhauser has been seduced by the sensual life of the Venusberg, and the artist has visualised Wagner's epic as a Florentine palace with Tannhauser bewitched by Venus and her attendant, both nudes of classical perfection. Other early acquisitions included Arthur Hacker's sentimental *The Children's Prayer*, but landscapes were more popular and among the best was William Llewellyn's *Padstow, Cornwall – Evening* of 1890. It has the solid and descriptive, but also lively, paintwork characteristic of an artist then working in the tradition of British Impressionism and of the New English Art Club. More specifically from the Newlyn School is *Finery* by Leghe Suthers, a Southport artist. The sharp perspective, empty foreground and strong side light are Newlyn features, as is the contrast between the working-class cottage and the fine clothes. This was a gift, not a purchase. Similarly Frank Brangwyn's *The Slave Market* (FIGURE 47) of 1893 was presented by J.H. Johnson in 1895. This was one of his first paintings to have bright discordant colours and sharp contrasts of light and shade, rather than the grey tones of his earlier seascapes. Critics complained of 'barbaric splendours' and 'the colours of stained-glass windows' replacing the 'unity and simplicity' of his earlier work.

Among the more remarkable later purchases was W.R. Sickert's *Theatre of the Young Artists, Dieppe*, an early work still relying on Whistler's subdued grey tones. Around 1922 the owner of Southport's principal newspaper, W.H. Stephenson, had bought this painting from a Manchester dealer, C.A. Jackson, who was introducing Sickert's art to Lancashire. Stephenson went to see Sickert, then leading an impoverished and reclusive bohemian life in London, and eventually arranged for Sickert to write art criticism for his newspaper, the *Southport Visiter*, and to lecture in Southport. Meanwhile Stephenson had sold

FIGURE 47

The Slave Market
by Frank Brangwyn
(Reproduced by kind permission of Sefton MBC Leisure Services
Department, Arts and Cultural Services, Atkinson Art Gallery, Southport)

FIGURE 48

The Wedding Breakfast
by F.D. Hardy
(Reproduced by kind permission of Sefton MBC Leisure Services
Department, Arts and Cultural Services, Atkinson Art Gallery, Southport)

his *Theatre of the Young Artists, Dieppe* to the Atkinson Art Gallery for £80 in 1923. In the following year he bought Sickert's much more important *L'Armoire à Glace* from the artist; he sold this painting to the Tate Gallery in 1941. During one of Sickert's visits to Southport Stephenson took him to the home of a very important modernist Lancashire collector, Frank Hindley Smith (see p. 38), where the artist found a forged drawing signed *Sickert*. Hindley Smith left most of his collection to galleries in London, Bolton, Oxford and Cambridge but he did give a group of about 40 paintings and watercolours to Southport in 1923, including Sickert's *Sinn Feiners*, a major Symbolist painting by William Stott entitled *The Faerie Wood*, landscapes by British Impressionist painters, including Mark Fisher and James Charles, as well as – to demonstrate the catholicity of his taste – the touching and affectionate *Misses Gurney* by G.F. Watts. Stephenson was a member of Southport Council's Libraries and Arts Committee and Hindley Smith was a consultative member.

In 1929 John Henry Bell bequeathed nearly 200 pictures. There were many notable watercolours and the oil paintings greatly extended the range of mid-nineteenth-century British painters of genre and landscape already represented in the collection thanks to Miss Ball's bequest fifty years earlier. F.D. Hardy's *The Wedding Breakfast* (FIGURE 48) of 1871 is one of his largest and most ambitious paintings but still possesses his dispassionate observation, unsentimental approach, sympathetic characterisation and simple charm in grouping and colour – even if this wedding party is higher in the social scale than the family interiors painted by Hardy and the Cranbrook Colony in the 1850s.

Bell's bequest and other gifts encouraged the Atkinson Art Gallery to collect British watercolours and drawings seriously and, although works by the most celebrated artists are rare, the collection is remarkably wide ranging, particularly for the early twentieth century. Historic British art in oil was a low priority for acquisition apart from two major early works by T.S. Cooper bought in 1949. The romantic and picturesque life of the adventurous and self-sufficient Scottish cattle farmers who drove their animals south to the rich English markets had first been painted by Edwin Landseer under the influence of Walter Scott's detailed and glamorous accounts of Scottish peasant life. T.S. Cooper visited Cumberland in 1835 and his *A Halt on the Fells, Cumberland* of 1838 won the prize offered annually by the Liverpool Academy for the best painting at its exhibition. It was bought by a Liverpool coal mine proprietor, Richard Benson Blundell Hollinshead Blundell of Deysbrook, for £200. In his catalogue notes on the painting Cooper described

the scene as an 'Anglo-Berghem party', indicating the extent to which his style, crisp in detail but atmospheric in his distances, was indebted to Nicolaes Berchem and to seventeenth-century Dutch art. Hollinshead Blundell was so pleased with Cooper's painting that he commissioned him to paint his own favourite bull called Charley with a cow and calves as *A Group of Short-horns*. Much of Cooper's later animal painting is hard and mechanical but these two paintings show a command of grouping and of anatomy worthy of Stubbs. Their acquisition by Hollinshead Blundell encouraged other patrons in the Liverpool area to buy paintings from Cooper and greatly enlarged his reputation in the region. Southport owns another fine highland droving painting, Richard Ansdell's *The Drover's Halt* of 1846, which is also rich in domestic and family incident and detail. In fact by this period droving was in sharp decline but the pictorial possibilities of this image of primitive rural life still attracted both artists and patrons.

Acquisitions in the 1920s and 1930s concentrated on fashionable artists with those technical skills in handling, colour and composition which ensured their success at the Royal Academy exhibitions, notably Augustus John, D.Y. Cameron, Alfred Munnings, Walter Russell and William Orpen; this tradition carried on during and after the Second World War with the purchase of flamboyant, extrovert and emphatically representational paintings by Gerald Brockhurst, Laura Knight, Ambrose McEvoy, Frank Brangwyn and Gerald Kelly. Modernism came quite suddenly to Southport. Gerald Kelly's *Spanish Girl* was bought for £100 in 1958; in 1962 Sheila Fell's bleak and sober *Winter, Cumberland II* with its rough and massive simplified forms cost Southport £150 and works by other young progressive artists including Edward Middleditch, Michael Ayrton and Robin Philipson were also purchased in the same year.

Astley Cheetham Art Gallery

The Cheethams were long-established Stalybridge cotton spinners. In the early nineteenth century their mill was known popularly as the Bastille, but with John Frederick Cheetham at the end of the century they acquired a reputation for public work and philanthropy. The family were Congregationalist in religion and Liberal in politics. J.F. Cheetham was for some years a Liberal Member of Parliament for Stalybridge. He was educated at London University where he studied Classics and travelled extensively, particularly to India and the Himalayas. His father was also fond of foreign travel, especially in Italy and Switzerland, and he must have had some interest in art as he was a member of the General Council of the great Exhibition of Art Treasures held in Manchester in 1857. It is possible but unlikely that Cheetham's father, rather than Cheetham himself, collected some of the paintings later given by Cheetham to Stalybridge. The family money had been consistently enhanced by good marriages: J.F. Cheetham's father married the daughter of a mill-owner from Ashton-under-Lyne and he married the daughter of Francis Dukinfield Palmer-Astley, who owned extensive estates noted for their mineral wealth at Dukinfield not far from Stalybridge. His fortune therefore represented old money, as that term was understood in industrial Lancashire and Cheshire, and this may be reflected in his taste for Old Master paintings. His father-in-law and brother-in-law had given generously to the Dukinfield Public Library established as early as 1833, and their example may have induced J.F. Cheetham to build a new public library for Stalybridge which was opened by his wife in 1897. The architect was J. Medland Taylor, well known for his many churches in the Manchester area and for a highly original Gothic style, although his sources at Stalybridge are Jacobean rather than medieval. There was a large and high first-floor lecture room with open beams and it was this room that became an art gallery in 1932 when most of J.F. Cheetham's collection of paintings were placed in the Public Library which he had built. He had bequeathed them to Stalybridge many years earlier, but had allowed his sister, Agnes, to retain them during her lifetime. A part of his collection had been sold in 1923 following the death of his wife, and these paintings were similar to those which later went to Stalybridge; there were Italian early Renaissance devotional paintings attributed to Bernardino Luini and Masaccio as well as two works by G.F. Watts.

FIGURE 49

Virgin and Child Enthroned with Angels and Saints
by the Master of the Straus Madonna

(Astley Cheetham Art Gallery, Stalybridge)

The two most remarkable paintings given by Cheetham to Stalybridge were originally attributed to Cimabue and to Giotto; they are thus much earlier and more 'primitive' than the rather picturesque, charming and lively fifteenth- and early-sixteenth-century paintings which were so popular in late Victorian Britain, particularly with the patrons of the Pre-Raphaelites. *The Virgin and Child with Two Adoring Angels* is now attributed not to Cimabue but to Jacopo di Cione, a brother of Andrea Orcagna. In its total rejection of any sense of three-dimensional space it is similar to paintings of the period of Cimabue, but it was probably the elaborate background patterning and Jacopo's soft decorative colours and style that appealed to Cheetham. *The Virgin and Child Enthroned with Angels and Saints* (FIGURE 49), now thought to be the work of the Master of the Straus Madonna rather than that of Giotto, also has the total rejection of space and volume characteristic of the International Gothic style; although it was probably painted thirty years later than the *Virgin and Child with Two Adoring Angels* it shares with it a love of rich patterns, highly decorated surfaces and soft, clear colours. The saints on the left are James the Great (of Compostella) and John the Baptist, while on the right are Julian the Hospitaller and Dorothy. At the feet of the Virgin is Eve holding a miniature Tree of Knowledge; the Virgin is the new Eve who redeemed the original sin of Adam and Eve. The artist is named after a *Virgin and Child* formerly owned by Percy Straus and now in the Museum of Fine Art at Houston. There is yet another painting of around 1400 at Stalybridge, a Triptych with the *Virgin and Child Enthroned and Saints Paul, Peter, Catherine and Anthony Abbott* in the central panel, the *Annunciation* and *Crucifixion* on the right shutter and the *Angel Gabriel with Saints John the Baptist, Lucy and Onuphrius* on the left shutter. This is by an unidentified Florentine artist of the last quarter of the fourteenth century and has the same decorative emphasis as the other two panels, particularly in the rich foliage tooling of the backdrop. Very few of the Lancashire and Cheshire manufacturers collected early Italian art; it is possible that Cheetham knew of the similar collection formed by the Reverend Walter Davenport Bromley at Capesthorne some forty years earlier. Both men lived in East Cheshire, although the Davenports had been landowners there for many centuries while Cheetham's wealth derived from his great-grandfather who arrived in Stalybridge around 1760 from the Isle of Man with a pioneering carding machine.

Cheetham also collected contemporary art, particularly the paintings of G.F. Watts. *Sir Percival* was probably painted around 1869 and it shows the knight seeking the Holy Grail. His sad expression and downward gaze may reflect his human failings by comparison with the purity of Sir Galahad, as

related in Tennyson's *Idylls of the King*. He inhabits, however, the same distant and mystical medieval world as the stiff and static saints in their frozen poses against the golden backgrounds of Cheetham's early Italian altarpieces – a world immensely attractive to the late Victorian imagination, even among the cotton manufacturers of industrial north Cheshire.

Stockport War Memorial and Art Gallery

On 20 September 1858 Vernon Park was officially opened for the recreation of the citizens of Stockport. In his speech at the civic banquet, James Kershaw, the Liberal Member of Parliament for Stockport, announced that he and John Benjamin Smith, the other Member of Parliament for Stockport and also a Liberal, would build at their own expense a public museum in the Park. Stockport Council was respectful but rather unenthusiastic, preferring a town-centre site for a museum, but Smith and Kershaw built their museum at a cost of £1,000 and in 1860 handed it over to the Council. The lower floor was to be a museum and the upper floor an art gallery. An appeal was made for gifts of specimens and of works of art. Smith recollected in 1861 that during his visit to Rome in 1841–42 he had stayed at the Palazzo Brancadori; there the Marquis of Brancadori offered to sell him his entire collection of some seventy pictures, which indeed Smith bought; he hung six of them in his house and put the remaining 65 into a warehouse. They had ambitious attributions to Poussin, Murillo, Velazquez, Reni and other famous Old Masters; he now offered these 65 paintings to the Museum as a loan and they were the first exhibits at the new Museum. On his death the loan became a gift but sadly the paintings proved to be of very small importance or value. In 1865–66 a new wing was erected to house Stockport's first public library and the curator, after the defeat of an earlier proposal to accommodate him in the cellars. Important paintings and sculpture did not, however, come by gift or purchase to the Vernon Park Museum, which concentrated primarily on natural history and antiquities. Its fine art collections were eventually transferred to Bramall Hall which opened as a public museum in 1936.

Stockport made a fresh start with art gallery provision in 1919 when the Council decided to erect an art gallery in the centre of Stockport, containing within it a Hall of Memory as a memorial to the men of Stockport killed in the First World War. The entire cost, £24,000, was raised by public subscription and the War Memorial and Art Gallery opened in 1925. Within the Hall of Memory was placed a marble group by Gilbert Ledward symbolising 'the ideal of the sacrifice and the devotion of the 2200 men of Stockport who fell in the war'. It consists of a large Britannia holding a sword and a laurel wreath and in front of her a kneeling nude man on a rather smaller scale than Britannia –

kneeling to signify that he represents the fallen but looking up at Britannia to represent his ideals. A serpent is crushed beneath his feet and his sacrifice is demonstrated by a broken sword. The style is as austerely neoclassical as the building itself.

Gifts and purchases of paintings and sculpture were plainly expected but very few works of any importance were acquired. There are some interesting but relatively unimportant Victorian pictures by artists of the calibre of P.R. Morris, Frederick Goodall and John Phillip, together with two paintings by L.S. Lowry and some Contemporary Art Society purchases, but the collection is rather disappointing and the Gallery is understandably largely devoted to temporary loan exhibitions. Stockport was simply too late. By 1925 Lancashire and Cheshire were in economic decline. Major private collections of Victorian and Edwardian art, formed in earlier and more prosperous years, were still to be found in the area but confidence in the quality of works of art of that period had been eroded by modernist art critics. The Vernon Park Museum had been too small and too remote to attract substantial gifts. The War Memorial and Art Gallery was too late. Stockport is the only major industrial and commercial centre in north-west England without a notable public art collection.

Warrington Museum and Art Gallery

Warrington has a distinguished intellectual, academic and cultural history. Between 1757 and 1786 the Warrington Academy provided a university education for Nonconformist students generally superior to the courses then available at Oxford and Cambridge. In 1838 the Warrington Natural History Society was founded and, two years later, it played a large part in organising an extensive exhibition in the Town Hall of 'paintings and works of art, models of machinery and manufacturers, philosophical apparatus, specimens of natural history and objects of curiosity and interest'. Included in the exhibition were paintings attributed to Velazquez, Rubens, Reynolds and Landseer, as well as three 'Hindoo Idols', a lock of Sir Walter Scott's hair and a model of a railway post office. In 1848 the Warrington Museum and Library was established by the Town Council, which itself had been founded only a year earlier under Warrington's Charter of Incorporation. William Beamont, Warrington's first mayor and the author of many scholarly volumes on local history, was probably largely responsible. It was one of the earliest municipal museums in Britain and had at the outset a department of 'Art and Science' with an honorary curator for fine art. Admission was free for considerable periods; the governing committee included local experts who were not members of the Town Council; private funding was secured for the acquisition of objects and books. Thus it was at Warrington in 1848 that the three essential ingredients of any successful municipal museum or art gallery were first established. Indeed Warrington's new municipal library and museum were particularly commended by the 1849 Parliamentary Select Committee on public libraries and in 1855–57 a new building was erected for the Museum at a cost of £2,867. The Museum was dominated by natural history and archaeology, and the role of art was largely confined to the School of Art on the top floor. The presence of art throughout the Museum was, however, dramatically felt when the floor of the art school began to sag under the weight of its plaster casts. The supporting beams were rapidly reinforced.

In 1875–77 an art gallery costing £2,345 was built at the back of the Museum principally to house John Warrington Wood's life-size marble group *St Michael Overcoming Satan*, which had been commissioned in 1871–72 by a group of Warrington citizens who had subscribed £1,000 for the purpose. Wood had been

born in Warrington and by the 1870s, while living and working in Rome, had achieved considerable fame in his native town, particularly among the wealthy brewing families of the Greenalls and the Walkers. At Rome he followed in the conservative tradition established by the Liverpool sculptors there, John Gibson and B.E. Spence, remaining loyal to strict neoclassical principles, then very much in retreat throughout Europe. Like Gibson and Spence he largely relied on provincial patronage which continued to favour an unfashionable style. *St Michael Overcoming Satan* was appreciated locally for its religious message. A local critic wrote: 'The sermon in this marble on the misuse and degradation allied to the brutalising passions, and on the ennobling dignity of strength sanctified by alliance with noble and Godlike purpose, is most eloquently preached'. Pictures in the new Art Gallery were largely confined to copies of Old Master paintings by another local artist, Thomas Robson, presented by his brother.

The School of Art meanwhile was proving enormously successful under a dynamic headmaster, J. Christmas Thompson. In 1861, for example, its students gained more scholarships and awards than those of any other British art school, apart from Birmingham which had six times as many students. Thompson's most celebrated student was Luke Fildes, who was at Warrington School of Art from 1860 to 1863, but Henry Woods also studied under him between 1857 and 1865, and Warrington Wood was there from about 1858 until 1863. In 1884 the School of Art moved out of the Museum and Art Gallery buildings to new premises, where standards declined due to financial difficulties, and Thompson resigned in 1889. Local art galleries often developed from successful academies of art, particularly on the continent, and Thompson's famous school in the Warrington Museum must have encouraged the formation there of an art gallery. It is therefore appropriate that Warrington Wood, Fildes and Woods are well represented in the Warrington Museum and Art Gallery of today.

As well as Warrington Wood's *St Michael Overcoming Satan*, there is also his very early *Rachel*, commissioned by Gilbert Greenall in 1868. She is shown as a shepherdess at the moment when she first meets Jacob, her future husband. The long, plain, repeated folds of her drapery and her simple, linear profile are even closer to the neoclassicism of Gibson and Spence than the later *St Michael*. Fildes's first important painting *Fair, Quiet and Sweet Rest* of 1871–72 is also there. Like so many Victorian artists Fildes began his career as an illustrator and this painting developed from an illustration in the periodical *Once a Week*. Henry Woods, whom Fildes had met at Warrington Art School, was the model for the young man lounging in the bows of the boat and the models for the two women were his two sisters, Annie and Fanny (whom

FIGURE 50

On a Sussex Farm
by James Charles
(Warrington Museum and Art Gallery)

Fildes married three years later). The fanciful period costume and romantic dreamy mood make the painting an ideal illustration to Tennyson's *Lotus Eaters*, even if the loose, uncertain technique and enormous swan suggest the work of a beginner. The painting was, however, bought by a well-known dealer, McLean, for £600 before it was even exhibited at the Royal Academy – a remarkable achievement for a young unknown artist. Fildes became best known for his very different Social Realist work of the later 1870s and for his later female portraits. He was also one of an international group of artists to specialise in painting the everyday life of characteristic Venetian types and the *Daughter of the Lagoons* at Warrington is an example.

His brother-in-law, Henry Woods, belonged to the same group and spent much of his life in Venice painting gondoliers, priests, fishermen, market girls, laundresses, choirboys and many other typical contemporary Venetian figures. His setting is the streets, canals and squares of Venice, always in the open air and generally in strong sunlight. The mood is happy and contented. The great historic architecture and sculpture of Venice only appears as a witty contrast to the very trivial and casual activities of its late-nineteenth-century inhabitants. The *Venetian Water Seller* of 1902 is the best of these paintings at Warrington, but there are others as well.

The fourth of Warrington's great artists was James Charles. He was some five or ten years younger than the other three; he did not study at Warrington and by the time he had completed his studies at the Royal Academy Schools in the 1870s, the Parisian art schools had become fashionable for postgraduate study by British art students. Before he went to Paris in 1881, however, he painted *Our Poor*. Workhouse scenes expressing a strong element of social protest were painted in the 1870s by Luke Fildes and the other British Social Realists of the period, including Hubert Herkomer, but Charles's painting is objective, serene, even complacent with the figures carefully, almost classically, arranged in rows leading into space and the table and chairs exactly parallel to the plane of the painting. In Paris he was a friend of Wilson Steer and he gradually developed towards the end of the century into the British Impressionist closest in particular to Sisley with small, sunny, idyllic landscapes casually composed and loosely executed in the open air in Sussex (FIGURE 50), often filled with children playing. Degas admired his work and this last phase of his short life is well represented at Warrington.

After the Second World War the Warrington Museum and Art Gallery, following the example of Bolton and other galleries in the area, concentrated on acquiring early-nineteenth-century British watercolours with the help of a local industrialist and collector, J.H. Booth.

The History Shop

Wigan's art collections have been largely assembled by gift and bequest rather than by purchase and it has never had a public art gallery as such. Its paintings are now displayed in its former Public Library, a fine building designed by Alfred Waterhouse and opened in 1878. The Library, which cost £12,000, was built at the expense of Thomas Taylor, a Wigan cotton spinner and manufacturer. He was Mayor of Wigan in 1854–55 but soon moved to Aston Rowant in Oxfordshire where his private art gallery was open to the public on Wednesdays. Sadly he did not leave his large collection of Victorian paintings to Wigan, but, by a strange coincidence, Wigan's most important painting *Simpletons* is an early work of Luke Fildes who was Taylor's favourite artist. Taylor owned Fildes's famous and grim Social Realist *Applicants for Admission to a Casual Ward*, completed in 1874 but begun in 1872, and *Simpletons* was painted at exactly the same time. In mood, however, it could not be more different. Instead of a row of huddled and wretched poor families in a gloomy London street there are two young lovers in fanciful rococo dress flirting in a boat moored on a secluded river – such boating scenes were a favourite Victorian reference to sexual licence. She dips her hand into the water just as she is experimenting with the unknown sensation of her lover's advances – and we can see that she has no wedding ring. *Simpletons* is very much in the tradition of Fildes's *Fair, Quiet and Sweet Rest* at Warrington Art Gallery (see p. 181), and it sold just as readily, enabling the artist to concentrate on his much less marketable paintings of the poor and the oppressed. *Simpletons* was part of the collection of the Leigh solicitor, T.R. Dootson, and was bequeathed to Wigan with the rest of his collection by his widow in 1955.

By contrast Alice Havers's *Michaelmas Geese* conveys well the solemnity, dignity and simplicity of rural country life. It was perhaps an appropriate gift from the National Association of Medical Herbalists, who held a successful conference in Wigan in 1926 thanks to the efforts of one of their most enthusiastic Wigan members, Councillor Ramsden, who owned the painting.

The most interesting group of paintings at Wigan consists of three large and important classical works by William Blake Richmond which languished in the stores of various municipal collections until Wigan bravely took responsibility for them in 1953. The best is the *Lament of Ariadne* of 1871–72,

showing the distraught wife of Theseus on the island of Naxos just after he had abandoned her there. Her feeling of grief is conveyed not only by gesture, by facial expression and by pose, but even by her billowing draperies, and Richmond's classical restraint only heightens the pathos of the scene. This painting, together with Richmond's *Release of Prometheus* and *Diana in Pursuit of Actaeon*, still await conservation but will eventually form a remarkable display.

A recent purchase is Edward Haytley's *Sir Roger and Lady Bradshaig*, depicting in the background their home, the Elizabethan Haig Hall, situated on the edge of Wigan. The mid-eighteenth-century elegance of the portrait and the rural delights of the grounds well reflect the prosperity of Wigan and of its richer citizens in that period and contrast sharply with the nineteenth-century image of Wigan as a bleak and gloomy product of the Industrial Revolution. Haytley was probably from around Preston, and his style is similar to that of Arthur Devis, another native of that area. He painted flowers, landscapes and life-size portraits as well as conversation pieces such as this group.

Practical Information

Opening times and other details should be checked before visiting. Days closed over Christmas, the New Year and Easter are not given. Admission charges, which are constantly changing, are not listed. Unless otherwise stated, the railway station specified is within about a mile of the art gallery in question.

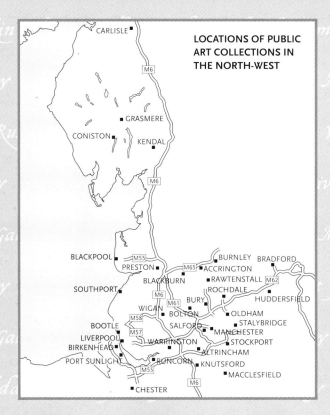

LOCATIONS OF PUBLIC ART COLLECTIONS IN THE NORTH-WEST

CARLISLE

M6

GRASMERE

CONISTON

KENDAL

M6

BLACKPOOL M55
PRESTON M65 BURNLEY BRADFORD
BLACKBURN ACCRINGTON
SOUTHPORT M6 RAWTENSTALL M62
ROCHDALE HUDDERSFIELD
WIGAN M61 BURY
M58 BOLTON OLDHAM
BOOTLE M57 SALFORD STALYBRIDGE
LIVERPOOL MANCHESTER
BIRKENHEAD WARRINGTON STOCKPORT
PORT SUNLIGHT ALTRINCHAM
RUNCORN KNUTSFORD
M55 MACCLESFIELD
CHESTER M6

ACCRINGTON
Haworth Art Gallery, Manchester Road, Accrington, Lancashire, BB5 2JS
(01254 233782), Wed–Fri 2–5, Sat–Sun 12.30–5, Bank Holidays 2–5.
Accrington Station, about 1 1/2 miles.

ALTRINCHAM
Dunham Massey, Altrincham, Cheshire, WA14 4SJ (01619 411025),
Sat–Wed 12–5 (summer months). Altrincham Station, about 3 miles.

BIRKENHEAD
Williamson Art Gallery and Museum, Slatey Road, Birkenhead,
Merseyside, CH43 4UE (0151 652 4177), Tues–Sun 1–5.
Birkenhead Central Station.

BLACKBURN
Blackburn Museum and Art Gallery, Museum Street, Blackburn,
Lancashire, BB1 7AJ (01254 667130), Tues–Fri 12–4.45, Sat 9.45–4.45.
Blackburn Station.

BLACKPOOL
Grundy Art Gallery, Queen Street, Blackpool, Lancashire, FY1 1PX
(01253 478170), Mon–Sat 10–5 (closed on Bank Holidays). Blackpool Station.

BOLTON
Bolton Museum and Art Gallery, Le Mans Crescent, Bolton,
Greater Manchester, BL1 1SE (01204 332190), Mon–Sat 10–5 (closed on Bank
Holidays). Bolton Station.

BURNLEY
Towneley Hall Art Gallery and Museums, Burnley, Lancashire, BB11 3RQ
(01282 424213), Mon–Fri 10–5, Sun 12–5. Burnley Station, about 2 miles.

BURY
Bury Art Gallery and Museum, Moss Street, Bury, Greater Manchester,
BL9 0DR (0161 253 5878), Tues–Sat 10–5. Bury Station.

CARLISLE
Tullie House Museum and Art Gallery, Castle Street, Carlisle, Cumbria, CA3 8TP (01228 534781), Mon–Sat 10–5, Sun 12–5 (winter months closes at 4 daily). Carlisle Station.

CHESTER
Grosvenor Museum, 27 Grosvenor Street, Chester, Cheshire, CH1 2DD (01244 402008), Mon–Sat 10.30–5, Sun 2–5. Chester Station.

CONISTON
Brantwood, Coniston, Cumbria, LA21 8AD (015394 41396), daily 11–5.30 (summer months), Wed–Sun 11–4.30 (winter months). Windermere Station or Ulverston Station, about 14 miles.

Ruskin Museum, Coniston, Cumbria, LA21 8DU (015394 41164), daily 10–5.30 (summer months) Wed–Sun 10.30–3.30 (winter months). Windermere Station, about 14 miles or Ulverston Station, about 16 miles.

GRASMERE
The Wordsworth Museum, Town End, Grasmere, Cumbria, LA22 9SH (015394 35544/35547), daily 9.30–5.30 (closed in January). Windermere Station, about 8 miles.

KENDAL
Abbot Hall Art Gallery, Abbot Hall, Kendal, Cumbria, LA9 5AL (01539 722464), daily 10.30–5 (summer months), 10.30–4 (winter months; closed January). Kendal Station (or Oxenholme Station, about 2 1/4 miles by bus service).

KNUTSFORD
Tabley House, Knutsford, Cheshire, WA16 0HB (01565 750151), Thurs–Sun and Bank Holidays 2–5 (April–October inclusive). Knutsford Station, about 2 1/2 miles.

Tatton Park, Knutsford, Cheshire, WA16 6QN (01625 534400), daily 11–4. Knutsford Station, about 2 1/2 miles.

LANCASTER
City Museum, Market Square, Lancaster, Lancashire, LA1 1HT (01524 64637), Mon–Sat 10–5. Lancaster Station.

The Ruskin Library, Lancaster University, Lancaster, Lancashire, LA1 4YH (01524 593587), Mon–Sat 11–4, Sun 1–4. Lancaster Station, about 5 miles by bus service.

LIVERPOOL
Walker Art Gallery, William Brown Street, Liverpool, Merseyside, L3 8EL (0151 478 4199), Mon–Sat 10–5, Sun 12–5. Lime Street Station.

Sudley House, Mossley Hill Road, Liverpool, L18 8BX (0151 724 3245), Mon–Sat 10–5, Sun 12–5. Mossley Hill Station.

Tate Liverpool, Albert Dock, Liverpool, Merseyside, L3 4BB (0151 709 0507), Tues–Sun 10–5.50. James Street Station.

University of Liverpool Art Gallery, 3 Abercromby Square, Liverpool, Merseyside, L69 3BX (0151 794 2347/8), Mon–Fri 12–4 (closed in August and on Bank Holidays). Lime Street Station.

The Oratory, Upper Duke Street, Liverpool, Merseyside (0151 478 4199), Sat 2–4.30 (summer months). Central Station.

MACCLESFIELD
West Park Museum, Prestbury Road, Macclesfield, SK10 3BJ (01625 619831/ 613210), Tues–Sun 1.30–4.30 (open on Bank Holidays). Macclesfield Station.

MANCHESTER
Manchester City Art Gallery, Mosley Street, Manchester, M2 3JL (0161 234 1456), re–opening 2001. Oxford Road or Piccadilly Stations.

MANCHESTER
Whitworth Art Gallery, Oxford Road, Manchester, MI5 6ER
(0161 275 7450), Mon–Sat 10–5, Sun 2–5. Oxford Road Station, about 1 1/4
miles by frequent bus service.

OLDHAM
Oldham Art Gallery, Union Street, Oldham, Greater Manchester, OL1 1DN
(0161 911 4657), Tues–Sat 10–5. Oldham Station.

PORT SUNLIGHT
Lady Lever Art Gallery, Port Sunlight Village, Bebington, Merseyside,
L62 5EQ (0151 478 4136), Mon–Sat 10–5, Sun 12–5. Bebington Station.

PRESTON
Harris Museum and Art Gallery, Market Square, Preston, Lancashire,
PR1 2PP (01772 258248), Mon–Sat 10–5 (closed on Bank Holidays).
Preston Station.

RAWTENSTALL
Rossendale Museum, Whitaker Park, Rawtenstall, Lancashire, BB4 6RE
(01706 217777), Mon–Fri 1–5, Sat 10–5, Sun 12–5 (summer months),
Mon–Fri 1–5, Sat 10–4, Sun 12–4 (winter months). Rawtenstall Station
(irregular service) or Bury Station about 8 miles by bus service.

ROCHDALE
Rochdale Art Gallery, Esplanade, Rochdale, Greater Manchester, OL16 1AQ
(01706 342154), Tues–Sat 10–4.30. Rochdale Station.

RUNCORN
Norton Priory Museum, Tudor Road, Runcorn, Cheshire, WA7 1SX
(01928 569895), Mon–Fri 12–5, Sat–Sun 12–6 (summer months),
daily 12–4 (winter months). Runcorn East Station, about 1 1/2 miles.

SALFORD
Salford Museum and Art Gallery, Peel Park, The Crescent, Salford, Greater Manchester, M5 4WU (0161 736 2649), Mon–Fri 10–4.45, Sat–Sun 1–5. Salford Crescent Station.

The Lowry, Salford Quays, Salford, Greater Manchester, M5 9JQ (0161 876 2000 or 0161 205 2000), Thurs–Sat 11–8, Sun–Wed 11–5. Harbour City Metrolink Station.

SOUTHPORT
Atkinson Art Gallery, Lord Street, Southport, Merseyside, PR8 1DH (01704 533133), Mon–Wed, Fri 10–5, Thurs, Sat 10–1. Southport Station.

STALYBRIDGE
Astley Cheetham Art Gallery, Trinity Street, Stalybridge, Greater Manchester, SK15 2BN (0161 338 2708/3831), Mon–Wed, Fri 1–7.30, Sat 9–4. Stalybridge Station.

STOCKPORT
Stockport Art Gallery and War Memorial, Wellington Road South, Stockport, Greater Manchester (0161 474 4453/4454), Mon–Tues, Thurs–Fri 11–5, Sat 10–5. Stockport Station.

WARRINGTON
Warrington Museum and Art Gallery, Bold Street, Warrington, Cheshire, WA1 1JG (01925 442392/442398), Mon–Fri 10–5.30, Sat 10–5 (closed on Bank Holidays). Warrington Station. Some works of art are at Walton Hall and can be seen by prior appointment.

WIGAN
The History Shop, Library Street, Wigan, Lancashire, WN1 1NU (01942 828128), Mon 10–7, Tues–Fri 10–5, Sat 10–1. Wigan Wallgate or Wigan North Western Stations.